CONSTRUCON SITE
FOR POSSIBLE WORLDS

CONSTRUCTION SITE FOR POSSIBLE WORLDS

Edited by
Amanda Beech and Robin Mackay

URBANOMIC

Published in 2020 by
URBANOMIC MEDIA LTD,
THE OLD LEMONADE FACTORY,
WINDSOR QUARRY,
FALMOUTH TR11 3EX,
UNITED KINGDOM

CaLARTS

Publication of this volume was supported by CalArts.

BRITISH LIBRARY CATALOGUING-IN-PUBLICATION DATA

A full catalogue record of this book is available
from the British Library
ISBN 978-1-913029-57-9

Distributed by the MIT Press, Cambridge, Massachusetts
and London, England

Type by Norm, Zurich
Printed and bound in the UK by
TJ International, Padstow

www.urbanomic.com

Contents

Language and its Possible Worlds is a research group based in the Center for Discursive Inquiry in the School of Critical Studies, California Institute of the Arts (CalArts). Bringing together a core group of international researchers and discussants from disciplines ranging across artistic practice, philosophy, film studies, architecture, and literary fiction, the project has manifested in a series of workshops, seminars, and events that develop the work of its first iteration **Cold War/Cold World**. **Language and Its Possible Worlds** asks whether it is possible to propose constructive propositions for forms of life, work, and futurity through scientific, mathematical, and natural languages.

Robin Mackay

Introduction

Is the despair attending the much-vaunted impossibility of imagining a world outside of capitalism—the conviction that the time of competing alternatives is over and that all possibilities converge upon the actuality of this world—so great that we have finally given up on the task of constructing any alternative? In any case, where the idea of other possible worlds is mentioned, it is increasingly not in connection to a programme or project, but in the hushed and wistful tones of those for whom it suffices to guard the guttering flame of hope, perhaps looking back to unrealised 'futures past' or scrutinising the world for signs of a collapse that would let *something else* through. There is certainly an appetite for other possibilities—for a different world that would not simply be more of the interminable production of capitalist difference-within-the-same. Undoubtedly, 'if you build it, they will come'—yet this precisely begs the question of construction, and many of today's calls for the collective imagining of other possible worlds ring hollow because they provide no ground plan, suggest no tools beyond imagination and hope and, while critiquing the existing world, rarely specify what part its residual artefacts will play in the construction of the edifice of the new—for, as Nelson Goodman reminds us, every making of a world is a remaking.

Building on the work of several multidisciplinary research workshops, this volume brings together contributions from philosophers, artists, musicians, and architects addressing the task of not merely imagining, aspiring to, or hoping for possible worlds, but of determining the conditions for their construction. Examining the reasons why so many projects that aim to mine other possibilities collapse back into the dominant logics of actuality—something that could almost be a definition of the condition of contemporary capitalism—demands a broad philosophical reassessment of some fundamental concepts: possibility, probability, project, speculation. The volume commences with historical and philosophical examinations of the entangled notions of possibility, probability, and contingency, and it will be noted that throughout, our contributors' attention

returns to two specific philosophical sequences: one concerned with the very notion of consistently thinking worlds that are possible but not actualised, and the struggle to either reconcile logical discourse with modal concepts or to expel them; the other, in particular in the work of Wilfrid Sellars and Robert Brandom, concerned with the emergence of the space of the conceptual that endows us with our capacity to negate the actual and participate in thinking the possible. These two tasks—a genetic account of our ability to enter possible worlds, and the intra-conceptual legitimation of modal thought—address the question of the construction of possible worlds at the most fundamental level. But equally, in the essays that follow, contributors draw upon the problems encountered by their own specific disciplines in envisioning alternative possibilities, and examine the constraints under which they currently labour. Appraising the nature of the present impasse, reexamining the tools at hand, reevaluating inherited attitudes, and alerting oneself to new circumscriptions of the possible imposed by the ingress of technology—these are the tasks at hand here, on the level of the highest abstraction and the most immediate local concern alike.

Daniel Sacilotto opens with a panoramic history of the concept of possibility and its connection with that of contingency, demonstrating the presence, from Aristotle through to German Idealism, of a pressing need to legitimate modal concepts twinned with a suspicion of the potential metaphysical excesses and logical absurdities they may herald. Soon we arrive at the 'modal revolution' which, in the twentieth century, largely succeeded in overcoming these reservations: finally, rather than being candidates for elimination or reduction to nonmodal terms, modal notions such as possibility were consistently integrated into logic. As Sacilotto shows, however, this war is not yet won, as the admission of modal concepts opens up an interpretive Pandora's box from which fly any number of metaphysical and ontological malaises previously believed to have been eradicated. Even the boldest attempts to adjudicate the aftermath of this 'revolution', such as the very different approaches of Robert Brandom and Alain Badiou, do not so much resolve the problem as alert us to the high philosophical stakes involved in the question of the modal, and therefore the nontrivial work lying ahead for anyone who wants to consistently speak of, never mind set about the construction of, possible worlds.

Turning from possibility to review the history of modern conceptions of probability, **Adam Berg**, setting out from Hume's problem of induction, describes how the quantification of the possible into degrees of probability leaves untouched the conundrum of the ultimate referent of probabilistic reasoning. Where philosophies of probability have attempted to save our ratiocinations from falling prey to scepticism, Berg also highlights how the philosophical interrogation of perception and causation is key to the question of induction—and only becomes more vexed in the post-quantum age.

As Sacilotto demonstrates, the problem of possibility—how things that do not in fact obtain may yet be 'possible'—passes through a singular point in Leibniz's ingenious philosophy of possible worlds. While his ontologising of the possible ends up, radically, bringing God's actions under the aegis of Reason, it also implicitly inaugurates the modern shift toward locating possibility in subjective epistemic frailty rather than in the (or a) world. It is only the positing of God's infinite intellect, capable of grasping the necessity of those things we register as contingent, that prevents contingency from tainting reality with incurable uncertainty; once this last bulwark is removed, we are left with only the finite human intellect, as powerless to divine the reason behind contingencies 'in one stroke' as it is to calculate the inflection of a curve down to the nth-order differential.

What steps in to compensate for this epistemic debility is, of course, the armoury of predictive instruments that will increasingly define a technologically mediated world obsessed by the calculative management of the unknown. In her text **Anna Longo** addresses the apparent counterfinality effect of these tools for combatting uncertainty: we have passed into a situation where the very computations devised to enhance our forecasts, through their continuous intervention, continuously perturb and render unpredictable the world they were supposedly to predict and control. Drawing again on the problem of induction, the history of probability theory, and developments in modal logic, Longo places the emphasis on the latter's connection to game theory, in the shape of David Lewis's 'solution' to Hume's problem. Here the acceptance of a logic of possible worlds goes hand-in-hand with the hypothesis that worlds are collectively generated as a way of coordinating the actions of a number of agents. As Longo points out, the apparent opening this may seem to provide for the creation of different possible worlds is shut down drastically when we take into account the reality

of the situation and its agents. The 'game' today consists of extremely complex systems incorporating many agents who do not enjoy complete information and are continually hypothesizing about the hypotheses of their fellow agents. Rather than favouring a tendency toward equilibrium or offering a basis for coordination, such a situation exacerbates 'generalised uncertainty' and promotes complex divergence. Moreover, the governing principles of the 'information economy' actually *demand* such divergence and the production of unpredictability—the 'condition of contemporary profit', of course, is information asymmetry. Here Longo not only gives us a portrait of the seemingly inescapable global game we are summoned to play, but also highlights how, if the game-theoretical conceptual schema fails to adequately capture this world, it also limits our capacity to imagine other possible worlds.

In two contributions that set out in different directions from the world of pop music and the culture industry, **Mat Dryhurst** and **Amanda Beech** develop critiques of suppositions and inherited attitudes liable to vitiate artists' attempts to manifest other worlds or to alter the conditions of this one.

In a highly pragmatic vein, in an interview Dryhurst discusses his findings on the disparity between the prevalent powers and mechanisms in today's music world, and a strangely persistent imaginary that hails from another era. Strategically poised between a distrust of utopian visions and an optimism about the possibility of other modes of operation, Dryhurst gives us a diagram of a culture industry turned upside down, an industry whose greatest product is the image of itself it sells to artists prepared to pay in the hope of being heard. This is a bracing call to 'kick the machine' and take stock of the fact that, even if the music industry has since its inception been in the business of selling hopes and dreams, the model has taken some profoundly new turns in the twenty-first century.

Setting out from a pop icon of earlier vintage, Beech uses an analysis of the motives behind David Bowie's invention of Ziggy Stardust as a way to interrogate a number of assumptions that contemporary artists have inherited from the impasse of negative dialectics and the excesses of poststructuralism. Bowie's identification with the alien, she argues, was a way to respond to the impossible choice of seeing pop as consigned to an eternal rehashing of already-existing tropes, or resigned to a zombie-like ironic declaration of its own death. As

Beech argues, the acceptance of this exclusive choice, and the effects it has upon the artist's conception of what their own languages are capable of, also indicates more profound dangers in relation to the possibility of a politics. Is it possible to escape from the double bind and to discover languages which, via an identification (rather than an identity) with the alien—the outside—would be capable of envisioning other possible worlds?

Architecture, **Jeremy Lecomte** convincingly argues, is an inherently future-oriented practice for which the challenge of *projecting* possible worlds is posed the most acutely, but one which generally fails to live up to its own ambitious, transformational rhetoric. Architecture's conception of its task may well still be afflicted by leftover modernist idealisms, yet rather than dismissing the urban space that is its 'fundamental horizon' as simply synonymous with the existing order, we need to understand the tension characteristic of architecture: that of a discipline constrained to project other possible worlds according to the constraints of the one in which we already live.

The proposition here is that it is the *project* that must be reconsidered in order for architecture to move away from mere optimisation of the existing environment toward the construction of other possible worlds. Drawing, like several contributions in this volume, upon Nelson Goodman's discourse on 'worldmaking', Lecomte seeks to reorient the concept of the 'projectile', concentrating attention neither on the aim of a project nor on the place from which it is projected, but on a continuing conversation between the two: a delicate negotiation between the remaking of what already exists on the ground and the envisioning of an unprecedented destination. In facing its past, architecture must therefore understand what we might call its *projectility* as a 'desiring negation'—one that we see emblematised by Mark Tansey's portrait of Robbe-Grillet 'cleansing every object in sight', in a desert overpopulated by the remains of prior constructions.

Lecomte notes that the predicament of architecture he describes has been aggravated rather than cured by the new tools at its disposal in the twenty-first century: while the computational revolution in architecture theoretically expands the means of imagining and constructing environments that diverge ever more extravagantly from their predecessors, the reality of digital architecture is generally disappointing. On the basis of a similar observation, **Matthew Poole** casts a sceptical eye over architects' digitally enhanced riffing on the Deleuzian

language of 'the fold', and sets out to explore the sources of Deleuze's conception of the Baroque in relation to Bernard Caché's concept of the 'objectile'. Turning to Mario Carpo's claim that Alberti's break with the 'allographic' model of architectural practice and his pioneering of an 'autographic' architecture is now being reversed as architectural design moves from blueprint to algorithm, from object to objectile, Poole, in a close and insightful reading of Deleuze's appropriation of Leibniz in *The Fold*, poses the question of whether Deleuze in fact gives us to see the objectile as a potential liberation—an 'exorcising of the concept from the object' that 'invigorates the subject' and suggests the positive possibilities harboured by an architecture no longer tied to a classical conception of concept and object. Poole's tentative suggestion is that the fluidity of the objectile's 'mannerism' may promise a 'florescence' in which authorship (and architectural auteurship) will become impossible to sustain in the face of the architect's complicity in Baroque matter-flows. We find in Deleuze's Baroque, then, the vision of a designing of possible worlds that, while in some sense a 'return', would open up imaginative possibilities inaccessible to the autographical epistemology of an Alberti.

Where Lecomte insists that '[a]lternative worlds are already built the moment they are described', in 'The Only Possible Project' **Elie Ayache** deepens his thesis on contingency, the market, and matter in relation to the 'falling' of an architectural project that was never built, and that project's transmutation into writing. Ayache begins with the trenchant insistence that, when it comes to building an alternative to the existing world, it is *possibility* that must be abolished. In response, that is, to the hopeless sentiment that every 'alternative possibility' proposed today is easily incorporated back into the world of capital, Ayache targets the recuperative power of possibility itself. His radicalised Bergsonian argument is that, where all speculation on possibility inevitably dwells within the light of the actual, thought must adopt *writing* as its medium in order to outstrip possibility, the 'instrument of confinement within the present world', and engage directly with the only world that exists. Building on the operation performed by Quentin Meillassoux—the 'untotalisation' of the possible which yields the necessity of contingency—Ayache's position is that this collapsing of the modal landscape of possible worlds into the one and only single world—namely, matter—is effectively 'the only construction'

possible—a construction to be set against 'speculation and pure hope'. While perhaps agreeing with Lecomte that the architect is supposed to 'build the future in advance', 'projecting' it from the future, by threading this idea through the story of HW Architecture's winning and subsequently dismissed proposal for Beirut Museum of Art, Ayache presents as the perfect project a building that was demolished before being constructed and, precisely after the exhaustion of its possibility, was transmuted into writing.

In order to construct possible worlds, we must first be capable of manipulating them in language. In his essay **Inigo Wilkins** recounts in detail the philosophical controversy over the nature of language that saw a whole lineage of thinkers attempt to adjudicate between its uniqueness and specificity to humans, its evolutionary provenance, and its continuity with animal behaviours—with Chomsky, most famously, refusing any such continuity. According to Wilkins, it is Wilfrid Sellars who most effectively points the way toward an account of language that preserves its irreducibility while remaining committed to a programme of naturalisation. He then takes up Gary Tomlinson's remarkable recent account of the emergence of 'musicking' to argue that, from an artefactual perspective, such extralinguistic practices may prove to be essential to any future account of hominids' entry into linguistic and conceptual space. Language, then, may owe a prehistorical debt to music, and extralinguistic practices including music, certainly, are capable of opening up new possible worlds. As Wilkins suggests, even the most advanced theoretical accounts of mind stand to benefit from attending to this broader artefactual perspective on the origins of language and the entanglement of conceptual with musical spaces of possibility.

Christine Wertheim extends the artefactual perspective to logic and its conventional notations, suggesting that the imaginary of prevalent science-fictional 'possible worlds' may be constrained by a reluctance to address the corporeality secreted in the logical formalisms that underly computational processes. Wertheim's essay seeks to undermine the closed and self-sufficient nature of these formalisms with a dual approach: understanding logical conventions as evolutionary products suggests the possibility of other logical worlds, while Peirce's extraordinary Existential Graphs, premised upon an acknowledgement of their own written materiality, present an approach to notation that opens onto bodies: a topological 'image of mind' quite different from that of classical logical scripts.

In Wertheim's hands, what may seem like a historical curiosity opens the way to a deeper consideration of the connection between the inseparably corporeal-cognitive prehistory of logic and the formalisms embedded within those artificially intelligent progeny which, according to popular apocalyptic lore, are set to obsolesce human bodies altogether.

In a programmatic text that closes the volume with the launching of an ambitious philosophical projectile, **Anil Bawa-Cavia and Patricia Reed** offer us in lucid axiomatic form a computational manifesto for worlding that distils much of what has been discussed in the foregoing texts, informed again by Goodman, but mobilising the resources of category theory and logic, and in particular Ruth C. Barcan's startling claim that any realisable world is already actual. One need not then have recourse to the dubious realm of the modal in order to conceive of alternatives; the task is rather one of developing the means to intuit situated interactions that are already in place (or rather, out of place) in this world, but which outline another that is yet to be concretised: shifting frames of reference away from the endlessly iterated re-cognitions imposed by the actual world, and designing world-models, languages, and abstractions that are not adapted to the actual, producing new modes of intuition. It is only through the most precise of manoeuvres that we are able to 'bear witness to a world that is not yet concrete' without falling prey to the twin snares signalled by many of our contributors: mere wishful thinking, or inadvertent re-enshrining of the status quo.

The sophisticated framework that Bawa-Cavia and Reed develop here testifies, as do all of the texts included here, to the contemporary urgency of the task addressed in this collection and by the 'Language and its Possible Worlds' research programme: that of harnessing all the resources of the imaginary and the logical, of exploring every cognitive instrument, logical model, and 'process-hack' in order to relieve possible worlds of their insubstantial, detached, wishful aura and to make them—whether in language, art, music, architecture, or politics—the object of pragmatic project(ile)s under construction.

Daniel Sacilotto

On the Philosophical Concept of Possibility: Modality, Contingency, Structure

In this essay I propose to draw out a protracted genealogy of the concept of possibility, tracing its relevance to different aspects of philosophical questioning across several key historical moments, from antiquity up to the present. In the first section, I briefly rehearse the way in which modality becomes a central topic within logic and metaphysics in Aristotle's twofold account of possibility, elaborated in its fundamentals in the *Prior Analytics*. I then trace the role that modality plays within a theological register during the mediaeval period, bearing upon not only metaphysical, but also practical and moral reasoning, and leading to Leibniz's conception of a 'possible world' in the context of thinking a solution to the problematic of evil.

After touching upon the inflection of the metaphysics of modality into the human subject in the German Idealist sequence with Kant and Hegel, in the first part of the second section I indicate how the 'analytic project of semantic analysis' (Brandom) leveraged new criticisms against the propriety of modal vocabulary for epistemological and metaphysical theorisation. As we shall see, this period rekindled the scope of the modern empiricist challenge to the concept of necessity within the contours of the linguistic turn, emblematised in Quine's assault on intensional theories of meaning. In the second part I address how Wilfrid Sellars, paving the way for the 'modal revolution' initiated by Kripke, Stalnaker, and Lewis which led to the development of possible worlds semantics, answered the empiricist challenge by way of an inferentialist account of meaning and a normative conception of rationality, rehabilitating the scope of the Kantian investigation into the cognitive faculties of sapient beings within the project of semantic analysis in a naturalist register.

Finally, in the third and last section, I rehearse two alternative conceptions of the role of modal reasoning for philosophical thought in the contemporary

context: Robert Brandom's extension of Sellars's inferentialist semantic frame into a conceptual realist account inspired above all by Hegel, and Alain Badiou's mathematical ontology of non-modal multiplicity and phenomenology of worlds, indicating some of the problems Badiou presciently identifies in coordinating the theoretical and practical aspects of modal concepts when conceiving of the articulation between language, formalisation, and the world.

I. The Classical View:
The Logico-Metaphysical Concept(s) of Possibility

(a) Aristotle's Twofold Account: Possibility and Contingency

In the history of philosophy, the term 'possibility' designates both a topic within the study of logic, and a central concept inherent to metaphysical, epistemological, aesthetic, and ethical investigation. In its primary logical and metaphysical senses, the elaboration of the concept of possibility finds its classical locus in the first Book of Aristotle's *Prior Analytics* (Pr. An. 1.13 32a18–21) and the study of the forms of the syllogism. In general, these forms encode the basic rules of inference that underwrite all theoretical and practical reasoning, and which express the inextricable relations between the *possible* and the *necessary*, each term being definable in terms of the other. As Cresswell et al argue, however,[1] in this text Aristotle's account distinguishes between two senses of possibility: 'one-sided possibility' refers to *what is not impossible*—anticipating the modern, logical conception following downstream from Frege[2]—while 'two-sided possibility' or *contingency* refers to what is neither impossible nor necessary.

> I use the expressions 'to be possible' and 'what is possible' in application to something if it is not necessary but nothing impossible will result if it is put as being the case [two-sided possibility]; for it is only equivocally that we say that what is necessary is possible [one-sided possibility].[3]

1. M. Cresswell, E. Mares, and A. Rini, *Logical Modalities from Aristotle to Carnap: The Story of Necessity* (Cambridge: Cambridge University Press, 2016).
2. This conception is also elaborated in Section 3 of *De Interpretatione* and Section 2 of *De Caelo*. For a discussion on these issues see M. Malnik, 'Aristotle on One-Sided Possibility', <https://www.nyu.edu/gsas/dept/philo/faculty/malink/Aristotle%20on%20One-Sided%20Possibility.pdf>. See also Cresswell et al., *Logical Modalities*.
3. *Pr. An.* 1.13 32a18–21.

The difference between these two definitions corresponds to two ways of conceiving of possibility in terms of necessity, such that the first, one-sided definition is said to be 'weaker', in so far as it is said to be 'equivocal', i.e. *p* is possible if and only if it is not ruled out that it is necessary, and *p* is necessary if and only if it necessarily follows that *p* is possible. In summary:

One-Sided Definition: Non-Impossibility

For any proposition *p*, *p is* **possibly** true if and only if:

(1) It is **not necessary** that *p* is **not** true.

(2) *p* is **necessarily** true if and only if it is **not** possible that *p* is **not** true.

The two-sided definition—which is more restrictive and 'stronger'—adds an additional condition to the one-sided definition: what is possible is that which *has no impossible consequences*: 'I mean, by being contingent, and by that which is contingent, whatever is not necessary, but being assumed to obtain, entails no impossible consequences'.[4]

Two-Sided Definition: Contingency

For any proposition *p*, *p is* **possibly** true if and only if:

(1) It is **not necessary** that *p* is not true; it is **possible** that *p* is true.

(2) If *p* is true, and *q* is **necessarily** not true, then *p* entails *q* is **necessarily** not true.

What makes the two-sided conception less epistemically tractable and yet metaphysically prioritised in Aristotle's account as 'belonging by nature' is not evident, however, but is doubtless related to the fundamental explanatory role that contingency plays for first philosophy.[5] And as Robin Smith argues, the need for a 'modal syllogistic' involves not only the clarification of the *logical* relation between *possibility* and *necessity*, but the *metaphysical* elaboration of the difference between *potentiality* and *actuality,* which is concentrated in Aristotle's polemical engagement with the Megaric school, evinced above all in *Metaphysics* IX.[6] He summarises the root of this tension in what he perceives

4. Ibid, 32a18-20.

5. Ibid., 14–22.

6. R. Smith, 'The Mathematical Origins of Aristotle's Syllogistic', *Archive for History of Exact Sciences* 19:3 (1978), 201–9.

as the blatant absurdity following from the view that possibility entails actuality and, conversely, that what is not actual is by extension said to be impossible:

> There are some who say, as the Megaric school does, that a thing 'can' act only when it is acting, and when it is not acting it 'cannot' act, e.g. that he who is not building cannot build, but only he who is building, when he is building; and so in all other cases. It is not hard to see the absurdities that attend this view.[7]

For Aristotle, accepting the being of 'unactualised potentialities' implies that there can be false propositions which are not impossible, which in turn entails that 'the false and the impossible are not the same; that you are standing now is false, but that you should be standing is not impossible'.[8] This is encapsulated in the second condition in the two-sided definition of possibility, which under-writes contingency: to be possible entails that what is not actual nevertheless counts as a *real potential* if and only if nothing impossible would follow from its actualisation. In this way, already in its incipient elaboration, the logical study of modality dovetails into metaphysical issues concerning the criteria for the individuation and differentiation of substance.

In its proto-formal elaboration in Book X of *Metaphysics* X—as part of the famous 'square of opposition'—modal reasoning becomes then crucial to understanding two different senses of *opposition*: firstly, the distinction between *inclusive* and *exclusive* opposition, and secondly, that between two kinds of exclusive opposition: *contradiction* and *contrariety*, in terms of which one articulates the relationships between quantified positive and negative statements. Like contradiction, contrariety is an *exclusive difference* in so far as if *p* is true then *q* is necessarily not true, and vice versa, e.g. if something is **triangular** it necessarily is not **circular** (compare: **triangular** and **red**). But while contradiction precludes the possibility of *p and* not-*p* being false, given *the principle of the excluded middle*, relations between contraries determine that if *p* is false, it does not follow that *q* is necessarily true, and vice versa, e.g. if something is not **triangular**, it is not necessary that it be **circular**.[9] As Robert

7. *Met.* 9.3 1046b28–33.

8. Ibid., 9.4 1047b10–15.

9. Moreover, objects can only stand to each other in relations of contrariety but not contradiction, since for an object B to be the contradictory of A it would need to exhibit *every* property that is incompatible with A. But since the set of all the properties which are incompatible with those

Brandom has elaborated, relations of contrariety thus encode those inferential relations of *material incompatibility* between concepts by virtue of which they acquire their descriptive content and become *determinate*.[10] And since our descriptive accounts can only be determinate in so far as their constituents are bound to enter into such counterfactually robust, modally rich oppositional relations of material incompatibility and consequence with each other, Brandom argues, 'modal realism comes for free. We didn't need Newtonian physics to get to conceptual realism in this sense; the barest Aristotelian metaphysics is already enough'.[11]

Following Aristotle's extension of modality to metaphysics, a panoply of senses of what constitutes possibility become progressively discerned, extending from the logical investigation of modality and constraining the intelligibility of ontological, epistemological, aesthetic and ethical investigation. For it becomes progressively evident that, just as the objective relations which serve to describe metaphysical relations are modally laden, so must the concepts that furnish the panoply of vocabularies through which we specify metaphysical, epistemic, practical, and aesthetic categories carry modal force. We shall return to this point below, when we assess how modality becomes central not only to theoretical but also to practical issues, and examine the way in which these different senses of the possible and domains of modal reasoning become explicitly elaborated within a pragmatics of reasoning, eventually to be formalised in the twentieth century under the banner of the 'modal revolution'.

(b) The Scholastic Theological Conception of a Possible World and the Modern Subjectivisation of Modality

As the logical and metaphysical investigation of modality develops over the mediaeval and Scholastic period, the concept of possibility becomes inherent to the appropriation of Aristotelian essentialism, dating to the recovery of the modal syllogistic from the *Prior Analytics* in the twelfth century.[12] In this context,

of a given object will include incompatible contrary determinations, this is impossible, e.g. the contradictory of a red square would need to be simultaneously blue, yellow, circular, hexagonal, etc.

10. R. Brandom, *A Spirit of Trust: A Reading of Hegel's Phenomenology* (Cambridge, MA: Harvard University Press, 2019), 57.

11. Ibid.

12. These developments become prefigured through a long and complex series of historical events: Boethius' commentaries on *De Interpretatione* in *Commentarii in librum Aristotelis. Perihermeneias* I–II; the translation of Averroes texts, etc.

modal metaphysics become inscribed within a theological context, prefiguring the concept of a 'possible world'. It is first concentrated in Augustine's account of God as deciding between 'alternative worlds' or universes, and then more formally elaborated in Duns Scotus's explicit thematisation of 'the neutral proposition' within a so-called 'divine psychology'.[13] According to the latter, 'logical possibility' designates all states of affairs that are *compossible* and so not 'repugnant' to being, even if they are unactualised, i.e. they do not exist in the sense of being actual, but nevertheless are real in so far as they satisfy not only the epistemic but the ontological conditions for anything that exists. This involved reconceiving the Aristotelian account of contingency explicitly in terms of the relationship between the actual and the possible, as inherent to the agency of the divine intellect: given that the divine act of creation must be freely willed, the 'first causes' for everything that exists cannot be necessary, since that would imply that they are themselves caused; they must have been able to have been otherwise, i.e. God must have been able to have willed the world to be other than it is. Thus Duns Scotus writes: 'I do not call something contingent because it is not always or necessarily the case, but because its opposite could be actual at the very moment when it occurs'.[14]

It is this conception of modality in terms of counterfactual reasoning about real but unactualised alternatives that leads to the elaboration of a new modal logic in the works of William of Ockham (*Summa Logicae*), John Buridan (*Tractatus de Consequentiis*, *Summulae de Dialectica*), and others. Here Abelard's distinction between *de dicto* and *de re* (or between *cum dicto* and *sine dicto* in Ockham's framework) assimilates metaphysical questions concerning possibility and actuality, such that the classical division between nominalism and Platonism is rekindled and recast in a new light. Without getting engrossed in the historical details, it was the metaphysical elaboration of modal metaphysics following downstream from Duns Scotus which thereby paved the way for the modern conception of 'possible worlds', defined by Leibniz in its most minimal form as 'ideas in the Mind of God'. A possible world or 'universe', according to Leibniz, is

13. See A.J. Beck, 'Divine Psychology', and 'Modalities: Scotus' Theory of the Neutral Proposition', in E.P. Bos (ed.), *John Duns Scotus: Renewal of Philosophy: Acts of the Third Symposium Organized by the Dutch Society for Medieval Philosophy Medium Aevum* (Amsterdam: Brill, 1998).

14. *Ord* I.2.1.1–2, 86.

a 'collection of finite things', that is, a relational and holistic network of individual substances, each with their own distinctive 'concept':

> [A]ll existent things [...] must needs be reckoned all together as one world [...] all things are connected in each one of the possible worlds: the universe, whatever it may be, is all of one piece, like an ocean: the elastic movement extends its effect there to any distance whatsoever.[15]

Following Duns Scotus's elaboration of the Aristotelian doctrine, Leibniz characterises contingency in terms of the (infinite) worlds that could be created by the divine intellect, with each possible world conforming to its own 'principal designs' or 'purposes': they are primary 'free decrees' which generally determine the particular 'laws' or the 'general order' by virtue of which individual substances enter into relations of composition with each other. In doing so, they reflect the modal structure of the world to which they belong, even if these worlds are never in fact actualised.

> I think there is an infinity of possible ways in which to create the world, according to the different designs which God could form, and that each possible world depends on certain principal designs or purposes of God which are distinctive of it, that is, certain primary free decrees (conceived *sub ratione possibilitatis*) or certain *laws* of the *general order* of this possible universe with which they are in accord and whose concept they determine, as they do also the concepts of all the individual substances which must enter into this same universe.[16]

The ordering or 'compossibility' between substances that constitute a possible world must preclude the possibility of a contradiction obtaining between them, which means that even the 'free decrees' upon whose basis God organises the creative act must answer to logical constraints, e.g. if, in a given possible world, the concept **Socrates** includes among its constitutive properties **Plato's teacher**, then in that world it is impossible for the concept **Plato** to include among its predicates **Socrates's teacher**, etc. This inability of God to bring the

15. *Theodicy* 8–9, 131.
16. G II 51/L 333.

contradictory into being in turn implies that metaphysical possibility or contingency is subordinated to (classical) logical possibility in the sense of coherency, something which distinguishes it from necessity, i.e. for a proposition p to express a contingent truth is for it to be subject to what Leibniz names 'infinite analysis', such that it is not possible to arrive at a complete demonstration to determine the necessity of this truth. Rather, such truths give way to an infinite regress of reasons, where ultimately only the decrees guiding the divine will and intellect may access its 'sufficient reason', inaccessible to the finite intellect of human beings.

> [I]n necessary propositions, when the analysis is continued indefinitely, it arrives at an equation that is an identity [...]. But in contingent propositions one continues the analysis to infinity through reasons for reasons, so that one never has a complete demonstration, though there is always, underneath, a reason for the truth, but the reason is understood completely by God, who alone traverses the infinite series in one stroke of mind.[17]

This seems to imply that contingency is in the last instance a form of necessity, so that what is contingent is not that which *could have been* otherwise; rather, contingent truths are necessary truths whose reasons for being are epistemically accessible by the mind of God alone. And this entails that God's creative act must always remain grounded in reason, however imponderable. The mystery that shrouds the divine remains thus constrained by the bounds of logical coherence, such that even God cannot act *without reason* (there is always 'a reason for the truth') or *against reason* (God cannot incur contradiction by bringing incompossibles into being).

Leibnizian Contingency:

For any proposition p, p is contingent if and only if:

(1) If p is true, then p is **necessarily** true.

(2) There is a sufficient reason(s) q for p, such that q entails p.

(3) Since q is a reason for p, q is **necessarily** unknowable by all finite beings, but

17. A VI iv 1650/AG 28.

necessarily known by God, i.e. humans cannot demonstrate that p is true since they cannot know that p follows from q.

(4) p is true because God knows (2) and wills that q.

(5) If r is contradictory with p, then p and r necessarily cannot be true at the same time (p and r are not compossible).

In any case, it is evident that in binding the divine will to reason, theology forges the path for the subjectivising of metaphysics and epistemology that would characterize the 'Age of Reason'. Indeed, it is conspicuous that binding divinity to reason was *required* to save God, as dramatised in Leibniz's answer to the problematic of evil: God must at once act in a rational way so as to preclude his indifference, incompetence, or imperfection, even as his optimally rational designs remain foreclosed from us. For it is not only the constraint of compossibility between finite substances to logical coherence which binds the creative act, but *God's own essential being* which must conceptually preclude contradiction, i.e. God cannot incur imperfection, but his deeds must cohere with his intrinsic nature, which must be rationally intelligible for us, even if the specific reasons guiding his creative act remain epistemically foreclosed. Accordingly, Leibniz famously argues that, since it is necessarily true that God is omnipotent and just (Principle of Perfection), yet bound by the Principle of Sufficient Reason, and since the realisation of any given possible world ultimately depends on the divine will, the actual world must be necessarily the 'the best world possible'. And since evil must necessarily infiltrate all worlds, regardless of their proximity to perfection, not even the best of all possible worlds can preclude a measure of evil:

> Evil may be taken metaphysically, physically and morally. Metaphysical evil consists in mere imperfection, physical evil in suffering, and moral evil in sin. Now although physical evil and moral evil be not necessary, it is enough that by virtue of the eternal verities they be possible. And as this vast Region of Verities contains all possibilities, it is necessary that there be an infinitude of possible worlds, that evil enter into divers of them, and that even the best of all contain a measure thereof. Thus, has God been induced to permit evil.[18]

18. *T* §21/*GP* VI 116.

With this said, it is also not difficult to see how, in restricting God's decision-making power to obey the formal demands of logical possibility, one also threatens its omnipotence and initiates the coruscating movement by which reason erodes the stability of the theological world view. The perfect alignment of God's agency to the order of reasons would then (not without irony) initiate a subsequent extension of the subjectivising of modality, migrating from the perfect but mysterious workings of the divine intellect to the fallible and imperfect decision-making capacities of the finite human subject. In this way, contingency would no longer designate a limit for us in our search for reasons *which we nevertheless know to exist*, but, more radically, would preclude the legitimacy of grounding necessity by appealing to an unknowable divine order of reasons; once brought under the immanent jurisdiction of modern rationality, the attempt to salvage necessity *within* contingency by appealing to an inaccessible realm of reasons only known by the infinite mind of God is longer sustainable.

The tensions between the rationalist and empiricist schools in modern philosophy remain paradigmatic in this shift: at its most corrosive extreme, the empiricist challenge to rationalist logicism would afflict the metaphysical essentialism latent in the reification of modality well beyond theological reasoning, giving rise to a global scepticism concerning the status of modal claims altogether. Perhaps the most dramatic iteration remains Hume's modal nihilism, which questioned the inductive leap from actuality into necessity, and in so doing undermined the epistemic legitimacy of natural lawfulness and substantive identity which underwrites the continuity between epistemic and metaphysical modality.[19] Contingency becomes in this process unhinged from its subordination to the Principle of Sufficient Reason, and the image of a preordained 'ordering of the world' by divine decree thus comes under increasing strain. Accordingly, while Leibniz sought to preserve metaphysical necessity by allotting to the mind of God those absent reasons we nevertheless know to exist, the

19. In what remains perhaps the most famous literary expression of this shift between the mediaeval and modern sequences, in *Candide*, Voltaire characterises Leibniz's position (parodied under the title of 'Panglossian optimism') as flying in the face of endless atrocity and inculcating a fatal conformism characteristic of human history, and implies that a better world might be possible, and that *we* are responsible for actualising it: 'We must cultivate our garden'). Put differently, short of being an essential predicate of the concept of the actual following from God's essence, the 'goodness' of the actual world must itself be thought as a contingent determination, in the sense of not being derivable, relative to free acts of the human subject.

empiricist sceptic reifies epistemic opaqueness to undercut even the legitimacy
of this postulation of an ineffable rational order. In the contemporary context, this
epistemic sceptical stance has led philosophers to claim not only that while we
can know that necessity obtains, we cannot know why it does, but that this lack
of reasons is in fact ontologically constitutive of nature: not a sheer epistemic
limitation to our cognitive faculties, but an ontological bulwark to ontogenesis.

As Quentin Meillassoux argues, transforming empiricist scepticism against
the Principle of Sufficient Reason into a positive 'principle of unreason', what
Hume took to be the sheer epistemic illegitimacy of postulating the necessary
being of any entity or lawful correlation between entities, ought to be absolutised
into the absence of necessity for any being to exist and for any natural laws to
obtain, such that the *only* thing that can be said to be necessary is contingency,
the possible non-being of anything that is said to be, or what he names 'the
principle of factiality':

> We must grasp how the ultimate absence of reason, which we will refer to as
> 'unreason', is an absolute ontological property, and not the mark of the finitude
> of our knowledge. From this perspective, the failure of the principle of reason
> follows, quite simply, from the *falsity* (and even from the absolute falsity) of
> such a principle—for the truth is that there is no reason for anything to be or to
> remain thus and so rather than otherwise, and this applies as much to the laws
> that govern the world as to the things of the world. Everything could actually
> collapse: from trees to stars, from stars to laws, from physical laws to logical
> laws; and this not by virtue of some superior law whereby everything is destined
> to perish, but by virtue of the absence of any superior law capable of preserving
> anything, no matter what, from perishing.[20]

In any case, it is in response to the sceptical challenge to the legitimacy of ale-
thic modal concepts first waged by the modern empiricists that Kant famously
inflects the categorial conception of substance derived from Aristotle into
the subject, launching the investigation into 'the conditions of possibility of
experience'. Modality becomes one of the four generic kinds of the categorial

20. Q. Meillassoux, *After Finitude: An Essay on the Necessity of Contingency*, tr. R. Brassier
(London and New York: Continuum, 2008), 53.

structures of the faculty of the understanding, divided into three categorial contraries corresponding to different classes of judgments:[21] *possibility/impossibility* corresponding to *problematical* judgments (*S* may be *P*), *existence/non-existence* corresponding to *assertoric* judgments (*S* is *P*), and *necessity/contingency* corresponding to *apodictic* judgments (*S* must be *P*). The subjunctive conditional relations between entities in the natural domain and their lawful correlations (subsumed under the categorial class of Relation) are thus reconceived as invariant aspects of finite human intuition rather than as the products of God's infinite intellectual intuition, thus deepening the subjectivising of modality initiated by rationalist theology.

Yet within the contours of the transcendental investigation into the conditions of experience, these categorical-transcendental structures had to appear as epistemic *givens*, i.e. 'factically' given to the subject in the sense that they themselves were foundational, underived principles. Furthermore, this residual 'essentialism' in the critical apparatus would salvage modality from the empiricist sceptical challenge, in turn generating an equally pernicious *transcendental scepticism* according to which the lawful necessity observed as holding between phenomena would have to be interpreted as relative to the human subject, with the reality 'in itself' being shrouded in darkness. In other words, in making modality an inherent feature of the *finite* human understanding, Kant could not but trade God's imponderable mystery for a gratuitous factical endowment for which no reasons could be given. As Meillassoux argues, this constitutes the decisive difference between Kant's transcendental idealism and Hegel's speculative idealism:

> Kant maintains that we can only *describe* the a priori forms of knowledge (space and time as forms of intuition and the twelve categories of the understanding), whereas Hegel insists that it is possible to *deduce* them. Unlike Hegel then, Kant maintains that it is impossible to derive the forms of thought from a principle or system capable of endowing them with absolute necessity. These forms constitute a 'primary fact' which is only susceptible to description, and not to deduction (in the genetic sense).[22]

21. I. Kant, *Critique of Pure Reason*, tr P. Guyer and A.W. Wood (Cambridge: Cambridge University Press, 1998), 212, 206 (A80/B106, A70/B95).
22. Ibid., 38.

For Hegel, subjectivising necessity into the human subject only transfers the epistemic obscurity that the Leibnizian rationalist assigns to the ineffable divine mind into the noumenal reality beyond appearance, just as it makes the natural laws that organise the phenomenal world subordinate to the factical 'transcendental' structures of our subjectivity. It is in response to this rational lacuna threatening the heart of the idealist project that Hegel subordinates the transcendental scope of Kant's enquiry into the finitude of the representational faculties of the subject to the historical and infinite movement of the dialectic, where the world *in and for itself* directly corresponds to the modal structure of the conceptual realm. In general, this involves a transvaluation of the epistemic constraints native to the investigation into the conditions of possibility of experience (which Meillassoux names *correlationism*, i.e. the thesis according to which one can only know/think how things appear to us, but not how they are in themselves) and its treatment of modality into a positive ontological thesis: the correlation between thinking and being itself becomes absolutised (giving way to what Meillassoux names *subjectalism*, i.e. the thesis according to which the correlation between the subject and being or an aspect thereof is taken to be absolute: sensibility, ideation, etc). As Robert Brandom argues, Hegel's speculative idealism thus implies a kind of *conceptual realism*, in which *alethic modal determinations* encoding relations of material incompatibility ('determinate negation') and material consequence ('mediation') between concepts were seen as directly corresponding to objective states of affairs. This constitutes a 'modally enriched empiricism' in which the concept of possibility is explanatorily basic in relation to actuality.

> Modality is built into the metaphysical bedrock of his system. Possibility is con-
> ceptually more basic than actuality, in the sense that an immediately given actual
> experience is intelligible as having the determinate content it does only insofar
> as it is situated in a space of possibilities structured by relations of compatible
> and incompatible differences [...] [B]y contrast to Kant, for Hegel the essentially
> modal articulation of what is determinate is not restricted to subjective thoughts
> or experiencings. It also characterizes objective determinate states of affairs,
> whether possible objects of sensory experience or not.[23]

23. Brandom, *A Spirit of Trust*, 141.

In bloating the fabric of representation that characterises finite intuition into the blueprint for the objective world, Hegel hypostasises the modal relations associated with the discursive-conceptual domain into nature writ large. Consciousness progressively makes explicit the objective modality of the world, within which what appears as merely given to consciousness from the purview of representation becomes actualised, becoming subject to deducibility, and revealing what appeared to be merely factical or given without reason to be necessary: giving 'contingency the form of necessity'.

II. The Semantic Concept of Possibility and the Structural Concept of a Possible World

(a) The Semantic-Logical Concept of Possibility: The 'Modal Revolution'

While the founding figures of the so-called analytic tradition were initially inspired by a recoil against the perceived idealist excesses of Hegelianism—concentrated in the influence of British Hegelians—they were likewise hostile to the psychologistic tendencies of parts of neo-Kantianism. As Brandom argues, for Moore and Russell, the 'idealist rot' responsible for the derailment of philosophy had already set in with Kant, and they enjoined a return to the empiricist tradition which, as we saw, initiated the decanting of theology from philosophy, and preserved the means to avoid the 'dangerous oxbow of German Idealism'.[24] As a result of this empiricist recoil, however, the incipient 'analytic project of semantic analysis' reiterated tropes and problems familiar from the modern sceptical assault, concentrated in two central challenges during the heyday of logical positivism:

(1) Firstly, the *pragmatist*-Wittgensteinian challenge to the very ideal of semantic analysis, which proposed to give up on the traditional focus of theories of meaning in favour of a consideration of the proprieties determining the use of expressions in a language.

(2) Secondly, and more importantly for our purposes below, Quine's assault against *intensional* theories of meaning following downstream from Frege, and their purported separation from theories of reference, extending an

24. Ibid, 107.

empiricist and naturalist critique of the central concepts which had under-written the method of analysis.

Focusing for now on the latter, at its core, Quine famously accuses intensional theories of meaning of harbouring a residual Aristotelian essentialism, albeit modulated into a semantic-linguistic key; particularly in its characterisation of the 'senses' which specify the determinate contents of discursive expressions in distinction to the extensional dimension of reference (or denotation).

> The Aristotelian notion of essence was the forerunner, no doubt, of the modern notion of intension or meaning [...]. Meaning is what essence becomes when it is divorced from the object of reference and wedded to the word.[25]

This line of attack was of a piece with a vigorous interrogation of a battery of interrelated concepts native to the very possibility of analysis—in particular, the unquestioned valence of the synthetic-analytic distinction. Hume's doubts concerning the epistemic legitimacy of modal notions were thus extended into the so-called 'linguistic view on necessity' formulated by Carnap and C.I. Lewis:

> [A] statement of the form 'Necessarily...' is true if and only if the component statement which 'necessarily' governs is analytic, and a statement of the form 'Possibly...' is false if and only if the negation of the component statement which 'possibly' governs is analytic.[26]

In a nutshell, Quine argues that, since the intelligibility of the notion of necessity supposes in turn the intelligibility of the notion of analyticity, and since the criteria for separating analytic and synthetic truths itself remains unintelligible, the distinction between the necessary and the 'merely possible' becomes precarious. For an analytic statement is supposed to be 'true by definition', in the sense that its predicates would be somehow 'already contained' or *synonymous* with its subject; but this just transfers the confusion concerning the 'meaning' of a word or concept to the question concerning just which definitional criteria satisfy

25. Ibid., 197.
26. W.V.O. Quine, *From a Logical Point of View* (Cambridge, MA: Harvard University Press, 1980), 143.

the conditions for synonymy. Distilled to its core, as Brandom elucidates, Quine's challenge can be summarised in terms of a demand: either explain modal notions in terms of non-modal ones, or else give up on them altogether. More precisely, Dagfinn Føllesdal argues that Quine sees two fundamental problems with the use of modal notions, which render the latter ubiquitously precarious in relation to semantic notions: it is not clear how to move from mere possibility to necessity, and the *ontological* import of modal concepts remains in need of clarification.

> There is not just vagueness, a problem of difficult borderline cases; even in the seemingly most clear-cut cases, it is difficult to understand what distinguishes the necessary from that which is merely possible. One can, of course, 'explain' necessity in terms of possibility: What is necessary is what cannot possibly be otherwise. However, unless we come up with an illuminating account of possibility that does not invoke necessity, we here move in a very small circle [...]. Quine's second problem with the modalities is that they are ontologically obscure. Not only is the notion of a possible world murky, but also what objects we are speaking about when we use modal expressions is unclear. These ontological problems are much more conspicuous in the case of the modalities than they are in connection with meaning.[27]

In response to the assault on modality formulated by Quine against theories of meaning, two fundamental rejoinders pave the way for the epistemic legitimation of modality in its descriptive-explanatory uses, within a new formal logical and metaphysical paradigm. Firstly, adapting Kant's strategy, Wilfrid Sellars postulates that the empiricist sceptical challenge to the legitimacy of modal notions is a non-starter, since it assumes an impossible stance to begin with. For in so far as the inferential roles that determine the meanings of concepts invariably comprise counterfactually robust relations of incompatibility and consequence in relation to other concepts, it is simply not possible to render intelligible 'the idea of an independently and antecedently intelligible stratum of empirical discourse that is purely descriptive and involves no modal commitments, as a semantically autonomous background and model with which the credentials of

27. D. Føllesdal, 'Quine on Modality', in R. Gibson and R. Gibson Jr (eds.), *The Cambridge Companion to Quine* (Cambridge: Cambridge University Press, 2004), 201.

modal discourse can then be invidiously compared'.[28] This insight forms the basis of what Brandom christens the 'modal Kant-Sellars thesis', which states that even those empirical concepts by virtue of which one makes non-inferential perceptual reports implicitly carry with them consequences of application, whose explicitation is accomplished by the use of modal vocabulary.[29] As a result, the idea that one would require an 'inductive leap' from an epistemically legitimate descriptive non-modal base to a modal context is a red herring:

> The classical 'fiction' of an inductive leap which takes its point of departure from an observation base undefiled by any notion of how things hang together is not a fiction but an absurdity. The problem is not 'Is it reasonable to include material moves in our language?' but rather 'Which material moves is it reasonable to include?' Thus there is no such thing as a problem of induction if one means by this a problem of how to justify the leap from the safe ground of the mere description of particular situations, to the problematical heights of asserting law-like sentences and offering explanations.[30]

Secondly, and in addition to this substantive rejoinder, C.I. Lewis and Kripke among others initiated the 'modal revolution' in logic and metaphysics, by virtue of which a thorough axiomatisation of the concepts of possibility and necessity was achieved, opening up a new sequence of constructive possibilities for analytic philosophy.[31] This involved the elaboration of a model-theoretic semantic meta-vocabulary to understand modal concepts extensionally, broadening the expressive resources of first-order predicate logic through the introduction of

28. R. Brandom, *From Empiricism to Expressivism: Brandom Reads Sellars* (Cambridge, MA and London: Harvard University Press, 2015), 134.

29. Within Sellars's own elaboration of the Kantian normative conception of rationality, alethic modal dependencies between states of affairs in the material mode implicitly express 'inference licenses' governing our descriptive and explanatory theoretical reasonings, which are made explicit by *deontic* modal subjunctive claims in the metalinguistic mode.

30. W. Sellars, 'Some Reflections on Language Games', in K. Sharp and R. Brandom (eds.), *In the Space of Reasons: Selected Essays of Wilfrid Sellars* (Cambridge, MA and London: Harvard University Press), 53.

31. Kripke famously questioned Quine's conflation between *necessity* as a metaphysical notion, *analyticity* as a semantic notion, and the *a priori* as an epistemological notion. Bridging the gap between theories of meaning and theories of reference, and so bringing together what Frege had pulled apart, while also reinvigorating the project of analysis after the positivist derailment, Kripke thereby challenged Quine's global modal nihilism.

'modal operators'. An updated iteration of the 'one-sided' definition of *possibility* formulated by Aristotle, in which possibility and necessity are defined mutually, was then formulated in the following way:

$\Diamond P \leftrightarrow \neg\Box\neg P$ For any proposition *p*, *p* is **possibly** true, if and only if it is **not necessary** that *p* is **not** true

$\Box P \leftrightarrow \neg\Diamond\neg P$ For any proposition *p*, *p* is **necessarily** true if and only if it is **not possible** that *p* is **not** true

With this formal advance came a conceptual one, wherein the centrality of modality across different domains of discourse gave way to a typology of modal concepts: just as the *alethic modal* concepts of necessity and possibility were explored through the introduction of the new formal operators, a variety of modalities become more rigorously distinguished: *deontic modal* concepts (obligation, permission...), *epistemic modal* concepts (knowledge, justification...), *temporal modal* concepts (always, before...), etc. But while the concept of 'possibility' appears to be but one modal notion among many to be explained, it also remains, in an important sense, semantically and logically fundamental. For modal *operators* are defined in a first-order extensional metalanguage, with quantifiers ranging over possible worlds, so that alethic modal concepts are themselves defined in terms of 'truth in a possible world'.

A statement *p* is necessary if and only if it is true in all possible worlds.
A statement *p* is possible if and only if it is true in at least one possible world.

This basicness accorded to alethic modal concepts allows us to better understand the sense in which the 'modal revolution' can be understood as a response to the sceptical worries about the classical project of semantic analysis. For, as Brandom notes, while the new formal semantics aimed to explain the use of modal notions within a first-order extensional register, it did so in turn by appealing to modal primitives. As a result, however, it cannot be plausibly taken to have eliminated modal vocabulary, and so cannot be taken as an positive answer to Quine's challenge.

The Kripke semantics is not even a candidate for providing such a reduction, because it owes its extensional character to the introduction of new primitive notions, possible worlds and accessibility relations (and in the case of quantified modal languages, further apparatus permitting re-identification of individuals and across worlds) that are themselves richly modal. [...] Any probative reasons to doubt the legitimacy of talk of necessity and possibility are just going to be passed off and transformed into corresponding reasons to doubt the legitimacy of appeal to such primitives. Thus, an appeal to advances in formal semantics for modal logic is not really responsive to the original conceptual challenge. The new semantics gives us much greater control over our use of modal vocabulary, helping us to get clearer about what we commit ourselves to by using it, how different modal notions related to one another and to some nonmodal ones, articulating the fine structure of modal concepts. But this clarification is resolutely internal to a language deploying the modal concepts, and does not address in any direct way more global worries about the legitimacy in principle of all such languages.[32]

Furthermore, as Føllesdal insists, it is this 'self-enclosure' of modal vocabulary that originally led Quine to argue that the new semantics did not really help in bringing us closer to an understanding of modality, nor did it help in mitigating worries about the latter's epistemic legitimacy:

Surely, such semantics are formulated in an extensional metalanguage, but since in this metalanguage one quantifies over possible worlds, the semantics do not bring us any further toward understanding the modal notions unless the notion of possible worlds is made clear. All the semantics tell us is how the key notions of the small circle are interconnected: Possibility may in most such semantics be defined in terms of necessity, thus: '$\Diamond p$ if and only if $\sim\Box\sim p$'. In some semantics, what is not necessary is necessarily not necessary: 'If $\sim\Box p$, then $\Box\sim\Box p$', and so on.[33]

32. R. Brandom, 'Modality, Normativity, and Intentionality', *Philosophy and Phenomenological Research* 63:3 (2001), 587–698.

33. Føllesdal, 'Quine on Modality', 201.

With this said, Brandom notes that since the putative force of the challenge posed by Quine is undermined by the Kant-Sellars thesis, it follows that while modal vocabulary *does* indeed remain in need of clarification within the scope of a *philosophical* semantic theory, it does not have to answer on account of its presumed epistemic precarity. Since modality is implicitly presupposed in the use of non-modal concepts, the only remaining plausible 'challenge' to modality is the demand to explain the relation between our ordinary descriptive concepts (which overtly make no use of modal vocabulary) and their implicit modal proprieties (which are made explicit by modal vocabulary). And it is precisely *this* relation that is illuminated by the new logic in a semantic metalanguage, in so far as it 'helps articulate the relation between ordinary descriptive predicates and explicitly modal ones, without pretending to reduce the content of the latter to the former, or explain the one in terms of the other'.[34]

Nevertheless, the resilient critic might worry that even if modality cannot be eliminated as a feature of conceptual content and inferential behaviour on sceptical grounds, the appeal to modal primitives in the definition of the truth-concept remains *ontologically* problematic. For what is a 'possible world', after all, if not a theological-metaphysical 'creature of darkness', an essentialist remnant that functions as an unexplained explainer without which the new logic cannot carry out its explanatory ambitions?

The crux of the issue concerns the basic role accorded to model-theoretic explanation as a semantic foundation, and the unclear status accorded to formal vocabularies. At the formal level, in its model-theoretic semantic frame, the concept of a possible world is *structurally* interpreted, minimally, in set-theoretical terms. Following the Hilbertian conception of what constitutes an axiomatic theory, the formal and substantive senses of possibility become again indissociable, so that a 'possible world' is defined as follows:[35]

34. Ibid, 21–22.
35. To take the paradigmatic example—and simplifying to the utmost—we can then define a 'Kripke model' as a triplet, consisting of a *modal frame* and a *relation*: $<W, R, \Vdash>$. A model frame is a pair $<W, R>$, in which W is a set whose elements $w_0 \dots w_i$ are possible worlds, and R is a binary relation $R \subseteq W \times W$ which determines for each world $w \in W$ which worlds w_y *are* 'accessible' from which worlds wy. An 'evaluation' or 'satisfaction' relation \Vdash is then added to the frame to correlate elements $w_0 \dots w_i \in W$ and model formulas/propositions $p_0 \dots p_i \in P$. These formulae/propositions would be truth-functional states comprising (extensional) quantificational first-order logical, base vocabulary.

(Semantic Modal Theory):

A modal **theory** is a **semantic metalanguage** which establishes rules of corre-
spondence (**C-rules**) that map the inferential relations into which the **modal
concepts of a logical language** are organised to the elements and accessibility
relations holding between the elements of a **possible world**, defined as a
model-structure.

The diagram below provides a basic illustration:

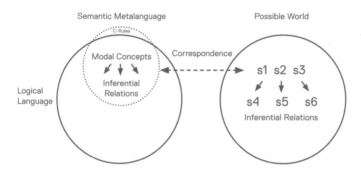

Without getting engrossed in the technical details, this structural definition entails
that 'possible worlds' comprise domains of *constructability* and *testability* for
an axiomatised logical system: what is possible must be *constructible* as a mod-
el-structure that functions as a domain of interpretation which verifies the axioms
and theorems of a formal-logical theory. *Testability* in turn requires that the mod-
el-structures which make up sets of possible worlds and the accessibility relations
among them are semantically correlated to the *statements of a language*, i.e.,
that possible worlds function essentially as domains of *verification* within which
the truth of propositions can be assessed, including modal statements. This
twofold constraint entails that 'possible worlds' are not given to us in advance
or from without; they are neither discovered experientially through *empirical
intuition* nor brought into being from an Ideal existence in God's mind through a
kind of *intellectual intuition*. Nevertheless, an understanding of possible worlds
as 'structures', even if these are constructed as opposed to discovered, seems to
take us into Platonist waters, where mathematical idealities provide the *content*
for theories, without which they would remain uninterpreted formal systems.

The question concerning the ontological status of 'possible worlds' therefore becomes rather hazy, leading to a variety of possible definitions and approaches that attempt to marshal their epistemic and metaphysico-ontological role, e.g. actualism/concretism, abstractionism, combinatorialism....

Taking Kripke's semantics as a target example, the Quinean sceptic might insist that what the primitive notion of a possible world reveals is precisely a continued adherence to an essentialist metaphysics that was already latent in the early project of analysis, and which presupposes that the conditions of reference across worlds can be settled without ambiguity. And this assumption requires in turn the capacity to rigidly designate a set of unchanging 'essences' or invariant conditions that would presumably hold for objects *across* all possible worlds, once again making an appeal to primitive modal notions, i.e. that the predicate 'human' is *necessarily* true of Nixon in all possible worlds, while 'being the president of the US' is not, etc. As to what plausible criteria could allow us to separate essential determinations from inessential ones without deferring to Fregean 'senses', Kripke's theory recommends that one 'consult one's metaphysical intuitions'. As Joseph Almog puts it:

> 'Nixon', the singular term used in expressing the property, is a rigid designator. On the other hand, that same individual could have failed to be the president of the United States in 1970 (again, a metaphysical judgment). Hence, the singular term 'the president of the United States in 1970' is a nonrigid designator. And so it goes: 'the square root of 81' is rigid; 'the number of planets' is not. How so? Consult your metaphysical intuitions.[36]

The irony becomes pressing: even if possible worlds are understood in a constructivist light, in order to coordinate model-structures to objects across possible worlds, one must again rely on an obscure appeal to an intuition; in this case, not so much sensory intuition as a kind of *intellectual intuition* that ultimately defers to common sense. But such deference to common sense won't satisfy the resilient sceptic; for the essentialist trap which Quine observed apropos Frege's postulation of 'intensions' reappears once we make the composition

36. J. Almog, 'Naming Without Necessity', *Journal of Philosophy* 83:4 (1986), 211.

of the objects of reference that ultimately compose the worldly correlates of possible worlds *qua* model-structures a matter of metaphysical caprice or fiat.

III. Two Deflationary Contemporary Approaches: Brandom and Badiou

In response to the seemingly interminable problems generated by modal concepts, two major deflationary strategies seem in order: a resolute Platonist solution which decants the model-theoretic enterprise from its purported metaphysical excess (Badiou), and a resolutely nominalist solution which interprets modal notions in purely metalinguistic-pragmatic terms, and rejects the notion of objective modality altogether (Sellars). While the second alternative accepts that modality is a non-eliminable feature of conceptual use (*modal expressivism*), it resists the ontologisation of conceptual relations into a fact-ontology, accepting only the reality of concrete particulars, which are overtly theorised in a process-monist metaphysical idiom (*modal anti-realism*). In so far as inferential relations hold between propositional states, it follows then that propositional form belongs only in the linguistic and conceptual orders. With this said, as Brandom argues, Sellars tells us very little about how to understand the difference between alethic modal locutions in so far as they characterise causal lawfulness and play a descriptive role in the objective mode, and the way in which deontic modal vocabulary makes this descriptive role explicit in its metalinguistic function. Indeed, Sellars seems to simply assume that the implicit sense in which deontic modality characterises the pragmatic bases of modality precludes the possibility of modal realism, since the latter entails endorsing a kind of idealism that would transpose propositional form onto nature writ large. As Brandom writes:

> Sellars acknowledges that modal statements do not *say that* some entailment holds, but distinguish between what is said by using a bit of vocabulary and what is '*contextually implied*' by doing so. Sellars says very little about this latter notion, even though it bears the full weight of his proposed emendation of the rationalist account. This is really all he says about the matter in the only essay he devotes to the exposition of his views about the 'causal modalities'.[37]

37. Brandom, *From Empiricism to Expressivism*, 187.

Brandom's alternative way to reconcile modal realism and modal expressivism is to embrace a version of Hegel's conceptual realism, which as we saw not only postulates an indissociable bond between causal and metalinguistic explanations, as Sellars does, but furthermore establishes a correspondence between the alethic modal locutions used to express the former and the world as such. Yet without explaining the epistemological conditions under which such alethic modal locutions can be said to be non-identical yet potentially analogous or isomorphic to real modal locutions, conceptual realism risks relapsing into a full-blown metaphysical idealism, for which the conditions of correspondence between the conceptual and the natural appear miraculous.

In resisting the speculative idealist reification of the correlation between thinking and being in the name of 'materialism', other philosophers have sought to resist the Hegelian solution to transcendental scepticism, claiming that the epistemic incapacity to know of the in-itself should be positivised into an onto-logical thesis. Accordingly, Meillassoux argues that the 'facticity' of thought—or the incapacity to find reasons why the correlation should be—must itself be absolutised:[38] it is *contingency* that is absolute, in so far as neither thinking nor being can be said to be necessary, a claim that pulverises the Principle of Sufficient Reason against the Kantian attempt to restrict necessity to experience, and the Hegelian attempt to absolutise the correlation. This forms the basis of a kind of 'speculative materialism' which claims that only contingency is necessary, so that it is in principle possible for things to be other than they are or not to be at all—including the 'laws' of nature.

Exemplifying the first alternative, Badiou proposes to radicalise the challenge to modality advanced by naturalised empiricism in a different way, detecting a lingering metaphysical kernel which underwrites all forms of analytic epistemol-ogy. He argues that what Quine misses from view is how the semantic enter-prise unwittingly harbours an unquestioned 'third dogma' afflicting even those positions that purport to reject empiricism in the name of naturalism: namely, the distinction between *form* and *content*, which subordinates mathematics and the process of *formalisation* constitutive of scientific rationality to the metaphysically loaded affordances of natural language. Whether in the name of

38. Q. Meillassoux, *After Finitude: An Essay on the Necessity of Contingency*, tr. R. Brassier (New York and London: Continuum, 2008), 57–60.

an observational vocabulary (empiricism), a scientific vocabulary (naturalism), or some common-sense idiom, these epistemologies would fail to assimilate the way in which mathematisation frees ontology from its metaphysical baggage, avoiding a relativisation of thinking to the contingency of 'bodies and languages' described by empirical discourse and natural language. And indeed, in rejecting the form/content dualism, Badiou argues that Quine's critique of the two dogmas nevertheless preserves a disfigured conception of the relation between thinking and being: the *representational* frame in which the ontological rights of natural science are epistemically secured by a semantic metalanguage in which fact and form are circularly defined, iterating the idealist serpent of Absolute Knowledge: 'If science is an imitative artifice, the artificial imitation of this artifice is, in effect, Absolute Knowledge.'[39] As Ray Brassier summarises:

> Thus in a surprising empiricist mimesis of the serpent of absolute knowledge swallowing its own tail, naturalized epistemology seeks to construct a virtuous circle wherein the congruence between fact and form is explained through the loop whereby representation is grounded in fact and fact is accounted for by representation [a theory of how science records 'facts'].[40]

According to Badiou, the constructive heart of scientific practice supposes a productive interplay between theoretical axiomatisation and model-theoretic experimentation (the 'testing of theories'), dispensing with the need to appeal to some discursive frame, whether couched in observational language, natural science, common sense, or otherwise. More than abstract ideographies which can only assume a descriptive-explanatory role by being coordinated with the world via appeals to metaphysical intuitions or natural/scientific languages, formal theories are 'tested' by structures that are precisely not 'intuited' but constructed:[41]

> It is precisely because it is itself a materialized theory, a mathematical result, that the formal apparatus is capable of entering into the process of the production

39. A. Badiou, *The Concept of Model*, tr. T. Tho and Z.L. Fraser (Melbourne: Re.press, 2007), 17.
40. R. Brassier, 'Badiou's Materialist Epistemology of Mathematics', *Angelaki* 10:2 (August 2005), 139.
41. If all deducible expressions in the system correspond to a true statement on the domain of interpretation, then the latter is a model for the system.

of mathematical knowledge; a process in which the concept of model does not indicate an exterior to be formalized but a mathematical material to be tested [...] Mathematical demonstration is tested through the rule-governed transparency of inscriptions. In mathematics, inscription represents the moment of verification.[42]

This immanent relay between the testing of theories and the construction of models provides the methodological lever for a so-called 'materialist epistemology of mathematics', which allegedly dispenses with any appeals to a notion of 'content' borrowed from natural language or metaphysical valences. This recalcitrance to qualitative or linguistic interpretation entails that, for the mathematical production which guides scientific thinking, 'no signifying order can envelop the strata of its discourse'.[43] Logical-mathematical *theories* operate upon themselves by stratifying their own syntactic material, while philosophical categories and ideological notions envelop them momentarily, only to be shed by a further stratifying process. This initiates a pendular movement between stratification and recapturing that expresses the dialectic of scientific cognition, tracking what Bachelard called an 'epistemological break [*coupure*]'.

From *Being and Event* onward, however, Badiou shifts his register from one of epistemological adjudication based on the coordination of theories and models, to a *historical* narrative in which the relation between axiomatic theories and set-theoretical models becomes progressively reworked, leading in its most recent iteration to the relation between axiomatised set-theoretical ontology and category-theoretic *logic*. Within this new polarisation, while set theory explores the pure forms of inconsistent multiplicity that underlie every consistent presentation, topology studies the 'objective' forms of appearing of the pure multiple in concrete 'worlds' with varying 'degrees of intensity', in accordance with what Badiou names the 'transcendental indexing' of the multiple. In taking the set-theoretical basis of modern scientific theorisation as self-sufficient, for Badiou, ontology becomes subtracted from the metaphysics of modality, i.e. the determinations of being become strictly speaking insensitive to the distinction

42. Badiou, *The Concept of Model*, 144.
43. A. Badiou, 'Mark and Lack', in P. Hallward and K. Peden (eds.), *Concept and Form, Volume 1: Selections from the Cahiers Pour L'Analyse* (London and New York: Verso, 2012), 173.

between the actual and the possible, the necessary and the contingent. As Oliver Feltham and Justin Clemens clarify, in place of the metaphysically loaded 'possible world' and its constitutive 'objects' (substances, facts, events…), Badiou offers the term 'situation' to define being as 'pure multiplicity', tracked by set theory:

> The term 'situation' is prior to any distinction between substances and/or relations and so covers both. Situations include all those flows, properties, aspects, concatenations of events, disparate collective phenomena, bodies, monstrous and virtual, that one might want to examine within an ontology. The concept of 'situation' is also designed to accommodate anything which is, regardless of its modality; that is, regardless of whether it is necessary, contingent, possible, actual, potential, or virtual—a whim, a supermarket, a work of art, a dream, a playground fight, a fleet of trucks, a mine, a stock prediction, a game of chess, or a set of waves.

This results in a curious rationalist critique, resonant in its diagnosis (if not in its implications) with the Kant-Sellars thesis: in so far as modality is implicitly and ubiquitously at work in our descriptive vocabularies, so the implicit 'essentialism' that Quine worries about is really an intrinsic feature of natural language and the descriptive-explanatory relations of material inference, including scientific and observational idioms. But while Sellars, refusing the Heideggerian compulsion to draw metaphysical conclusions from natural language wholesale, believes this enjoins a separation between the metalinguistic and objective modes of discourse, Badiou resolves to decant ontology from natural language and its metaphysically infested syntax altogether. Accordingly, mathematical language avoids not only the residual essentialism found in empiricist and naturalist theories of meaning, including Quine's own, but also sidesteps Hegel's *idealist* attempt to map the determinations of being in analogy with alethic modal conceptual relations of material incompatibility and consequence. In claiming that axiomatised set-theory mathematics as a strictly extensional, modally neutral regime of individuation just *is* ontology, Badiou thus aims to reject any purported relativisation of the latter to either a metaphysical order of qualitative essences, or to a semantic order of conceptual intelligibility. As he puts it: 'Every quality is modal. Multiple-being, whose determination is the ontology of quantity

as such, ignores modality'.[44] In turn, the category-theoretic phenomenology of worlds complements set-theoretical ontology by reinscribing modality in a non-linguistic register, subsuming the predicate logical calculus, and reinscribing objectivity outside of the valences of subjective experience: one no longer simply distinguishes between possible and actual worlds and their constituents, but rather admits of an indefinite plurality of intermediate intensity-values between inexistence and maximal existence, within an intuitionistic context.[45]

And yet, while the dislodging of mathematics from natural language might seem a welcome metaphysical cleansing for philosophy which would dodge the epistemic quandaries latent in intensionally rich vocabularies, as Lorenz Puntel argues, without being plausibly correlated to the *statements* that describe the constituents of 'possible worlds', empirical phenomena and their relations, set-theoretical and category-theoretical structures remain explanatorily empty, reducing ontology and phenomenology to a formally uninterpreted mathematical symbolism. And this vacuity cannot be ameliorated by drawing surreptitious analogies to various 'situations' in a metaontological (or metalogical) register, which must be after all couched in natural language.

> Within or by means of theoretical frameworks, contents are available for theorization, but this presupposes that the theoretical frameworks include elements that are not purely formal, but instead contain interpretations (i.e., relations to contents). For this reason, every philosophical or scientific theoretical framework contains, in addition to purely formal elements and concepts, also material or contental ones.[46]

And indeed, it is obvious that, without the meta-ontological and meta-phenomenological interpretation of mathematics provided by philosophy, neither can the Zermelo-Fraenkel formalisation of the concepts of set theory purport to speak about 'situations' any more than category theory can purport to speak about 'worlds'.

44. A. Badiou, *The Mathematics of the Transcendental*, tr. A.J. Barlett and A. Ling (New York: Bloomsbury), 166–7.

45. See A. Badiou 'From Logic to Anthropology, or Affirmative Dialectics' (2012), course at the European Graduate School, <https://www.youtube.com/watch?v=wczfhXVYbxg>.

46. L. Puntel, *Structure and Being: A Theoretical Framework for Systematic Philosophy*, tr. A. White (Pennsylvania: Penn University Press, 2008), 24.

Such metatheoretic interpretations proceed by surreptitious analogies to all kinds of vocabularies, expressing the bond between philosophy and its four 'conditions': science, art, politics, and love. And since these metatheoretic specifications and their correlation to 'ordinary' situations or empirical phenomena are uniformly dependent on natural language, they must remain modally laden. As a result, the status of modality as it pertains to philosophical theorisation remains unclarified, yet functions as the condition of intelligibility for ontology and phenomenology. This issue finally concerns the obscure relation between natural languages, mathematical languages, and the world, a relation which philosophy, in its systematic ambition, attempts to articulate. As a result, without clarifying the *pragmatic* role of what is involved in *theorisation* in general , and ontological theorisation in particular, the role played by modality as a feature of conceptual *use* and as a feature of the world as such, is bound to remain unclear.

If the structuring of worlds which endows 'objects' and their relations with specific 'degrees of intensity' must nevertheless be qualitatively specified by the use of modally laden natural linguistic vocabularies, then the question concerning the relation between the empirical and the formal remains necessary for any purported 'materialist' account that seeks to obviate metaphysical description or to sidestep any appeal to intuition: How are we to distinguish between the alethic and deontic modal relations that obtain in the conceptual order, and which are said to map determinate relations between objects and patterns in the real order? For if we are not to reproduce a kind of conceptual realism of the Hegelian sort, which postulates that states of affairs are structured analogously to the semantic and normative proprieties of the discursive order (as in Brandom's reconstruction of Hegel's idealism), without compromising the intelligibility of 'real modality' in nominalist spirits (as in Sellars's insistence that 'propositional form does not belong onto nature'), then we must establish *epistemological* criteria by virtue of which the modally robust inferential relations articulating conceptual order, while neither equivalent to the world nor miraculously in correspondence to it, nevertheless can function to produce an nomological counterpart or 'map' of the latter.

It is this insistence on the importance of separating the conceptual order and the real order that lingers on as perhaps the most provisory and yet most promising aspect of the Sellarsian nominalist and naturalist strategy, resisting at

once the blunt Platonism of those who ontologise mathematical form and the conceptual realism of those who ontologise conceptual modalities. By rising to this epistemological exigency, we would not, then, postulate a miraculous correspondence between the modalities proper to the conceptual and real orders, nor would we fall victim to the temptation to simply ontologise the concept of a 'possible world' in accordance with a specific formal-mathematical paradigm. Rather, we would adjudicate how mathematical vocabularies enable us to progressively gain traction on the objective modal structure of the world, and how the philosophical concept can render such a relation epistemically intelligible in its diachronic and historical realisation.

Adam Berg

Uses and Abuses of Probability: Perception and Induction

The notion of probability is entangled with that of perception and induction and, at least since the time of David Hume, has posed a challenge to rationality in light of the problem of induction on the one hand, and to nondeterministic conceptions of rationality on the other. The problem of induction is known through Hume's invoking of the circularity of reason when dealing with our beliefs and assertions regarding unobserved states of affairs: relying on our past experiences as a basis for causal explanation would inevitably imply that the differences between probable and demonstrative arguments are basically underdetermined and do not justify inductive inference.

With the advent of Hume's version of rational empiricism and the so-called problem of induction, probability attains a philosophical status independent of its earlier nebulous underpinnings in systems of divination and occult predictions.

In the following discussion I will examine Hume's coupling of probability with aspects of induction, and develop a broader discursive context, which will include art and science, for the purpose of situating the perception of probability, which often involves not merely a neutral usage or application, but an abusive method through which 'judgments' or 'determinations' are forced from the realm of the 'probable' (mathematical) into that of the 'possible' (modal).

Hume is pivotal in laying out the connection between induction, causation, and probability, and his contentions about this nexus are well expressed in his critical remark on John Locke:

> Mr. Locke divides all arguments into demonstrative and probable. In this view, we must say, that it is only probable all men must die, or that the sun will rise tomorrow. But to conform our language more to common use, we ought to divide

arguments into demonstrations, proofs, and probabilities. By proofs meaning such arguments from experience as leave no room for doubt or opposition.[1]

In so far as 'proofs' are based on arguments in Hume's sense, we must also entertain the possibility of incorporating 'probability' into both demonstrations and arguments as well, and this leads us to admit that probability is informed by our perception, and not only by underlying inductive inferences.

Probability's Unresolved Relation to Perception and Induction

Probability's unresolved relation to perception and induction undercuts a trivial distinction between the epistemological and ontological implications of its uses, and requires attention to the levels of objectivity of its constitution. Questioning how the perception of probability had continuously occupied a perplexing *topos* within the social sphere and its relation the so-called problem of induction leads us to the sedimentation of intersubjectivity and its relation to the constitution of objects, including that of mathematical objects and/or concepts.

The three main 'genetic' types of probability (see diagram) are:

(1) Probability instituted or synthesized passively as 'pure chance' or rudimentary randomness. This type pertains to my discussion below of the mediaeval to early-modern practice of drowning witches and to Marcel Duchamp's *3 Standard Stoppages* (1913), and can be elucidated by Charles Peirce's conception of 'chance', which I will also discuss below.

(2) Probability as formulated in classical thermodynamics, which implies a 'subjective' probability as a 'degree of ignorance' and is measured in terms of the system's entropy.

(3) The ontic or 'objective' probability associated with Boltzmannian statistical mechanics and later on with the quantum-mechanical context, which I will discuss in relation to Albert and Deutsch.

Husserl, in his *Judgment and Experience*, argues that Hume's so-called problem of induction stems from his understanding of probability. The perception of what

1. D. Hume, *An Enquiry Concerning Human Understanding* [1748] (Mineola, NY: Dover, 2005), 35.

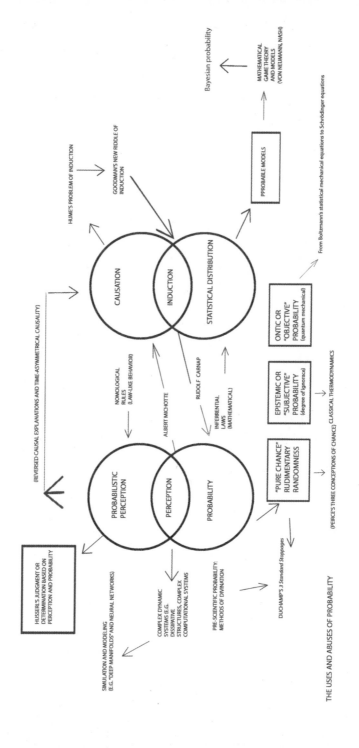

THE USES AND ABUSES OF PROBABILITY

is probable is different from the modal conception of the possible. Hume, in Husserl's understanding, imbues the perception of probability not with a modal conception of the possible, but rather, with the question of induction, and in doing so cements the 'modern' take on probability as lying beyond the scope of direct perception, thus paving the way for modern (post-Boltzmannian) science's assertion of indirect perception and its relation to the conception of probability as being connected to observation but without necessitating causal immediacy.

Later, with the rise of experimental psychology—following scientists and philosophers such as Helmholtz and Brentano, and Husserl's early phenomenological analyses (as in his *Logical Investigations* of 1900–1901), Gestalt psychology would be launched. With Albert Michotte's work *The Perception of Causation* (1945), perceptual phenomena, which historically were the province of non-experimental philosophical inquiry, were introduced into the context of a scientific psychology of perception. But the analysis of the perceptual mechanisms of causality still falls short of exhausting the concept of causation. In other words, since causation is related to induction and its inferences (unlike causality, which is linked to phenomenal perception), it becomes secondary to the perception of probability and hence to a large extent is undetermined on strictly perceptual psychological grounds. 'Causality' may be explained and may arguably be grounded in perception, but 'causation' is connected to the logic of inductive inferences, which is never entirely reducible to perception.

An examination of the perception of probability involves presuppositions about its connections to induction and thus to causality. In so far as Michotte's model for causal detection is based on how causal decisions are enacted as judgments or determinations of inferences regarding whether or not nonperceptual data point to a particular causal interaction, or whether a perceptual model of causality can be discerned through a given causal decision, it remains neutral in terms of its conception of the basis of causality. Hence, perhaps in a Kantian sense, induction is explained neither in terms of 'perception' nor 'causation' alone, but through a structuring of schemata.

The main conclusion that can be drawn from Michotte's work on the perceptual character of causation is that it involves either non-perceptual or perceptual input from both 'perception' and 'causation', and that such input is inferred from a sort of apperception, which in turn implies more than a mentalistic rendition

of a 'black box' that converts nonperceptual and perceptual information alike into inferential determinations. In the classical Humean sense of causation, the underlying inferential decisions are not split between two types of causal inter-actions—one derived from perceptual input and another from nonperceptual input. Rather, the processing of data is construed as the 'output' coming from the agent's or system's 'black box' without relying on a causal explanation. In Michotte's analysis of causality, the determination of the perceptual 'output' is aligned with a post facto psychological description of perception, but not of causation. Consequently, following Michotte, we can define the perception of probability as the analysis of a 'phenomenological theory' within science, which, as Mario Bunge contends, is based on a 'blackboxism'—namely, the conversion of nonperceptual and perceptual input is based on multivariant statistical distri-bution models, and hence on inferential laws.[2]

The respective inferential characters of 'perception' and 'probability' (e.g. multivariant statistical laws) do not differ simply in the way they are accounted for as phenomenal distributions, but rather in so far as the former involves reversed causal explananda while the latter involves epistemic time-asymmetry. Perception is explained or retrodicted on the basis of its 'predictive manifolds', and, as Alain Berthoz argues in his seminal work *The Brain's Sense of Movement*, [3]much of the neural activity of perception consists in simulating and relying on 'predictive manifolds' that act as a preview in anticipating movement and coming input as well as generated output. Probability, on the other hand, can be coherently and consistently used as an epistemic or ontic explanation only in so far as it relies on causal time-asymmetry. Otherwise, the conceptual basis of probability would be merely a question of arbitrary degrees of convention.

In *An Enquiry Concerning Human Understanding* (1748), David Hume puts forward the following contention in regard to probability:

> Though there be no such thing as Chance in the world; our ignorance of the real cause of any event has the same influence on the understanding, and begets a like species of belief or opinion.

2. M.A. Bunge, 'Phenomenological Theories', in M.A. Bunge (ed.), *The Critical Approach to Science and Philosophy* (New York: Free Press of Glencoe, 1964).

3. (Cambridge, MA: Harvard University Press, 2002).

There is certainly a probability, which arises from a superiority of chances on any side; and according as this superiority increases, and surpasses the opposite chances, the probability receives a proportionable increase, and begets still a higher degree of belief or assent to that side, in which we discover the superiority. [...]

It seems evident, that, when the mind looks forward to discover the event, which may result from the throw of [...] a dye, it considers the turning up of each particular side as alike probable; and this is the very nature of chance, to render all the particular events, comprehended in it, entirely equal. But finding a greater number of sides concur in the one event than in the other, the mind is carried more frequently to that event, and meets it oftener, in revolving the various possibilities or chances, on which the ultimate result depends.[4]

Hume's insight here is that correlations between probabilistic chance and our mental determinations (e.g. beliefs) are based on repetition and redundancy rather than on causal explanation. This is, in a nutshell, the essential argument for the problem of induction: our inferential reasoning on probability cannot be explained simply through the 'principle of redundancy' when it comes to our mental determinations on the course of events and chance. Hume's underlying argument for the fundamental undecidability of induction can be broken down into the following arguments:

(1) Chance has no ontological structural primacy.

(2) The real cause of 'chance' is our degree of ignorance (which is effectively our relative lack of knowledge).

(3) The objectivity of probability is correlated to the mental constitution of belief.

(4) Probabilistic chance (e.g. dice throwing, coin flipping) is epistemically neutral.

(5) Our mental determinations (e.g. beliefs) are based on the redundancy of results (repetitions of observation or experiment) without ever relying on descriptive causal explanations.

4. Hume, *Enquiry*, 40.

Thus, following Hume, probabilistic chance and our 'web of beliefs' (à la Quine) are not based on the same inferential logic, but rather are mentalistically coordinated and corroborated in order to substantiate the coherence between induction and causation via the role of redundancy. Hence induction, according to Hume, is always a simultaneous manifestation of our ignorance and our ability to overcome it by 'taming' probabilistic chance. Notwithstanding, Hume's phenomenalism does not differentiate between 'sensations' and 'perception', sense data and models of perception. In order to construe better the role of perception in relation to probability, we must look for an explanatory scheme that surpasses the notion of the role of redundancy.

A conception of deep probability asserts that over and above the uses and abuses of probability in terms of its application via inductive inferences and causal laws, it is radically constructed (a Goodmanian 'worldmaking') through perceptual manifolds. Not perception construed as rudimentary 'sensation' or as phenomenalistic 'sense data', but rather perception construed through the instantiation of sensory information organised as perceptual manifolds (or even, in Goodman's case, as 'projectiles').

Nevertheless, as Ian Hacking recalls in his history of probability, Peirce challenged Hume's negative conception of chance by arguing for or affirming 'absolute chance': 'Peirce reversed Hume's dictum, "that chance, when strictly examined, is a mere negative word and means not any real power which has anywhere a being in nature".'[5] In Peirce's own words:

> For a long time I myself strove to make chance that diversity in the universe which laws leave room for, instead of a violation of law, or lawlessness. That was truly believing in chance that was not absolute chance. It was recognizing that chance does play a part in the real world, apart from what we may know or be ignorant of. But it was a transitional belief which I have passed through.[6]

Hume's reliance on associations and connections in his explanation of 'human understanding' falls short of phenomenologically explaining how is it that we

5. I. Hacking, *The Taming of Chance* (Cambridge: Cambridge University Press, 1990), xci.
6. C.S. Peirce, *Collected Papers of Charles Sanders Peirce*, ed. C. Hartshorne and P. Weiss (Cambridge, MA: Harvard University Press, 8 vols, 1958), vol. 6, 409 [1893], quoted in Ibid.

assume induction to be probable without reducing probability to the simply 'perceptible' or directly observed. This stratum of analyticity in the enactment of probability, which involves logico-mathematical inferential laws, would come to haunt contemporary philosophers such as Hintikka, Putnam, and others, who identified two separate sets of problems when coming to articulate the relation between induction and probability.

The first is that the logic or laws of inductive systems are either deductive or axiological, and thus not inductive, and that they differ formally from the content of judgments—which implies the secondary 'nature' of induction as subordinated to judgments and not as a precept to them (here I will visit Wittgenstein's perplexing encounter with the metre rod and the question of criterion in reference to Duchamp's work 3 *Standard Stoppages*).

The second is that there is no clear way to determine the relation between induction and probability without asserting a theory of causation, or for that matter an anti-causal theory of physics (e.g. quantum entanglement or synchronicity). This leaves us undecided as to whether the nature of probability (and thus induction) is related to a mathematical formulation, or stems from a meta-mathematical logic that is in Gödel's sense incomplete, and inexhaustibly so.

Husserl, as I noted, identifies the circular logic in Hume's conception of probability, where, on the one hand, probability cannot be grounded or explained only in terms of the psychology of perception, yet, on the other hand, the habitual probabilistic nature of perception does not explain perception itself. In *Experience and Judgment*, in his discussion of Hume and the problem of probability and perception, Husserl gives the example of an object's multitude of profiles. For example, I look at a coffee mug with a pattern and presuppose that the pattern continues on the other side of the ceramic mug, and such a 'habitual assumption' is probabilistic in a passive-synthesis sense—one neither 'cogitates' it nor 'perceives' it as sense data.

So how is the determination of experience different in principle from that of judgments themselves, in so far as they both involve probability? Husserl observes that Hume 'even considered the idea that perhaps the *principles of probability* could be adapted to the justification of our causal inferences and in general all our judgments of experience which extend beyond the immediately given', but rejected this idea since 'he believed he could show that judgments

of probability spring from the same psychological principles of blind habit and association as judgments of causality and would thus bring us no further'.[7]

Following his discussion of the Humean dilemma, Husserl concludes with a constitutive differentiation between 'explanation' and 'perception' based on probability. Accordingly,

> [i]f we know that judgments of experience of this kind can have only the dignity of judgments of probability we must then investigate—before all questions of their psychological origin—whether the principles pertaining to objectivity are not here also to be apprehended through adequate generalization, therefore if reason is not the same in the sphere of probability as in the sphere of the relations between ideas.[8]

In this way, Husserl radicalises the Humean dilemma concerning the Janus face of probability and its relation to causation and induction, by emphasising the intertwining of 'ideas' and 'beliefs'—ideas here being construed as grounded in sensations, and beliefs as our mental determinations or ideas about given ideas. Husserl contends that

> [w]here Hume asked how it happens that a great number of possibilities so 'act on the mind' that they awaken assent or belief, we ask ourselves from our point of view: with regard to a series of favorable chances, do we have the right to objectively assert a probability?[9]

Husserl's insight here is very valuable both in terms of Boltzmann's conception of probability in relation to a system's initial conditions and its entropy, and in terms of the quantum-mechanical deterministic conception of probabilistic measurement based on physical reality rather than scientific conventionalism or representationalism, since it squarely raises the question of whether, and under what conditions, we can assert probability *objectively*.

7. E. Husserl, *Experience and Judgment*, tr. J. Churchill (Evanston, IL: Northwestern University Press, 1975), 393.

8. Ibid.

9. Ibid., 394.

Husserl distinguishes between a kind of probability that 'refers to the weight which belongs to presumptions of being' and its perceptual possibilities, and another that is 'objective' and is logically inferred from mathematics and statistics and yet lacks noetic content in itself—i.e., that is without the *explanandum* of scientific reasoning.[10]

Husserl's reading of Hume's contentions on the character of induction and probability should not be construed as critically negative, but rather as a radicalisation of Hume's insightful embrace of an epistemic underdetermination of the inferential rules of 'judgments' (and beliefs) with respect to the inferential laws of a probabilistic model. Such radicalisation sharpens both the commonality and difference between the probabilistic mechanisms of perception and the appropriation of statistical inferential models in scientific explanation—thus effectively accounting for both animal and human perception without assuming anthropocentric concepts of cognition.

To the extent that the perception of probability à la Husserl involves not only 'tools' but also 'ideas' of probability, our account of such 'ideas' informs the phenomenological constitution—construction—of 'worlds' that comprise the pre-given and given objects in the 'Lifeworld', and asserts the logical/formal, material/ontological, and transcendental heterogeneity of probables.

Worldmaking and the Perception of Probability

We can have words without a world but no world without words or other symbols. The many stuffs—matter, energy, waves, phenomena—that worlds are made of are made along with the worlds. But made from what? Not from nothing, after all, but *from other worlds*. Worldmaking as we know it always starts from worlds already on hand; the making is a remaking.[11]

Worlds, actual worlds, are probable rather than possible. In his groundbreaking work *Ways of Worldmaking*, Nelson Goodman argues that 'attempts to construe truth in terms of confident belief, or of credibility as some codification of belief in terms of initial credibility together with inference, confirmation, probability, etc.

10. Ibid., 96.
11. N. Goodman, *Ways of Worldmaking* (Indianapolis: Hackett, 1978), 6.

face the obvious objection that the most credible statements often turn out to be false and the least credible ones true. Credibility thus seems no measure even of nearness to truth. But this obstacle may not be insurmountable.'[12] Goodman takes Hume's position on the correlation between 'probability' and 'belief' a step further by advancing an intermediate stage between inferential rules and probabilistic chance in terms of predicates that construct worlds, or what he calls 'projectiles'.

What is more or less probable in a given linguistic predication is not reiterated in representational correspondence to states of affairs, but instead is decided by the inferential rules appropriate to the projectability of worlds. For Goodman, projectible predicates such as 'green' and 'blue' as opposed to non-projectible predicates such as 'grue' and 'bleen' are adjusted and restricted through observational inductive premises and arguments. As in the case of projective predicates of emeralds as 'grue' (e.g. green turned blue) or 'bleen' (e.g. blue turned green), unlike deductive rightness, confirmation relies on inductive rightness, which in turn is never categorically 'true' or 'false' but rather is contingent upon the inferential validity or invalidity of the observed state of affairs. Goodman's conclusion is that beyond the two categorical possibilities of deductive and inductive rightness, there lies 'a third kind of rightness in general: rightness of categorization', determinable laboriously by the results of truth-values through repeated experimentation—that is, an underlying statistical distribution.[13]

Thus, following Goodman's analysis, induction and causation are linked not simply through inferential rules but rather through a third categorical way that involves projectability as habitually tested usage of predicates' probabilistic distribution (statistical inferences) as a context or 'background principle'.[14] In so far as such background or meta-principles are based upon the deduction of observed (and indeed unobservable) processes through probabilistic distribution, statistical inferences are used in the construction of a 'world' through projectiles, be it 'grue' or a scientific concept such as 'inertia' or 'gravity'.

'Worldmakings', of art and science alike, in Goodman's brand of nominalism, are marked by the ontological relativity of 'kinds' and 'types' of 'worlds' rather

12. Ibid., 123.
13. Ibid., 127.
14. Ibid., 128.

than by their primacy in relation to the real. Thus, instead of embracing a universe populated with 'possible' or counterfactual worlds and which entails only a single actual and 'real one' (à la Leibniz or Lewis), Goodman's 'worldmaking' intertwines the possible predicates of 'facts' and 'fictions' with the same inferential probable projectiles, without compromising or conflating the calculus of the probable with that of the possible. Goodman's 'irrealism' is thus intricately linked to the construction of 'worlds' (and 'worldmaking') on the basis of probability distributions and statistical inferences that underly the rules and principles of predication via projectability.

It is in this sense that Goodman's seminal essay 'The New Riddle of Induction' is a radicalisation of the Humean understanding of the problem of induction in terms of justification or lack of it, but extended to the claim that there can be no justification of our inferential reasoning and practices outside of a given 'world'.

Furthermore, the uses and abuses of probability—as seen from Goodman's perspective—exceed the problem of induction in Hume's sense, connected with experiment and the enumeration of facts leading to determinations, and instead introduce the sphere of inferential practices as entailing a 'reflective equilibrium'[15] which traverses backwards and forwards 'determinations', namely, the web or webs of how determinations or judgments of various types are stabilised between 'perception' and 'predication'.[16]

Nonetheless, although Goodman's legitimation of predicates such as 'blue' (and delegitimation of those such as 'grue') on the basis of the entrenchment and spatiotemporal restrictions of projectiles may offer a solution to the problem of induction by redirecting our attention to the ways in which predication is connected to causal inferential rules, it still relies on a kind of linguistic transcendentalism that relieves us from the need (à la Hume) to come up with an underlying theory of causation, but confines us to the limits of language and its powers of projectability. Languages, natural and artificial alike, varying in types and categories of meaning-bestowal and 'projectability', may assist us in uncovering how various 'worlds' are made or constructed, but they cannot instruct us in the statistical inferential rules we ought to follow in each case of instantiation → predication.

15. J. Rawls, *A Theory of Justice* (Cambridge, MA: Harvard University Press, 2nd edition 1999).

16. Ibid.

The worldmaking involved in artworks is often self-proclaimedly 'fictional' or 'imaginary' even though it is grounded in perception, facticity, and immanence. More rarely, as in the case of Marcel Duchamp, an artwork is both generated from and thematises the notion of probability. In fact, in the case of Duchamp we can argue that the artist's fascination with probability is manifested through different informed 'uses' (and 'abuses') of probability which I would designate as follows: pure chance (*3 Standard Stoppages*, 1913), game theory (*Obligations pour la roulette de Monte-Carlo*, 1924), and statistical computability (Chess). Even though I will discuss his invoking of pure chance, my underlying contention is that Duchamp's doubting of the rational structure of art (precisely from a Humean critical vantage point) and of the modal arbitrariness of the artwork serves him well in addressing an overarching rationalist (perhaps hyper-rationalist) conception of the artwork as one among many types of 'probable'.

Long before its modern statistical formulation, probability defined a fundamental nexus between 'perception' and 'induction'. I will examine some perceptual and phenomenological implications that stem from Duchamp's *3 Standard Stoppages* (1913) in relation to Boltzmann and Brentano's exchange on perception, and probability and quantum probability. Despite the 'taming of chance' (to use the title of Hacking's historico-constructivist book), statistical probability and its connections to computational algorithms have not obliterated the need (and perhaps even the urgency) to address the grounds of probability's increasing role in our experience and judgments.

In *3 Standard Stoppages*, Duchamp employs two strategies or methods of randomness; randomness in regard to the method of production, and randomness in terms of the inferential determination of that which is stabilised or standardised. Duchamp's method of execution is based on dropping three one-metre-long threads from a metre-high ladder step onto a canvas; upon hitting the ground each thread is arrested in a curved shape out of which three 'standardised' metal blades are manufactured from each of these 'chance' stencils.

Duchamp's probabilistic parody of the concept of the 'metre' rod as a measure or a 'rigid designator' is reminiscent of Wittgenstein's contention in his *Philosophical Investigations* that

[t]here is *one* thing of which one can say neither that it is one metre long, nor that it is not one metre long, and that is the standard metre in Paris. —But this is, of course, not to ascribe any extraordinary property to it, but only to mark its peculiar role in the language-game of measuring with a metre-rule.[17]

Wittgenstein argues that the standard metre stick (kept under controlled temperature in Paris) is neither 'the actual' metre, nor does it possess a metric measure. It invokes a language-game that implicates criteria of measure with the measurement or 'standardisation' of a criterion as such. Duchamp, rather nihilistically, enacts types of 'chance' for the determination of 'rules', and *3 Standard Stoppages* turns out to be a rigidification of probabilistic distributions; the rules for chance are interchangeably conflated with chance or random rules. Hence, like Wittgenstein, Duchamp points to the difference between 'play' as rules-in-flux and the 'game' as a set of axiomatised rules interacting with chance.

Duchamp's abuse and use of 'chance' ventures out from the surrealistic sphere—typified by Comte de Lautréamont's statement 'as beautiful as the chance encounter of a sewing machine and an umbrella on an operating table'—into the statistical inferential structures of probabilistic distribution. In more than one respect, Duchamp's provocation of aesthetic judgments is based on exposing the irrational, arbitrary 'unreason' of chance and hence the abusive powers (despite their joyful play/game dialectics) exercised by probability in the social construction of culture. Duchamp, somewhat paradoxically, finds in types of probability both a liberating force for aesthetic practices (paving the way for John Cage's later experimentation with chance) and an oppressive factor in social discipline and regimentation, be it aesthetic or political. Nonetheless, Duchamp's abstention from explicitly critiquing the uses and abuses of probability on moral grounds is marked by an ambivalence toward its questionable employments.

The numerous illustrations (e.g. woodcuts) of the practice of drowning witches are not solely a testimony to brutality, but also, and moreover, to the abusive powers of probability used as a method of blind inferential determination. A suspected 'witch' would have her hands and legs tied and be

17. L. Wittgenstein, *Philosophical Investigations*, tr. G.E.M. Anscombe (Oxford: Blackwell, 1986), 25 (Remark #50).

thrown into the river's currents. If she survives then she must be a witch and hence must be executed; if she drowns, her soul has been saved. A lose/lose outcome for the poor victim, and yet a 'reason' to overcome the 'unreason' of the practice during the period of witch-hunt trials. The term 'reason' signifies both a material cause (an excuse) and an appeal to rational method (a determination) and corresponds to probability's Janus face as inferential laws and causal determination or method.

In this way, the example of drowning witches in the seventeenth century suggests a modern sense of 'blind probability' with its overriding sense-data from observational results. As in Brentano-Boltzmann's opening-of-the-drawer experiment or the concept of Schrodinger's cat, the witch is always found 'dead' and 'alive' in a 'superposition', and hence executed. Quantum mechanics ontically asserted the irreducibility of 'measurement' and 'interference', and as such its counterintuitive assertions resonate oddly with premodern uses (or in fact abuses) of 'blind probability' in order to gloss 'reason' (statistical inferences) onto 'unreason' (witch-hunt drowning). Perhaps we can identify Duchamp's unresolved ambivalence towards probability, in all of its mathematical, blind and generative forms, as a testimony to the employment of various statistical methods (rudimentary and scientific alike) as an ideological tool.

Probability as Scientific Raison d'Être

Scientific worldmaking is unique not simply in terms of its uses of types of probability but also in so far as it presents a nomological model of probability. Even without invoking the Popper-Hempel deductive nomological model specifically, scientific probabilistic models are not simply based on inductive inferences, but rather rely on axiomatisation and deductive systematicity.

Boltzmann was the first to suggest that probability can be construed without a binding relation to causality. This suggestion was far-reaching, and science and physics in particular only caught up with it decades later with the advent of quantum mechanics.

In order to grasp the radicality and novelty of Boltzmann's interpretation of probability in non-causalistic fashion, we must examine the relation of probability to causal explanations up to Boltzmann. Namely, as formulated by

thermodynamics, as opposed to its later reformulation by Boltzmann's statistical mechanics and his 'cosmological hypothesis'.

Classical thermodynamics has a clear 'subjectivistic' or 'phenomenological' bias (in Mach's and Boltzmann's senses) in that it construes entropy as a degree of ignorance, which has an epistemic character, namely, the perception of observed causation or lack of it in the measuring of energy within a system. Such epistemic supposition is in fact retained in first and second (to some extent, with the exception of autopoiesis) generation cybernetics—from Shannon and Weaver to computational models that rely on classical thermodynamic concepts of 'sensory causation', as in the notion of 'input' and 'output' and negative and positive feedback (whose legacy, in contemporary misuses and abuses of probabilistic models in the age of algorithms, calls into question the problematic nexus of probability-causation).

Unlike the thermodynamic notion of causalistic probability, which is grounded in perception, Boltzmann's articulation of statistical mechanics offers a non-causal model for probabilistic distribution according to which statistical assemblages of either microstates or the cosmos are never actually directly observable or based on direct perception of causation. Rather, Boltzmann's cosmological hypothesis suggests something quite different, namely that most processes, and even the direction of temporal unfolding of those processes, is determined neither by direct perception nor by sensation nor by a teleological principle (e.g. weak or strong interventionism) but rather by the unlikelihood of reversals in nature as determined by the law of probability. This explanation is ontic in character, and relies on no causal stratum of the perception of micro-states and or macro-objects.

Boltzmann has two cosmological hypotheses formulated as alternatives to the classical thermodynamical entropy:

B1 [...] [T]he entire universe itself at present is in a very improbable state. The universe began in low entropy state and has since increased in entropy but is still in a state of low compared to maximum entropy.

B2 There must be in the universe, which is in thermal equilibrium as a whole and therefore dead, here and there relatively small regions of the size of our galaxy

(which we call worlds) which, during the relatively short time of eons, deviate significantly from thermal equilibrium.[18]

Boltzmann's version of the second law, in his H-theorem, is that it is highly probable that $Sb(t_1)>Sb(t_0)$—that is, that the probability distributions of initial states (Big Bang) had a lower degree of entropy. The assumption that entropy was lower in the past gives a reason for time asymmetry, but is not evident without the explanandum of probability. Unlike the quantum mechanical explanation of the frequency of statistical distributions connected to the 'spontaneous collapse' of particles, Boltzmann's reasoning by 'probability' is ingenious, but remains incomplete and opaque as to why probability is so special and foundational to the laws of physics.

Nevertheless, Boltzmann showed science the path away from the metaphysical supposition of the (Humean) codependency between probability and causation. He did so by debunking the supposed necessity of relying on direct perception (Mach's phenomenalism) for a theory's hypothesis and prediction, and instead, by embracing atomism, paved the way for quantum mechanics. However, Boltzmann did not 'tame' probability so much as free it from its bonds to causation. The scientific epistemology that emerged as a result was one which favoured probabilistic as opposed to causal explanations.

Contrary to empiricist or phenomenalist assertions about the 'immediately given' sense data of direct perception, indirect perception allows a more flexible understanding of 'observation' in science. In so far as 'induction' is based on causal laws and 'causation' on statistical inferences, than 'probability' can be both derived from the theory's causal determination and applied to the theory's method of experimentation, construction, and predication. Boltzmann's conception thus enables the 'rules' and/or 'laws' holding between 'induction' and 'causation' to be mitigated through the primacy of 'probability'. Furthermore, as later with quantum mechanics, the concepts of 'probability' and 'observation' will be epistemically and ontically linked equally to experimentation, construction, and predication.

18. L. Boltzmann, in N.S. Hall (ed.), *The Kinetic Theory of Gases: An Anthology of Classic Papers with Historical Commentary* [1897], tr. S.G. Brush (London: Imperial College Press, 2003).

Hacking's historico-philosophical work on the 'taming' of probability asserts a sociological vantage point. One result of this is Hacking's reluctance to consider either a phenomenological and/or a transcendental plane when addressing probability's eidetic descriptions beyond contextual inferences. This bias is a shortcoming, particularly in light of computational science on the one hand and quantum mechanics on the other, both of which assert a conception of deep probability that clearly implies an ontic constructivism that exceeds epistemological constructs construed in terms of a conventionalist scientific methodology alone.

Hacking, much like Foucault, assumes an explanatory method for reason which is grounded in and illustrated by an interplay between diachronic and synchronic histories, without entraining the possibility of 'reason' as a probabilistic genesis itself, whether biologically or computationally (reminiscent of Popper's methodological Darwinism on the one hand and evolutionary biology from a scientific epistemological point of view on the other).

However, Hacking's account of probability does not deal with implications stemming from quantum probability, or from objective probability related to computational systems. I will return to this in my concluding section on Deutsch and Albert's respective accounts of probability in relation to quantum physics.

Hacking argues that in Peirce's embrace of 'absolute chance' (based on spontaneity) as opposed to probabilistic randomness, Peirce contended on the one hand that 'absolute chance' is 'real', and on the other hand that the task of science is to describe it through the employment of statistical probabilities.

Like Popper after him, Peirce developed a 'propensity' theory of probability which pertains to the probabilistic physical conditions in experimentation, and in doing so also elaborated an interpretation of probability based on 'frequency'. The concept of frequency is of particular relevance to interpreters of quantum mechanical 'wave-function collapse' theories, such as the Ghirardi–Rimini–Weber (GRW) theory, which probes the spontaneous collapse of particles as measured through accumulative probability frequencies instead of the single propensity of the experiment's statistical distributions.

More recently Albert and Deutsch have introduced the conceptual analysis of probability vis-à-vis propensity and frequency as a way to explicate the role of interventionism in respect to both 'measurement' and 'observation'.[19]

As Stephen Leeds argues in his review of David Albert's *After Physics* (2015):

> The interventionist also takes the interventions to be probabilistically distributed;
> here, however, the relevant notion of probability is not chance, as it is in GRW,
> but frequency: our interventionist will claim that as a matter of empirical fact the
> outside interventions on any given system are distributed in a way that can be
> modeled by a probability distribution, or by one or another member of a family
> of probability distributions.[20]

Interventionism in the ontic quantum mechanics sense, especially with regard to wave-function collapse, replaces the earlier scientific discussion surrounding the question of direct and indirect perception with scientific experiment, observation, and measurement. Since the interventionist assertion is an irreducible aspect of the physical theory (GRW), it gives us a cosmological principle aligned with Peirce's assertions on 'absolute chance', thus distancing the concept of probability from the Humean notion of subjective and inductive degrees of ignorance.

Furthermore, in Albert's interpretation of quantum physics, modal interpretations such as Everett's many-worlds view in effect 'reverse' the role of probability in the Peircean sense, conflating the 'probable' with the 'possible' and as a result overlooking significant outcomes of the role of intervention in quantum physics.

David John Baker, in his review of *After Physics*, argues for the importance of Albert's position, in that he

> attacks the trendy decision-theoretic account of probability in the many-worlds
> interpretation. Prima facie, it is a great puzzle why we should observe the
> ordinary probabilities predicted by quantum mechanics on the many-worlds
> view, which entails that every possible outcome of every experiment actually

19. E.g. David Albert's *After Physics* (Cambridge, MA: Harvard University Press, 2015) and David Deutsch's *The Fabric of Reality* (New York: Viking, 1996).

20. S. Leeds, 'Interventionism in Statistical Mechanics', *Entropy* 14:2 (2012), 344–69, <https://doi.org/10.3390/e14020344>.

occurs in some branch of the universal wavefunction. (No, there aren't more branches for the more probable outcomes.) The going answer to this puzzle is that when a supposedly well-motivated principle called equivalence is adopted, together with some axioms of decision theory, it would be irrational to bet on the outcome of an experiment except in a way that accords with the ordinary quantum probabilities.[21]

Betting, as Albert observes, is hardly the only role that probability plays in our lives, and as he rightly points out, a variety of problems for the many-worlds view stem from this fact. He follows this up with an entertaining and pointed attack on the equivalence principle assumed by the many-worlds view.[22]

David Deutsch—within the context of a different interpretation of quantum physics but with an equal dislike of Hugh Everett's many-worlds modal interpretation—argues that computational processes (and his research on quantum computation is continuous with this approach) should be understood as expanding the fabric of reality, and hence allots an 'unknown' potential to the role of probability pertaining to both physics and our understanding of reality.[23]

Deutsch has cautioned against the use of probability as a sort of explanatory speculation in science, a tendency that turns pertinent objective properties of physical and computational probability into means of over-rationalising and thus avoiding actual problems within a theory. As Deutsch states:

> When in recent times statistical analysis of experiments in physics have started to use determinations of what is not worthy of pursuit, e.g. the very term 'explanation' can be exhausted by a formula without a need to rely on explanatory arguments.[24]

Deutsch could hardly be blamed for overlooking computational 'probability', which is integral to quantum computation. Nevertheless, the critical scope of

21. J.D. Baker, 'Review of David Albert, *After Physics*', *Notre Dame Philosophical Reviews*, 24 June 2015, <http://ndpr.nd.edu/news/58730-after-physics/>.

22. Deutsch, *The Fabric of Reality*.

23. Ibid.

24. D. Deutsch. 'The Logic of Experimental Tests, Particularly of Everettian Quantum Theory' (2016), <https://arxiv.org/pdf/1508.02048.pdf>.

his problematisation of the use of 'probability' in physics, through its conflating
of 'epistemic' and 'ontic' concepts, affirms as follows:

> The decision-theoretic argument, since it depends on game-theoretic axioms,
> which are normative, is itself a methodological theory, not a scientific one. And
> therefore, according to it, all valid uses of probability in decision-making are
> methodological too. They apply when, and only when, some emergent physical
> phenomena are well approximated as 'measurements', 'decisions' etc. so that
> the axioms of non-probabilistic game theory are applicable. Applying them is a
> substantive step that does not (and could not) follow from scientific theories.[25]

Deutsch's critique, then, does not apply to computational science conceptions
of 'probability'. Without examining interpretations of probability within the field
of computational science (such as Samson Abramsky's work), suffice to say
that the interplay between 'logic' and 'probability' is of paramount significance
here. As Stuart Russell points out:

> Perhaps the most enduring idea from the early days of AI is that of a declarative
> system reasoning over explicitly represented knowledge with a general inference
> engine. Such systems require a formal language to describe the real world; and
> the real world has things in it. For this reason, classical AI adopted first-order
> logic—the mathematics of objects and relations—as its foundation. The key
> benefit of first-order logic is its expressive power, which leads to concise—and
> hence learnable—models.[26]

'Probability' and 'perception' can be redescribed in terms of 'logic', and such
an undertaking on the part of computer science is essential to the grasping of
computational processes that are better equipped to integrate first-order logic
both mathematically and mechanically (e.g. AI) and, as such,to circumvent
the 'limits' of Chomsky's later critique of computational language as being

25. Ibid.
26. S. Russell, 'Unifying Logic and Probability', *Communications of the ACM* 58:7 (2015), 88–97,
10.1145/2699411.

incommensurable with the syntax/sematic structure of a natural language, after abandoning his earlier position in terms of proto-generative language.[27]

One of the pervasive effects that result from the integration of 'probability' and 'logic' in computational science is the extent to which algorithmic transcoding has mutated our understanding of machines and systems on the one hand, in respect to networks on the other hand. The so to speak 'probabilistic evolution' of networks seems to unravel according to entirely different principles of 'reason', demonstrating a 'logic' which goes beyond Popper's wildest dreams in ascribing a Darwinian evolutionary principle to the 'logic of scientific discovery'. One such effect is the 'de-archiving' of information and its continuous recursive reshuffling.

Hacking's work on the 'taming of chance' still follows Foucault's line of archaeology, which is based on information that is fossilised and which obeys a thermodynamic concept of entropy as based on epistemological asymmetry in relation to the past, or the system's initial conditions. Archaeology, in Foucault's sense, enables a discourse based on positivities, a fossilised record of historical determinations which in turn are defined as past events and as retrodicted on the basis of the 'system's initial conditions' (or the genesis of signs and what later Foucault refers to as a genealogy). Hacking, like early Foucault, is reliant on the attainability of such a record deposit or archive but, unlike Foucault, remains suspicious of a mapping of origin, or genesis.

De-archiving is the effect that computational processes have on a stable conception of the 'past'; instead of obeying a tense-temporal conception of past-present-future (following both McTaggart's and Mellor's paradoxical arguments regarding the illusion or reality of time), we can speak of destratified complex dynamical systems that no longer necessitate a projection of a 'future' or 'futures' in relation to the system's emergent agents, which replace the notion of deterministic predication, since they function within computational networks.

In this sense, the tendency toward de-archiving is a sort of a 'specious present' (James) that suggests a similar reading of two species of 'probability'

27. 'We investigate several conceptions of linguistic structure to determine whether or not they can provide simple and "revealing" grammars that generate all of the sentences of English and only these. We find that no finite-state Markov process that produces symbols with transition from state to state can serve as an English grammar. Furthermore, the particular subclass of such processes that produce n-order statistical approximations to English do not come closer, with increasing n, to matching the output of an English grammar.' N. Chomsky, 'Three Models for the Description of Language', *IRE Transactions on Information Theory* 2 (1956), 113–24.

in relation to analysing 'perception' in the Husserlian sense, whereas the active syntheses of 'objects' rely on perceptual and hyletic flux, and its stabilisation of the passive syntheses of objects as pre-givens assumes them as the context for the pre-phenomenal or pre-phenomenological system.

Computational networks which defuse dynamical complex systems' recursion and shuffling of ir/revisable processes suggest that the emergence of states of affairs need not be explained according to the classical mechanical model (Newtonian, Laplacian, or classical thermodynamics) that relies on 'initial conditions' as the key for an idealised scenario for deterministic prediction. Here, Cassirer's curious take on the latency of Laplacian determinism in science (his thesis in *Function and Substance*), as discussed sceptically by Hacking, should be considered more carefully, since complex dynamical systems help us to identify and reiterate two kinds of epistemological accounts of probability: the classical thermodynamical one that rests upon our degree of ignorance of the system's initial condition, and a second one related to a new stabilisation (or in/stability states) of 'perception' as enabled by computational processes or agencies that no longer rely on human mediation and direct perception of causation or causal explanation.

We can see that, with the circumscribing of the Humean problem of induction by removing the experiential, perceptual factors or faculties of 'human understanding' and replacing them with computational calculus, there results a need to address anew the 'fabric of reality' and perhaps, as Deutsch has suggested, to encompass 'information' as a constitutive force within our physics. Nonetheless, Hume's seminal formulation of the problem of induction is pertinent not only in terms of the role of probability in judgments or determinations, but above all in its decoupling of the notions of induction and causation within the confines of reason (human understanding), and the way it opened the threshold to both the perils and the generative construction of probable and possible worlds,

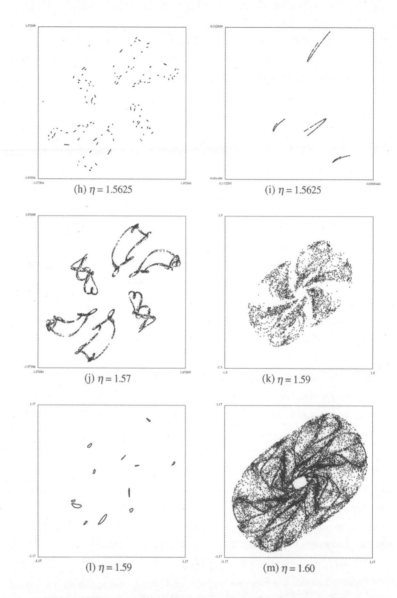

(h) $\eta = 1.5625$

(i) $\eta = 1.5625$

(j) $\eta = 1.57$

(k) $\eta = 1.59$

(l) $\eta = 1.59$

(m) $\eta = 1.60$

Attractors in the phase space of a model of the dynamical behaviour of heterogeneous markets with diverse types of trader agents, showing complexification through increase in the intensity of adaption. Adapted from W. Brock, C. Hommes and F. Wagener, 'Evolutionary Dynamics in Markets With Many Trader Types', *Journal of Mathematical Economics* 41 (2005), 7–42.

Anna Longo

Knowledge of Risk and Risk of Knowledge: How Uncertainty Supports the Illusion of Freedom

We have at our disposal today the most advanced predictive technologies, and yet we are also exposed to unprecedent uncertainties. Risk no longer consists of a finite number of calculated dangers against which we may deploy precise measures for prevention, in an attitude of control. As new risks constantly emerge unpredictably, forcing us instead into an attitude of resilience whereby plans, means, and ends can be modified at any moment, our practices are liable to lead to unsatisfactory or undesirable results rather than to the expected benefits. The uncertainty we are experiencing today is that of a situation where the risk estimation of a future decision is modified by the very activity of improving the efficacy of predictive hypotheses—an activity whose developments, like the evolution of scientific knowledge, cannot be forecast. This situation of ever-evolving uncertainty demands ever greater efforts in terms of predictive technology even though, rather than reducing the risk that humanity is facing, it seems that our sophisticated learning processes, through which hypotheses are constantly updated, are merely bringing about more awareness of unexpected threats that can hardly be kept under control. Since our world is evolving so unpredictably, can we really think of any alternative world that it is not just one of the innumerable possible evolutions of the same global Schumpeterian competition?[1] How did it come about that efforts to improve scientific knowledge so as to predict those events that are less predictable led to this increasing uncertainty, rather than to the total control of which the critical thinkers of the

1. According to Joseph Schumpeter (1883–1950), the competitive process is driven by the entrepreneur through innovation. The function of the entrepreneur is to innovate along the lines of what Schumpeter describes as 'new combinations of knowledge'.

sixties were so afraid? Is this unpredictable evolution the expression of collective creativity and freedom, or is it a prison wherein we are forced to play the role of creative and free agents whose payoff is dependent upon a willingness to engage with ever new risks and challenges?

To attempt a broad reconstruction of what went wrong in the process of the development of knowledge, we will have to go back to the epistemological problem of induction: How can we know that our beliefs about what will happen in the future are grounded on necessity, rather than on arbitrary habits? This would be possible if we possessed the rational principle from which any possible truth can be derived, but what if knowledge of this principle is unavailable to us? Then we must try to discover the practices that most efficiently respond to the problem posed by an unpredictable environment, so that the regularity of our inferences can be justified as reasonable. However, this does not change the fact that future events must be considered as probable rather than certain, and that the problem of passing from a set of past observations to the probability of the next persists. It is evident that the problem of induction cannot be separated from the advent of probability calculus. Awareness of this came relatively late, but today it is central to scientific and epistemological enquiry.

In 1933 Andrej Kolmogorov formalised the theory by grounding it on five axioms. However, rather than facilitating agreement on the use of the probability calculus as a mathematical tool, this opened up a major debate concerning its interpretation. The principal controversy set against one another advocates of the objective, the subjective, and the logical account of probability.

Objective probabilities are inferred from stable frequencies given an infinite or sufficient large number of trials. For example, the probability of obtaining a six when throwing a die is expressed as the limit of the relative frequency of this event over an infinite or large number of trials.[2] This interpretation satisfies the statistical needs of experimental scientists, since it means that probabilities can (in principle) be discovered by a repeatable objective process. The difficulty of this interpretation however is that it supposes, if not an infinite, then at least a very large class of past events similar enough to the event one wishes to predict, in order to calculate its future probability. On the one hand, it is not

2. According to Von Mises's definition (R. von Mises, *Probability, Statistics, and Truth* [1939] [New York: Dover, 1981]).

always possible to gather this information, particularly in the case of events whose occurrence is too rare to draw such conclusions, and on the other hand, it is not clear what criteria need to be satisfied in order to consider past events as a class of occurrences of the same event one wishes to predict. For example, if one wants to find out the probability of the outcome of an experiment by repeating it a sufficient large number of times, one must be sure that all the conditions of the trial have been perfectly respected, or one must establish a norm according to which results that differ are occurrences of the same event. Hence this so-called 'frequentist' approach does not allow us to calculate the probability of rare events that appear to have probability=0, even though in some cases it may be highly important to predict them. For example, the risk of catastrophic events cannot be calculated according to past frequencies, since they have not happened often enough to do so; however, this does not mean that we should not expect them. Moreover, since the frequentist approach can predict only the probability distribution of possible future facts, it does not allow us to establish the likelihood that a particular fact will obtain tomorrow, rather than once over an infinite time period—which effectively prevents us from taking any practical decision about the near future, thus rendering the calculus pragmatically unhelpful.

The opposite view, the subjective interpretation,[3] says that, rather than an induction from stable frequencies, probability might be better considered as a measure of the degree of belief in a predictive hypothesis. Rather than expressing the likelihood of a future event, probability refers to the credence that such a forecast, or inference, is reliable. The degree of belief is not necessarily based on the observation of past frequencies (even though one might take them into account), but is determined by a broader range of reasons that amount to the available information—although, from the subjective standpoint, there are no a priori restrictions on what can count as pertinent information. The degree of belief in a hypothesis is usually calculated according to the method of bets—i.e., the amount of money that one is willing to put on the realisation of a future event. For example, if one is asked to bet on which team will win

3. The subjective interpretation of probability was introduced in the 1930s by Bruno de Finetti ('Probabilism: A Critical Essay on the Theory of Probability and on the Value of Science' [1931], *Erkenntnis* 31:2–3 [September 1989], 169–223) and Frank Ramsey ('Truth and Probability' [1926], in *The Foundations of Mathematics and Other Logical Essays* [London: Trubner & Co., 1931], 156–98).

the next World Cup, the decision will depend upon various types of information one has collected and which justify the belief in the probability of an outcome, even though the reasons supporting the prediction cannot be limited to past frequencies. Moreover, different individuals may exhibit different degrees of belief in the hypothesis that a particular team will win, and it is not possible to state, a priori, that one of them is wrong: both bets may be reasonable with regard to the information under consideration. However, reasonable degrees of belief must be coherent and they must respect the laws of probability, otherwise no payoff can be rationally expected. For example, it is coherent to estimate that the probability that France will win the World Cup is 70% and the probability that Germany will win is 30%, since the sum of the two figures is 100; conversely, it is not coherent to believe that the probabilities of the two teams winning are respectively 70% and 50% (the sum is > 100). To explain the criterion of coherence, subjectivists usually refer to the Dutch Book argument, which states that a set of degrees of belief must be such that no bookmaker can take advantage of it by proposing a system of bets.

Subjective interpretation, then, implies a pragmatic approach, and considers probabilistic hypotheses to entail decisions concerning the realisation of future events or states of the world. Accordingly, one does not expect that the future will resemble the past in terms of the frequency of possible events (there is no reason to believe that this is the case), but one may have reasons to believe that the rules that oriented past successful inferences and decisions will be helpful in the future. This allows one to choose between different predictive hypotheses with respect to the specific problem one is facing, and relative to the result one wishes to achieve. Finally, the subjective approach considers that the subjective degrees of belief in a hypothesis become stronger or weaker according to Bayes's rules of conditional probability, i.e. when new evidence or information provides further reasons supporting (or undermining) the decision. For example, the hypothesis that France will win the World Cup appears to be more likely after having observed the results of a certain number of matches, so the defeat of an increasing number of opponent teams is said to condition the degree of belief in the prediction, meaning that one is willing to put more money on the result having observed that one's team made it to the semi-finals. However, this does not entail that the initial degree of belief was less reasonable

than the final one, nor that one was wrong to have expected something that would turn out to be disproved later on. On the contrary, it would be unreasonable to state that inductive inferences can be said to be true or false with respect to the facts, since they are mere rules to orient practices and decisions which are valuable to cope with the unknown. The difficulty here, though, is that the criteria for evidence or pertinent information is vague, and prevents us from establishing a priori and universally the value of different hypotheses: Why do we consider scientific theories more credible than forecasts of the next winner of the World Cup? According to the subjective standpoint, this is not actually a problem, considering that no set of empirical data can allow us to state the necessity of an inductive inference (which would mean that the future is predictable), even though any set of information may allow us to take reasonable decisions. From this standpoint, for example, a causal relation is a highly probable hypothesis according to which, given event A, one can expect B. However this does not mean that there are necessary causal connections in Nature, but merely that decisions taken according to such an expectation are usually efficacious. Hence, rather than proving natural laws (the existence of random variables included), the repetition of experiments is a way of testing practical procedures, or strategies of action, in order to increase the probability of obtaining some desired result. That we are more likely to believe in scientific hypotheses rather than other forecasts is then a matter of habit, or of the conventional selection of particular operational regularity. Accordingly, the difference between Newton's gravitation and Einstein's relativity is a matter of the kind of decisions and actions that they support, rather than a matter of adequation to some absolute truth. This perspective is difficult to accept, though, as it seems to deny the possibility of establishing any criteria for objective scientific truth, while reducing scientific theories to more or less arbitrary beliefs that cannot be said to differ from any other.

To overcome this problem, Carnap suggested, since probability refers to the belief that a probabilistic inference is correct, one should evaluate it with respect to its logical truth. Accordingly, *logical probability* is defined as 'the degree of inductive support',[4] and indicates the truth of the probabilistic inference as a conclusion that is supposedly analytically derived from the premise. From this standpoint, a probabilistic forecast is a claim regarding the logical implication

4. R. Carnap, *Logical Foundation of Probabilities* (Chicago: Chicago University Press, 1950).

of a proposition about a state of the world and a proposition about possible future states, and therefore the belief can be grounded on the formal validity of the implication. However, this approach also is not without its difficulties, since it implies logical omniscience or knowledge of the logical axioms and rules of inference from which any possible truth can be derived. Facing the impossible challenge of demonstrating that there is anything like an ideal system of inductive logic, after the sixties Carnap relaxed his position in favour of a more 'subjective' account and concentrated on the logical conventions that support different possible methods of induction proven to be efficient relative to a specific enquiry. Moreover, he proposed a recursive updating of a predictive hypothesis by following a method which is not too far from the rules of Bayesian inference, although Carnap was convinced that the confirmation of a theory should rely exclusively on precise sets of empirical evidence (atomic propositions), not on any information whatsoever. The probability of a future event is seen to be relative to a scientific hypothesis the logical validity (truth value) of which can be assessed according to conventional axiomatics (rather than subjective pref-erences or utilities) that allow for a strengthening or weakening of the belief in the truth of the inference on the grounds of explicitly selected evidence (rather than any available data). Some difficulties remain, however. As Quine observed,[5] once he had dropped the idea that it was possible to establish the axioms of an absolute logic, Carnap assumed the possibility of different logics which can be established by convention by choosing a finite set of axioms, and from which any possible truth may be derived; but this does not guarantee the truthfulness of the rule of inference thus 'conventionally' adopted. Hence a supplementary axiom would be needed in order to guarantee the validity of a particular inference rule. Nevertheless, in so doing, one makes a move that requires further justification, since it presupposes the use of an extra rule, and so on, in an infinite regress. Moreover, Carnap's empiricism is dubious since on the one hand, truth is sup-posed to be established analytically by logical deduction, while on the other hand theories have to be tested by experiments. This implies that concepts must have been conventionally established on the basis of experience itself. For example, two different concepts—'animal' and 'flying creature'—might have the same

5. W.V.O. Quine, 'Truth by Convention', in O.H. Lee (ed.), *Essays for A.N. Whitehead* (New York: Longmans, 1936); 'Carnap and Logical Truth', *Synthese* 12:4 (December 1960), 350–74.

extension, but this cannot be deduced from the concepts, since it is an empirical fact that the proposition 'any flying creature is an animal' is true. So if logic, as a convention, rests upon experience, then it would be expected to change with the advent of new experiences and consequently would be completely useless as a tool for stating any a priori possible truth; while if logic as a convention is independent of the reality to which its propositions refer, then it is not possible to distinguish, a priori, propositions about our world that are true from those that have no referent. The logical truth of a proposition does not entail the existence of the referent, and propositions that are true because they refer to real relations between objects are contingently, rather than necessarily, true. It would seem, then, that on the one hand, no empirical evidence can confirm a theory since what counts as empirical evidence depends on the convention and, on the other hand, that no logic convention can be established without either relying on a previous logic convention or some conventionally conceptualized empirical data. How can scientific conventions be distinguished from inferential habits? And if scientific hypotheses are inferential habits, how can we justify their truth, or at least the reasons for acting according to their predictions?

David Lewis's theory of convention and the modal logic of possible worlds are meant to solve Quine's objection to the idea of adopting a conventional language that would allow us to establish a priori logical inferences that are true for the reality in which we live. Inspired by the economist Thomas Schelling's game-theoretic approach,[6] Lewis showed that a broad linguistic convention is not established either on the basis of the arbitrary choice of a set of axioms from which any possible truth might be derived, nor on the basis of denotation (concepts produced according to experience), but that it is established as a way of coordinating actions. A convention (linguistic and not) is defined as a regularity of action whose adoption depends on the *belief* that it will probably be adopted by others, and it arises in order to satisfy a desire for coordination.[7] Within this game-theoretical framework, agents are supposed to find the best strategy with respect to the strategies of others, and in this way to achieve an equilibrium, a selection of moves and responses deviation from which is in nobody's interest. For example, driving on the right-hand side of the street is

6. T. Schelling, *The Strategy of Conflict* (Cambridge, MA: Harvard University Press, 1960).

7. D. Lewis, *Convention: A Philosophical Study* (Cambridge: Harvard University Press, 1969).

such a convention that is established as the solution of a coordination game where agents adopt a specific regularity of action from among all possible behaviours because they expect that others will do the same. The probability of the hypothesis about others' behaviour depends upon there being common knowledge of the decision that one ought to take, within a specific problematic situation, in order to maintain the commonly desired outcome. Now, for Lewis, the emergence of linguistic conventions can be explained in the same way, providing that agents adopt those linguistic behaviours which are meant to satisfy the utility of truthfulness.[8] Inferences are then regularities of actions that are performed while expecting that others will conform in order to coordinate in such a way that everybody's utility of communicating true statements about the real is satisfied. The actual world, or surrounding reality, is then the domain in which a set of denoting inferences are true according to the shared convention; it is the referent of the set of denoting statements that all agents agree are true once the equilibrium of the coordination game has been reached, i.e. the set of inferential moves divergence from which is in nobody's interests. This allows Lewis to overcome Quine's paradox by showing that a convention can be established as the solution of a coordination game without ending up in an infinite regress, since the rules that guarantee the sought-after stability (or the equilibrium of the game) are learned through repeated interactions among rational strategic agents. Moreover, thanks to modal logic, Lewis can reintroduce the difference between necessarily true statements (all bachelors are necessarily unmarried), statements that are true in the actual world (it is contingent that all flying creatures are animals), and statements that are true in a possible world (it is possible that, in another world, there could be a flying creature that is not an animal), while making of analyticity a regularity of inferential strategies. In this way, the truthfulness of a scientific theory does not depend upon empirical evidence for its confirmation, but upon the fact that it expresses a regularity of action which is efficient with respect to convergence on equilibrium of the coordination game played by a community. So, for example, a theory establishing the probability of a future event can be said to be credible if it is an acceptable inference according to shared conventional norms, i.e. if it is a linguistic move

8. D. Lewis, 'Languages and Language', in K. Gunderson (ed.), *Minnesota Studies in the Philosophy of Science, Volume VII* (Minneapolis: University of Minnesota Press, 1975), 3–35.

that we have reason to believe others will conform to. Lewis's game-theoretical approach allows him to uphold the conventional character of the inferential regularities that characterise scientific hypotheses, while avoiding the difficulty of Carnap's logical foundationalism and, at the same time, the radical subjectivity that abandons any restriction on the construction of predictive hypotheses. A hypothesis deserves a high degree of belief if it conforms to the inferential behaviours that have been selected in order to solve the coordination game played within the scientific community, hence the convention that is reasonable to follow since it satisfies the common utility of truthfulness.

We might think, then, that conventions can be changed according to the desire of living in a different possible world—a world of social equality, for instance—and that conforming behaviours can be produced as shared inferences. There would then be still some hope for a 'construction site for possible worlds' if there were not some further difficulties that undermine the rationality of this expectation. As Donald Davidson observed,[9] by grounding language (or logic) on practical conventions, Lewis is actually making it depend upon wills or desires that are not necessarily 'rational' expectations—on the contrary, we must assume that we have hopes, wills, and desires *because* we have language. We do not have linguistic conventions because we wish to coordinate our behaviours in order to achieve a common interest, it is because we have language that we have conventions and might expect some form of coordination on the grounds of its epistemic value. Accordingly, an inference is not true because it fulfils some desire that happens to be shared. Rather, legitimate expectations depend upon linguistic norms that refer to what we *ought to* do, and what we ought to do depends upon epistemic utilities or the ideal of true knowledge. Hence, rather than hoping for the actualisation of an (im)possible alternative conventional world according to desires, we should expect this reality to become a perfectly rational one when our conventions become coordinated within the only true inferential norms. Within this universal game of knowledge, the degree of belief in a given predictive hypothesis depends not only upon the conformity of an inference with respect to an arbitrary convention, but also upon the conformity of the convention to *the norm of reason*. New inferential moves can be introduced to

9. D. Davidson, 'Convention and Communication', in *Inquiries into Truth and Interpretation* (Oxford: Oxford University Press, 1984).

make conventions evolve according to what has been called the *game of giving and asking for reasons*, in such a way that the arbitrary choice of equilibrium that characterises Lewis's game is explained according to the rational improvement of strategies. Rather than limiting the process to a spontaneous agreement justified by the desire for coordination, this more sophisticated game places different hypotheses and various conventional possible equilibria in a broader competition where the score depends upon conformity to a supposed universal norm of reason. In this evolutionary game of knowledge, public discussion is the arena where different inferential hypotheses compete in order to increase the collective degree of belief. In Bayesian terms, here what conditions the probability of an inference is neither empirical evidence nor arbitrary agreement, but rational commitment: a predictive hypothesis is more likely to be true the more it produces not mere belief but commitment or the willingness to act accordingly. On the one hand, the historical process through which the knowledge of the rules of knowing (the normative rules of inference) evolves is unpredictable—since one cannot account in advance for the introduction of new moves—while on the other hand, the final equilibrium to be achieved is such that anybody will feel constrained by no interest other than that of truth.

This solution to the problem of induction can be said to be a sort of game-the-oretic synthesis between Carnap's logicism and subjective Bayesianism: the collective degree of belief that a hypothesis exhibits conditions the probability that the rule conforms to the norm of reason, and this allows a distinction to be drawn between scientific or lawlike inferences, and other kinds of predictions. This circularity is the effect of Bayesian conditioning, through which different predictive hypotheses are tested with respect to pertinent evidence, although this evidence, which offers reasons to commit, attests to the conformity of the inference to the norm of reason. Here, the emancipatory rational expectation is the convergence of our practices toward universal normativity through a learning process that would allow us to gain true knowledge by constructing a shared reality (the world described by shared concepts that nobody has any interest in contesting). From this standpoint, uncertainty is the temporary effect of our ignorance of the true norms of reason, the actual fact of the competition among different hypotheses the less credible of which must be eliminated in order to commit to the more probably true solutions. This does

not entail that foreknowledge will be obtained, but that the practices that most
reasonably enable us to cope with true unpredictability are likely to be selected.
The question is: Can this world in which our decisions, actions and behaviours
are to be shaped by the true laws of reason (with a Hegelian flavour) actually
be considered a rational expectation?

According to game theory, the process described above supposes a tendency
toward equilibrium—that is, the different strategies tend to converge toward a
stable set of behaviours which guarantee the highest payoff for all concerned:
no agent could be better off by choosing a different strategy. However, this
supposes that the agents share a great amount of common knowledge: the
rules and the structure of the game (language), the way in which the score is
attributed (rule-governed behaviour), the utility of others (truth), and knowledge
of the other's knowledge (I know that you know). Is such a situation realistic?
Are we really engaged in such a game? Recent game-theoretic modelling of
strategic interactions among agents in the market has relaxed the assumptions
concerning common knowledge for the sake of realism, i.e. to produce more
credible predictive hypotheses concerning the dynamics of the system. In
particular, evolutionary game theory has been developing different models to
simulate the dynamics that lead to equilibrium under different conditions of
knowledge and information. Evolutionary game theory was introduced by
Maynard Smith[10] to study the selection of stable sets of behaviours in animal
populations without any assumption that they act rationally, but assuming only
that efficient inherited strategies spread, while inefficient ones disappear. Accord-
ingly, the fittest behaviours are those action hypotheses that characterise species
interacting in a situation of equilibrium, when they couldn't be better off by
playing a different strategy. However, it was noticed that, in order to model
humans' strategic interactions, it is essential to take into account the ability to
learn (to adopt behaviours that are not genetically determined), to introduce
new utilities, and to make hypotheses about the information, moves, and utilities
available to other agents in order to take satisfactory decisions. In these games,
agents do not enjoy complete information: they may be ignorant of various
parameters such as other agents' utilities, strategies, and information, even

10. J. Maynard Smith, *Evolution and the Theory of Games* (Cambridge: Cambridge University
Press, 1982).

though they are considered as Bayesian learners who can update their degree of belief in different hypotheses concerning future states of the world (what others will do) through repeated interactions.[11] These game-theoretic models have been applied to studying the attaining of equilibria in economics: on the one hand, they have shown that relatively stable situations (where functional strategies are selected and maintained) can be achieved without assuming complete information and, on the other, that the dynamic becomes more and more chaotic and unstable once agents are provided with sophisticated learning abilities and improved strategic rationality.[12] In particular, when agents are engaged in forming hypotheses about the future moves of other agents without knowing their utilities and their information (what they know) while updating their beliefs and action hypotheses, equilibria appear to be unstable and the dynamic is instead one of rapid changes and temporarily stable phases.[13] Since multiple heterogeneous agents are continuously updating their strategies by introducing new moves and modifying their utilities (they can learn from others and imitate successful behaviours and predictions), 'the act of learning changes the thing to be learned'.[14] As a consequence, sophisticated Bayesian learners' games converge to equilibrium only under special assumptions about players' prior coordinated expectations—assumptions that real agents might well fail to satisfy. These models explain the rapid evolution and instability of financial markets, where not only do agents make use of the partial information available in order to try to predict others' action hypotheses, but where sophisticated technology is employed to continuously update predictions and the consequent action strategies. The result is one of generalised uncertainty that justifies the Bayesian approach, in particular the subjective attitude (allowing for conditioning on anything that can count as pertinent information in a situation of necessarily

11. J.C. Harsanyi, 'Games With Incomplete Information Played By "Bayesian" Players. Part I. The Basic Model', *Management Science* 14:3 (November 1967), 159–82.
12. P. Milgrom and J. Robert, 'Adaptive and Sophisticated Learning in Normal Form Games', *Games and Economics Behavior* 3 (1991), 82–100.
13. W. Brock, C. Hommes and F. Wagener, 'Evolutionary Dynamics in Markets With Many Trader Types', *Journal of Mathematical Economics* 41 (2005), 7–42; R.G. Palmer, W. Brian Arthur, J.H. Holland and B. LeBaron, 'Artificial Economic Life: A Simple Model of a Stockmarket', *Physica D* 7.5 (1994), 264–74.
14. H. Peyton Young, 'The Possible and the Impossible in Multi-Agent Learning', *Artificial Intelligence* 171:7 (2007), 429–33.

partial knowledge and thus bounded rationality), while contributing to the reproduction of this same uncertainty. Data mining and related algorithms are needed to introduce and test hypotheses concerning a reality which is no longer conceived as a given set of possible states, but as a continually evolving set of hypotheses concerning future possible states or behaviours: uncertainty cannot be escaped, but can only be reproduced even by the most sophisticated devices that are meant to reduce it. This is the world we live in, a world that ceaselessly becomes other than itself, one in which continuously updated probabilistic hypotheses concerning its future states bring about the possibility of what was considered impossible before. On the one hand, uncertainty is related to the effects of the unpredictable evolution of agents' knowledge, agents that are able to introduce innovations and new options. But on the other hand, this same uncertainty is quite functional for the game of financial neoliberalism, where anything seems to be possible except its end. It seems then that, rather than leading to the selection of stable sets of beliefs concerning rational expectations, the present situation has the effect of reproducing uncertainty or the impossibility of taking decisions owing to the probability of a close number of possible outcomes: different hypotheses suggest different strategies with respect to heterogeneous bodies of evidence, data, and information. Moreover, the degrees of belief in these different hypotheses concerning agents' future behaviours are updated and conditioned by their effective 'normativity' or the number of conforming strategies of action. As a consequence, new hypotheses take into account these expected dynamics and suggest new decisions and practices to take advantage of predictability owing to temporary general conformity to a predictive convention. For example, this is what happened once the Black-Scholes formula for pricing options became a normative predictive rule producing conformed behaviours: speculators began to place higher-order bets taking into account the occasioned predictability of most agents' behaviour, thus reintroducing uncertainty into the economic system. This is the reason why big data is so important nowadays: it allows the prediction of behaviours, as they are determined by sets of beliefs, in order to produce higher-order hypothesis that are meant to enable more profitable, although riskier, bets. This is the reason why ours has been called an *information economy*,[15] meaning that profit depends

15. G.J. Stigler, 'The Economics of Information', *Journal of Political Economy* 69:3 (1961), 213–25.

upon the quantity and quality of information. Now, given that information is costly, the agents who are more likely to be better off are those who have the technology to gather, explore, and process the largest possible amount of data and those who have the resources to buy higher-order hypotheses and the consequent strategies. Disparity of information, then, is what provides the occasion to place more advantageous bets, and hence is what must be reproduced: valuable information is information that is not shared, and that therefore allows one to take advantage of conventional norms informing common strategies. Here, profit depends not so much on the production and exchange of goods as on the production and selling of information, under the provision of maintaining a functional asymmetry. In order to be sold profitably, just like any product that everyone needs, information cannot be equally distributed, as was supposed by the classic theory of equilibrium according to which prices conveyed, for free, perfect knowledge about the state of the system. In order to be sold profitably, information must be worth the opportunity of forecasting the effects of commonly believed predictions or their practical realisations. Within the uncertain game of finance, one is not engaging with a priori commonly known risk, one is betting on the expectations, and related actions, of those who *think* that they are engaging with a specific risk. For example, an algorithm detects a particular pattern of correlated variables such as the market price of a certain good and the price of the shares of a certain type of company. When it detects a change in the value of the good that is not immediately followed by the expected change in the price of the shares, it sends an alert: it has reason to forecast, with a certain probability, a rise in the value of the shares within the next day. This signal suggests the action of immediately buying the shares in order to sell them at the end of the day, according to the rational expectation of making a profit. Once the hypothesis is confirmed, since the inference has actually made some money, more and more agents might become interested in buying the forecasting system and the information that it provides. In this way, a conformist behaviour is produced that then becomes predictable for another algorithm that can take into account the effects of this widespread schema of

J.E. Stiglitz, 'The Revolution of information Economics: the Past and the Future', National Bureau of Economic Research Working Paper 23780 (2017), <http://www.nber.org/papers/w23780>; U. Birchler and M. Bütler, *Information Economics* (London: Routledge, 2007).

action upon the price of some correlated financial product. This allows the production of a new hypothesis to be tested and sold, and the introduction of a new rationally supported inference or an updated risk forecast. The gathering of this new information has a cost, which is often high since it depends on the development of technology and computational science, and it can generate a profit only if it is not common knowledge (shared knowledge would lead to equilibrium, market efficiency, and fewer opportunities for arbitrage and spec-ulation); once it becomes common knowledge, in fact, the hypothesis no longer has any market value. We could say, then, that the condition of contemporary profit is the uncertainty generated by an asymmetry of information or by the costly necessity of continuously updating 'knowledge' to outstrip what is com-monly believed.

Not only does any convergence toward the shared universal normativity of reason seem utopian, it does not even seem a desirable goal, since it would prevent the rational expectation of economic growth and higher payoffs by reducing the uncertainty entailed by the disparity of knowledge, i.e. informa-tion. It seems to me that the correct name for the 'knowledge' which we, as sophisticated Bayesian learners, are producing today, is actually *ignorance*, qua necessarily partial and nonsymmetric information that functions to reproduce uncertainty. This uncertainty does not express any knowledge of real random processes, but the very unpredictability of the predictive theories—basically gambling strategies—that are constantly introduced into the global competition. The circularity of the process is not the virtuous realisation of the supposed norms of reason that would shape the practices through which the world is constructed in agreement with the requirement of freedom. On the contrary, it is the vicious circularity of a self-reproducing game in which players bets on each others' betting strategies shape the real as an ever-evolving set of behaviours that, on the one hand, constitute the data that confirm the truth of the theory to which they conform, and, on the other hand, provide the ground for the introduction of more profitable higher-order gambling hypotheses. It would seem then that any possible world one can think of as realising a more egalitarian agreement is but an action hypothesis that is free to compete within the only universal game by contributing to its becoming, while offering predictable behaviours that speculators can easily exploit. The neoliberal global market game appears

to be the evolutionary process that produces and includes all differences, but which is different from nothing: anybody is free to take a chance, but nobody can leave the table.

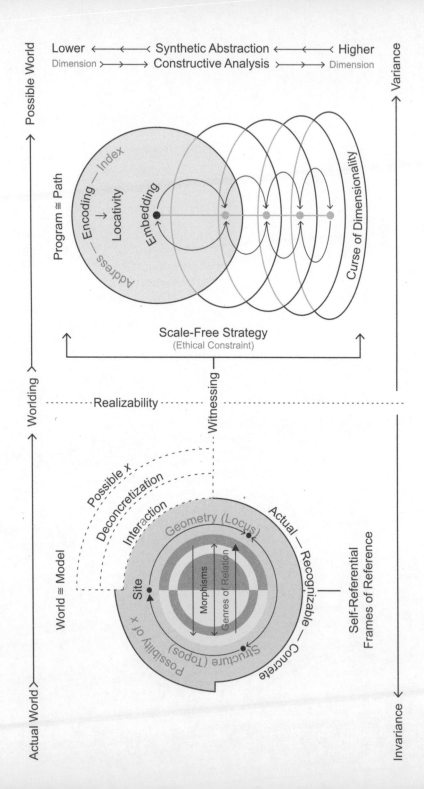

Anil Bawa-Cavia and Patricia Reed

Site as Procedure as Interaction

To think away intuitions that one possesses is easy; but to imagine sensibly to oneself intuitions of which one has never possessed an analogue is very hard. When, therefore, we pass to space of three dimensions, we are hampered in our capacity of imagination by the construction of our organs and the experiences obtained through them, which conform only to the space in which we live.

— Hermann von Helmholtz[1]

It must be possible to think, in a world, what does not appear within the world.

— Alain Badiou[2]

Proposition 0:
All procedures of worlding
require a deconcretisation of the actual

What is called an 'actual' world is the indexing of a recognisable world. In everyday speech, the actual world is isomorphic with a familiar world.

An actual world appears concretely because a shared conceptual possibility-space exists that enables its recognition. This impersonal concretion informs the domain of personal experience as the fusion of 'percepts, affects, concepts, and intersubjective relations' in an impure mixture.[3] This possibility-space of enablement and the perceptual codes of 'sense making' that constitute it, delineate an enclosure, a distinct world.

1. H. Helmholtz, 'On the Origin and Significance of Geometrical Axioms'. Lecture held in the Dozentenverein of Heidelberg, 1870.
2. A. Badiou, *Logics of Worlds: Being and Event II*, tr. A. Toscano (London: Bloomsbury, 2013), 122.
3. G. Catren, 'The Trans-Umweltic Express', *Glass Bead*, Site 0 (2016), <https://www.glass-bead.org/article/the-trans-umweltic-express/?lang=enview>.

This enclosure maps a particular space of intuitions (the conditioning of experience), as well as intuitions of space (the conditions for experience). Intuitions of space shape particular mental pictures of relationality and causation between bodies and entities, serving as the abstract ground through which ways of being and doing (*ethoi*) are justified.

Worlding is the contestation over the justification of the material-conceptual borders enclosing the actual, but is not necessarily *just*. Worlding is always arduous, yet is qualitatively ambivalent.

Proposition 1:
A world is always a model of a world

A world is distinct *and* identifiable by its undergirding frames of reference. These frames of reference determine the logic of that particular world, setting a foundation for modes of reasoning to play out within its contours or limits. A possible otherworld, and not the actual world, is tethered to the construction of frames of reference upon which novel systems of self-reference are created.

Nelson Goodman's axiom that all worldmaking is a remaking of worlds already at hand, sets the stage for a concept of worldmaking as an immanent procedure.[4] Imagining a world diagrammed as an enclosed circle,

4. N. Goodman, *Ways of Worldmaking* (Indianapolis: Hackett, 1978), 6.

the axiom suggests (a) that a robust understanding or account of what is 'already at hand' is required; and (b) that 'what is at hand' (i.e. within the enclosure), can—under certain proce-dures—serve as a vehicle for the construction of otherworlds in excess of a given, actual world enclosure. The intelligibility of a possible otherworld from within the given, actual world is equal to witnessing the permeability and deconcretisation of said enclosure, disproving the self-referential veracity of its particular and fixedly decided frames of reference.

Proposition 2:
Every world summons a topos or site

The topoi that correspond to worlds are those that describe the structure of possible relations (morphisms) between entities in that world in a constructive manner.

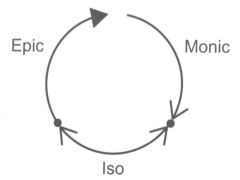

The study of morphisms—category theory—uniquely defines mono-, iso- and epi- morphic mappings. We denote a structure of such relations a topos.

The structure of possible relations is what lends a world certain qualitative affordances, in both operational and semantic terms. A common diagram of our time—the flattened network—where nodal points are connected by edges (lines) mapping a system of inter-relationality, is conceptually impoverished, for it speaks nothing of the quality or genre of those relations. Such a diagram can only depict the existence of relations without describing, even minimally, the conditions, or conditioning of them. Although all diagrams are compressions of complicated or complex structures, the labour of compression nonetheless requires descriptive accountability. Not all relations, nor the consequences of relations, are the same. Representations matter in the elaboration of what can be described as *genres* of relation.

The corresponding site of a world is both topological—that is to say, structural—and geometric, in so far as it is defined by its actualisation as a locus of interactions in the real.

All worlds bear these two spatial articulations—structural (topos) and geometric (locus). Homotopy, the equivalence of paths in space established via continuous deformations, is the bridge between these two articulations of site.

The integration of these two expressions of spatiality is sealed by the univalence axiom (Awodey), which establishes isomorphism as the basis for identity. The implications are considerable—on these univalent foundations, both the topos and locus that define a world are brought into the domain of the computable.[5]

There can be no instance of situated thought without a site. Situatedness marks a certain position (locus) for interactive opportunities enabled by the structural (topos) configuration endemic to a world. The setting of a world and its corresponding site

5. S. Awodey, 'Structuralism, Invariance, and Univalence', *Philosophia Mathematica* 22:1 (2014), 1–11.

of interactive possibility inform the spatial framework through which situatedness needs to be re-cognised. Accounting for situatedness also entails an account of the spatial specificities that constitute what positionality operationally means within a world. Perceptually, positionality does not necessarily conform to the dimension of experience of a situated identity.

The non-conformance of human experience with conditions of the current world captures a turbulent incompatibility of our moment: the condition of planetarity. The human-centred forces that have driven processes of globalisation have yielded plane-tary consequences wherein the human has become decentred as a primary agent.[6] Elsewhere 'planetarity' has been upheld in ethical contradistinction to a concretely globalised world, where 'ethics' can be understood as a demand for new genres of con-stitutive morphisms or qualities of relation.[7] The planetary has yet to be adequately spatialised, meaning that it is an unsituated concept without a site for operational interaction. The planetary has yet to be worlded.

Proposition 3:
All worlds are actual in so far as they are realisable

Adopting the Barcan formula,[8] we propose that possible worlds are not ontologically ampliative—the possibility of the existence of A implies the existence of the possibility of A. That is to say, the actualisation of possible worlds is always an immanent operation implicit in the logic of those worlds. It follows that 'nothing comes into existence on moving from a possible world

6. D. Chakrabarty, 'Cultural Institutions and Globalization', Lecture for OPEN SPACE, K20 Dusseldorf, Germany, 17 February 2019, <https://www.youtube.com/watch?v=bEzEjnqugfw>.
7. See A.J. Elias and C. Moraru (eds.), *The Planetary Turn: Relationality and Geoaesthetics in the Twenty-First Century* (Evanston, IL: Northwestern University Press, 2015).
8. R.C. Barcan, 'A Functional Calculus of First Order Based on Strict Implication', *Journal of Symbolic Logic* 11:1 (1946), 1–16

to an alternative'.[9] Barcan's intervention—a formal dismissal of modal realism—is not *prima facie* intuitive, but in its demand for a new conception of the actual, it is foundational for conceiving the possible as a computable realm.

> The condition of situatedness, understood not as a self-enclosed instance of partiality, but as the positioning of interaction, is what lends excessive possibility to the seeming rigidity of a concrete world at hand. The emergence of situated interactions between entities, even within the constraints of a concrete world, is what makes worlds at hand contingent, their site, impermanent.

> The self-referential logic of an actual world has the effect of obscuring possible worlds in excess of its immediate limits. If situated intuitions typically conform to the veracity of said self-referential framings (whether explicitly or implicitly), the problem of counter-intuiting possible worlds (for which one possesses no immediate site for sensation) is bound to the constructive mutation of frames of reference that structure the experience of intuition.

Computational actualism contends that existence is only actual if a realisable procedure for that world can be described in computational terms. Realisability is that which distinguishes the *merely possible* from an actual possibility, marking out the conditions for the actuality of a world expressed as a program for its construction. A program is a process conceivable both as a logical structure (topos) and a path (locus) whose realisability is enshrined in a formal syntax. What is the modal status of the realisable? Realisability imposes itself as a modal operator acting as a qualifier on the possible. This insistence on a decision procedure to construct a coherent world-model, an immanent

9. M. Fitting, 'Barcan Both Ways', *Journal of Applied Non-Classical Logics* 9:2-3 (1999), 329–44.

world which adheres to logical and material invariances that we
call universals, is what marks out the modality of the realisable.
The computability of worlds does not merely indicate a deter-
ministic account of the possible. This misrepresents the nature
of computation, which exists not as a static execution of logic
but rather as the very carrier of language forms and the medium
of interactive worlding.

> The making of new worlds is predicated on seizing upon the
> referential reconfigurability of the given world, that is, departing
> from an actual possibility space that is neither infinitely open,
> nor absolutely determined. If, in natural language, to 'compute'
> is to reason, then incomputability names the plight of fantastical
> non-realisability. At play in this modelling of possibility is the
> tension between variation (difference) and invariation (isomor-
> phism), yielding the question of thresholds of transformation.
> What operations of reconfiguration merely rearrange the furni-
> ture of an actual world while upholding undergirding frames of
> reference? What operations of reconfiguration generate a world
> that is constitutively other, and how can the traversing of that
> threshold be witnessed?

> At stake in this scenario is the comparative meta-relation (of
> variation and invariation) between the actual world and an
> otherworld.

The prescription of a program in the form of a model is what
legitimises a world as a modal entity, and this expression is
computational in so far as it delineates a structure of relations
with an accompanying logic or language. All three aspects of
a world, its expression in these three domains—its structure,
language, and logic—should be elaborated to confirm its realis-
ability. It is this trinity which marks out the computational nature

of worlding, as computation is no more and no less than this threefold expression of form (Harper).

> The unmodulated structure, language and logic of an actual world—and the site for intuitions that emerge from it—hinders the capacity to witness the realisable possibility of otherworlds. Counterfactual tinkering of the trinity—including aesthetic vehicles that instigate reconfigured frameworks of experience—serve as organons for worlding. While not yet fully actualised as a concrete world, the vantage points (positions) created through the activity of counterfactual modelling construct useful mental scenarios through which to compare worlds.

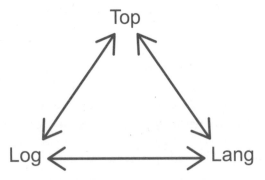

A topos *Comp* comprising a triadic of isomorphic identities mapping Constructive Logic (**Log**), the category of Topoi (**Top**), and Formal Languages (**Lang**)—standing in for Logic, Structure, and Language in computational trinitarianism.[10]

10. R. Harper, 'The Holy Trinity' (2011), <https://existentialtype.wordpress.com/2011/03/27/the-holy-trinity/>.

Proposition 4:
Computation is a vector for the realisability of worlds

Following the realisability interpretation of logic,[11] we can say that the truth of a proposition is defined by our ability to construct a proof or specify a program that realises that proposition. Possible worlds are postulates and are subject to just such an interpretation of realisability. What does it mean to realise a world? Firstly, it is the design of a world-model, accordingly expressed as the structure, language, and logic of the world. But it is also the recognitive material practice of justifying such a world through linguistic forms which develop a 'locus' of interactions.[12] To realise a world is to enact a program, in the broadest sense of the term, that interactively develops a site of relations in a language informed by a topos or logic.

Common language is an adaptive correlation to the site of an actual world, signalling that possible worlds require toying with non-adaptive languages. Non-adaptive languages must be attentive to the tension between variance and invariance: with too much variance there is an utter loss of sense or communicability; with too much invariance there is simply no transformation. Non-adaptive languages on their own do not realise a possible world (without their integration within the trinity), they gradually contaminate the semantic space of the concrete world, eroding its self-referential legitimacy, setting the seedbed for realisability.

11. S.C. Kleene, 'On the Interpretation of Intuitionistic Number Theory', *Journal of Symbolic Logic* 10:4 (1945).
12. J.-Y. Girard, 'From Foundations to Ludics', *Bulletin of Symbolic Logic* 9.2 (2003), 131–16.

Proposition 5:
Embeddings transform the domain of the possible

Two computational operations—embedding and encoding—
inform the transformation of possibilia into realisable worlds.
Embedding is a transformation that shifts an object of study
between higher and lower spaces, introducing or eliminating
domains in which entities can be contemplated. It alludes to
a topological morphism, but one with geometrical implications,
since it changes the dimensionality of a structure.

> The transformation of possibilia into realisable worlds is not
> abrupt in its temporality. Embedding names an iterative process
> of movement through dimensions (where 'higher' and 'lower'
> denote degrees of complexity). Such a process not only shifts
> an object of study through dimensions, but allows for the con-
> sideration of the shifting consequence of an object of study in
> various contexts of dimensionality.

> For planetary worlding, the human, as a living-breathing entity
> (bios) *and* as a concept (mythos),[13] must be grappled with
> across such dimensions of coexistence, in order to decipher
> actual possibilities (realisabilities) from mere possibilities.

To move from higher to lower spaces is to commit to synthetic
acts of abstraction, whereas the converse movement represents
analytical acts of construction. The dialectic of construction/
abstraction or analysis/synthesis is laid bare in its spatial treat-
ment as a matter of dimensionality.

| Higher | \longrightarrow | Lower | = | Abstraction |
| Lower | \longrightarrow | Higher | = | Construction |

13. S. Wynter, 'No Humans Involved: An Open Letter to My Colleagues', in *Forum N.H.I.: Knowledge for the 21st Century* 1:1, 'Knowledge on Trial' (1994), 42–70.

Instances of worlding that emphasise one side of this movement of embedding between abstraction and synthesis are not only insufficient, but often yield distortedly violent sites of interactive enablement. In much the same way as homotopy is a bridge between structure (topos) and geometry (locus), procedures of worlding must learn to labour in a continuum across dimensions, in a bidirectional manner. Such a movement folds further into the bidirectional necessity to consider objects in their discrete and continuous instantiations.

A unidirectional, historical instance of worlding from a colonising frame of reference, that has made many rightfully sceptical of the term.[14] Considering this realised misuse of 'worlding', it is crucial to underline the necessity of embedding objects of study across dimensions.

The so-called 'curse of dimensionality' cast by the real elicits embeddings as a computational response—a neural net is a technology for just such morphisms. If recursion is a form of (self-)embedding, then to embed a proposition or statement in a higher space is a shift in perspective that induces entirely new domains, in the same manner as self-referential statements burst their logical frame of reference. High-dimensional spaces are the product of such transformations, and are the site for the synthesis of new possibilia.

The condition of planetarity exemplifies this curse of dimensionality. We have not yet been able to 'world' the planetary, because we have only been able to label it in a higher degree of dimensionality, without labouring for its realisable site. The globalised site of interactive constraints persists, despite the

14. G. Spivak interviewed by E. Gross, 'Criticism, Feminism and the Institution', *Thesis* 11:10–11 (1985), 175–87.

epistemic discovery of planetarity that demands submission to rigorous embedding.

Planetarity names a paradigm of spatial hyper-relationality that is predicated on multi-dimensional morphisms we cannot (yet) intuit, sense, or name. It is a particular historical marker, as it charts, for the first time in human history, an environmental condition in common.[15] There can be no claim of a human 'ethics of planetarity' for this environment in common without the construction of a corresponding site of interactive enablement. An ethics shorn of a site of interaction is empty. Submitting the possibility of worlding planetarity to the necessity of embedding entails not only an address from the higher to the lower, abstract plane, but equally from the lower to the higher, synthetic plane.

B

Induction on a Base Type, **B**. To *induce* a new domain is to provide a new frame of reference for the entity in question.

Proposition 6:
Encodings ground the site of a world in language

Encodings refer to an indexing operation that introduces a sense of locativity to a world—manifesting its relation to other worlds—by providing a formal syntax for its representations.

15. S. Wynter. 'A Ceremony Must Be Found: After Humanism', *Boundary* 2:12 (1984), 19–70.

The indexical nature of encoding encompasses the addressability and givenness of an object in a computable domain. Gödel famously arithmetised logic via such an indexing operation. Likewise, when Curry draws an equivalence between proofs and programs,[16] this is arrived at via an encoding of the lambda calculus in a proof-theoretical language. Every encoding exposes the context sensitivity of a world—it is precisely this interlinguistic mediation underpinned by a sign we call Number. It grounds the transformations enacted via embeddings in linguistic forms, facilitating mappings and translations between languages, enabling morphisms between world models.

> To realise a possible world premised on planetarity requires the encoding of a sensorium of locativity within it. More straightforwardly said, it requires constructing sites for new frames of reference for what and where a location is that are contextualised by multi-dimensional transformations. It is through this multi-dimensional lens that the discrete context sensitivity of location can be exposed to the continuum of an environment in common, and vice versa. The continuum or wholeness designated by the 'planetary' is subject to reverse dimensional engineering, echoing Édouard Glissant's more poetic notion of one world (tout monde) containing many worlds within it.[17]

Proposition 7:
The transformation of possibilia is computational in nature

These complementary operations—embedding and encoding—allow for perspectival shifts that propel the autonomy of the formal, allowing for the construction of syntactic structures that inform the realisation of new worlds. Embeddings allow for

16. W.A. Howard, 'The Formulae-as-Types Notion of Construction', in J.P. Seldin and J.R. Hindley (eds.), *To H.B. Curry: Essays on Combinatory Logic, Lambda Calculus and Formalism* (Boston, MA: Academic Press, 1980), 479–90.

17. É. Glissant, *Traité du Tout-Monde (Poétique IV)* (Paris: Gallimard, 1997).

a shift in dimensionality (synthesis and abstraction) and encodings allow for an indexing (locativity), with corresponding influence over the topos and locus of a world. Their computational treatment is marked by terminal objects, halting procedures and operational closure. But these are far from being closed systems; the dynamics and indeterminacy of such operations is elaborated via a new category of formal language known as interaction grammars.[18]

> A planetary perspectival shift—that is, a common world (continuity) composed of many worlds (discreteness), demands elaboration of its grammars of interaction. It is here that the correspondences between worlds can be proposed in their indeterminacy; correspondences subject to perturbation from the emergence of locatable interactions. A planetary shift in perspective as the movement between embeddings and encodings does not entail an absolutely fixed vantage point of perception.

Proposition 8:
Worlds are actualised via recognitive acts of reason

The agency of actors in the realisation of worlds is paramount to the elaboration of languages that summon those worlds, for every attempt at world construction is an exercise in freedom and a test of agency. It is only through interactant driven language formation that possible worlds can come into existence as model-theoretic entities arrived at by acts of reasoning.

This process of syntactic structuration casts language as computation—new worlds correspond to new models in the form of novel languages, logics, or syntactic structures. A plurality of infinite languages gives rise to encodings as a necessary mediator for such mappings.

18. D. Goldin and P. Wegner, 'The Interactive Nature of Computing: Refuting the Strong Church-Turing Thesis', *Minds and Machines* 18:1 (2008), 17–38.

Likewise, agent interactions are a prerequisite for the development of the geometric site of a world, but their coherence is only bound by the model of the world that they realise through dialogue. This *geometry of interaction*[19] emphasises the autonomy of the formal, eschewing denotation in favour of operational semantics via immanent computations. Languages in this conception are the very form taken by computation in developing a locus of interactions, suggesting a formal grammar of world-making, or a syntax of worlds—one that is always situated in a dynamic locus of reason grounded in a dialogics of worlding.

In worlds constituted by geometries of interaction, agency, including the agency to reason, is always deprivatised. Agency is not action or thought in isolation, but rather *inter*action and dialogue. Agency is the construction of a certain quality of relation, as well as the capacity for transformation because of dialogic relations.

Crucially, the curse of dimensionality endemic to planetarity signals an exhausted picture of human agency belonging exclusively to a dimension of lived reality wherein immediate cause-and-effect relations are perceptible. This does not mean that linear/mechanical agency is irrelevant, but it is insufficient with regard to the demand for embedding its conception across multiple dimensions, including a diversity of laminated temporalities belonging to those dimensions. What is an adequate picture of agency embedded in various dimensions, and how does it get encoded (localised) at a dimension available to human recognition?

19. J.-Y. Girard. 'Towards a Geometry of Interaction', in *Categories in Computer Science and Logic. Proceedings of Symposia in Pure Mathematics 92* (American Mathematical Society, 1989), 69–108.

Proposition 9:
Scale-free strategies for worldmaking
expose global constructions

Scale-free strategies allude to those logics, structures, or languages that are not locally sensitive and exhibit global qualities. The global and the planetary clearly have distinct lineages—we must be careful to identify locales and neighbourhoods of truth construction, and to put universal claims to rigorous tests, rather than imposing logics on an asymmetrically conceived spatial field shaped by inequality and oppression. Many languages and logics can and must coexist in order for heterogenous worlds to exist, with common encodings as the basis for translation and correspondence between these worlds.

Scale-free strategies for worlding elaborate the domain of necessity as a formal constraint against a concept of worlding as a (trivial) practice of infinite possibilities. This scale-free requirement reigns in hubristic perversions of worlding unleashed from a particular dimension, with no fundamental testing or care of its veracity throughout a spectrum of dimensions and heterogenous worlds. With this procedural constraint, an ethics of worlding is enabled. Here universality is not a uniform determination imposed asymmetrically, but the invariant glue between interacting indeterminate entities. It is through scale-free strategies that the ambivalence of worlding can be held to account.

Proposition 10:
Universals are invariant laws that structure
the domain of the actual

The identity of a world is marked by isomorphisms that allow for equivalences to be drawn between worlds. The actual only coheres in so far as invariants exist to give rise to such

structure-preserving transformations. Universals are those invariant logics that hold in the totality of possible worlds and as such define the domain of the actual—of that which counts as actual. Universal invariants act as laws, both logical and material, and such laws are constantly under revision owing to the infinite nature of language forms, a domain over which universals cannot assume closure without transcendental appeal. The realisability of a world is subject to the eligibility criteria imposed by universal invariants—such as spatiotemporal priors—which provide a semantics for the actual. Without such a semantics the descent to linguistic relativism would prompt a Carnapian 'principle of tolerance', which would amount to a suspension of the ethics of worlding, an arbitrary proliferation of syntaxes with no end or justification.

> The question at the heart of possible worlds is how to become witness to a world that is not yet concrete; a world that does not appear within the existing frames of reference that configure the perceptibility of concreteness. To be a witness entails not only the ability to perceive, but also the capacity to testify to the ramifications of what has been witnessed. Witnessing is more than mere seeing. It is not only the agency required to deconcretise the actual (that of seeing the rigidity of self-referential frameworks of the actual world as contingent, and thus not invariant), but also the agency to participate in the semantic actualisation of nontrivial possible worlds.

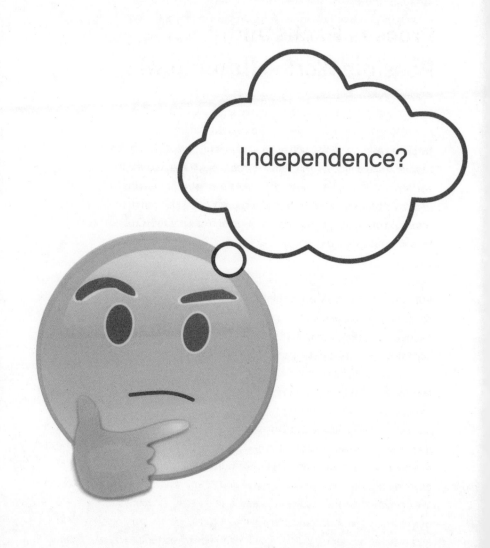

Mat Dryhurst

Process Hacks and Possible Worlds (Interview)

Mat Dryhurst is a thinker and artist who in recent years has made numerous interventions and actively provoked debate on changes in the infrastructure of the music industry brought about by the advent of new business models such as streaming services. In his work with Holly Herndon, most recently employing machine learning technology on the album PROTO, these concerns for solidarity, 'interdependency' and the commons are brought to the stage and dramatised through music and performance.

ROBIN MACKAY: Could you describe in the broadest terms what your approach would be to the question of scoping out and building new possible worlds for the disciplines and practices within which you work? And do you see this as a political or rather as a practical or technical question?

MAT DRYHURST: Beyond the fact that on most political issues I would identify as quite far left, leaning toward the libertarian, generally speaking I come from an analytical background rather than from a politically dogmatic background. If anything, I'm a pragmatist—I think if I have any function whatsoever, it lies exactly in the fact that, while ideals are wonderful, most of my knowledge of anything comes from lived experience and scrutinising first principles. I feel like I approach a lot of topics backwards, in a sense, since my experience is one of working in various industries without too much of a plan, and having to figure things out for myself—I'm a bit neurotic so I do tend to try and figure everything out.

You have the grand utopian statement which is, all things being equal in a perfect universe, we could build *x*. That kind of thinking can be useful in a purely academic setting, but I'm mostly concerned with the wellbeing of my

family and other people with whom I share a common story or ambition, and the reality there is that things aren't going to happen like that. There are a lot of utopian thinkers with very clean shoes, who are going to be disappointed if a very complicated process isn't executed perfectly, whereas I'm more interested in smaller steps, minor process hacks.

Of course, this approach can be very frustrating too, because at least when you have a utopian thought, you concede to yourself that it's probably not going to happen, or that it's out of your hands. The problem with my approach to it is that I think, 'You could probably do this in the next few weeks'—so then when people don't do it, it torments me because I'm like, 'no, no you can actually do this thing'...!

My big issue is that a while ago I reached a point where I couldn't determine whether the people around me believed what they said they believed. Which is not to label anyone a cynic, but more to say that many are so far away from entertaining the possibility of anything changing, or so few options appear available to them, that there's not much consistency between stated beliefs and actions.

RM: You're saying that there's a discourse around improving or reforming things, but no real conviction in terms of taking any action to follow it up?

MD: Yeah. I mean, of course there are a minority of people who take action, but in areas like music, art, and culture, where in a sense everyone— particularly at this moment when we're all expected to be activists of some kind—is expected to be contributing positively to the world, often it seems purely gestural. It's confusing to tell who means it and who is participating in a choreography. When I propose feasible stuff to do, I often feel like I am entertaining, rather than being entertained. It's weird.

RM: Your recent talk on protocols at CTM 2019[1] attracted a lot of attention, so it seems that it's not impossible to involve people in thinking through the technical

1. <https://soundcloud.com/ctm-festival/ctm-2019-protocolsduty-despair-and-decentralisation>; transcript at <https://medium.com/@matdryhurst/protocols-duty-despair-and-decentralisation-transcript-69acac62c8ea>.

details of how inequitable and potentially culturally corrosive existing systems are—in this case, the systems for music sharing, delivery, and distribution.

MD: With that talk, all I was trying to do was to look at the platforms and ask whether they're doing what they say they're doing. Because the disparity between what people think Spotify or Facebook are working on, and what they actually appear to be working on, is so vast. It is sometimes useful to literally kick the machine and ask: Is this doing what it says it does? It's refreshing to pull everything out of the symbolic order and blood sports, and into the practical domain.

RM: A concrete example of that would be your analysis of streaming models.

MD: Yes, I think that to properly understand streaming logic, it is worth understanding the fallout of technical decisions that go back to the establishment of the web. We are in this pickle for good reason.

I also try and keep my analysis somewhat impersonal, because I could be a puritan and start throwing eggs at individuals and I'd probably get more Twitter followers, but I'm not stupid enough to think much would be accomplished through doing that.

RM: The ranks would close against you.

MD: Yeah, then it becomes personal. I've never been a political zealot, although I have positions I fight for. If you do it right, certain new concepts, or definitions, emerge. Once you identify a problem and propose a well considered fix, it endures longer than any attack or emotional outburst. Like, for example, when I proposed that DJs share their fees with the artists whose music constitutes their set. There are all kinds of ideological positions wrapped into that proposal, but the proposal itself doesn't need them to gather steam. It's one of those things that, once brought into the world, will now never go away. I can almost guarantee it. I get a kick out of that.

RM: Out of specifying or naming the problem, and indicating this gap between what's being said and the material reality?

MD: Exactly. And also, just to spot opportunities, to be honest. In the realm of music specifically, I'm a nerd for figuring out how people are making money. In music there is one huge blockage in the conversation around streaming. Streaming companies are engaged in a race-to-the-bottom war, raising a tonne of money (unless they already have it, as in the case of Apple) around an idea that as of yet has not turned a profit. So everything they say hinges on a speculative romantic narrative they are asking people to invest in and believe in.

On the other hand you have characters who, for good reason, are very wedded to an older time period, or who would love to return to some simpler era, and they are burdened by these very humanistic, kitschy arguments about the value of community and the meaning of music and so on, when in reality I don't think that approach is going to cut it either..

If you disenthrall yourself of those two flawed proposals, and also the suggestion that one idea could work equally well for everybody, there are actually thousands of things we could try out in music. I've been looking at ways for scenes to fund common resources and distribute equity, for example, which I think is something that only scene music could achieve. Maybe to some that sounds boring, but I think in practice it would be the opposite.

RM: Precisely because it's not utopian in an appealingly dreamlike sense.

MD: I need to do a better job at making things dreamy. With the performances with Holly [Herndon], we've been trying to fill that gap a little bit—I mean, it's certainly not dry. I commonly say that we need a TAZ for whatever this new thing is. People fell in love with the poetry of it. Irrespective, I don't think scene musicians have much choice—we either process-hack our way out of this, or we are stuck in this abject predicament for a while.

RM: By 'process-hacking', then, do you mean a piecemeal, trial-and-error way of working with and around the tools that are available?

MD: Yes, taking advantage of a kink in the way that something currently works. Generally speaking it is almost impossible to gather the momentum and funds necessary to sustain something outside the platform ecosystem, so you have to exit through them somehow. The wealthy do this all the time: they find loopholes, they find ways to move money around, ways to evade tax. And often in order to be able to make that process hack you have to get as close to the processor as possible. You have to get as close to tax law as possible to understand where the opportunity might be for you.

Here's an example. There was a story in the news many years ago when SoundCloud was at the centre of everything, about some clever artist who had figured out that if you put certain keywords in a song, you could be the next recommended song after the latest Kanye West hit. So in a sense it's a kind of finessing of the system. You're reading a system and figuring out how to hack that process a little bit so as to find an advantage in it, ideally for the betterment of more people than just yourself.

RM: But if you're saying that the only pragmatic way to create some kind of opening is to game the systems that are in place, there seems to be some ambivalence as to whether you're really opening up new possibilities at all, or simply conceding, resigning yourself to working within the environment those large players have put in place.

MD: I don't see where the funds or the human power or the skills would come from to create, let's say, a separatist internet. Ten years deep into playing around with stuff like this, I'm not holding my breath. And what appears to me to be the opportunity is, I'm not conceding anything, but I just don't see a scenario in which the FAANG lose their grip on online culture. I've been through that process of trying to build something new and know many others who have too; it sounds great but it's impractical.

RM: In 2015 you devised and built the self-hosting publishing framework Saga, designed to give artists some power over how and where their work is displayed online by enabling them to control how embedded content behaves depending

on the context within which it's displayed. How did that project develop, and what did you learn from it?

MD: Initially I just saw an opportunity: at the time websites were perhaps more powerful centralised structures than they are now, and were often dependent on embedded content from elsewhere. So I built a tool that allowed you to take control of that content throughout the web, asserting that online, just as in the real world, a piece of art has a different value depending on where it is hosted. So I ought to be able to charge X on a Nike blog, and nothing on a fan blog. This simple mechanism of versioning and permissioning content opens up the possibility for other applications too. Twitter is now working on something very similar with the New York Times and Adobe, as a means of determining the authenticity of content. It's one of those simple concepts that I have no doubt will become common over time.

My experience with it was one of doing it as an art project. I had a bunch of interest from people within what was then the very early crypto community. My challenge at the time was that I found it impossible to raise any money to develop it any further. Myself and the developer friend who was helping me, we put it together for less than a thousand pounds. I had a few people help me to petition arts grants bodies, and basically came to the conclusion that it's impossible because it falls in between the cracks of all these funding models that were established in the nineties. I could've raised more money making a hypothetical video essay about the possibility of the software, as 'media art', than I would have been able to raise for actually building the software itself. I did get someone approaching me at UCLA after I first presented it, who was like hey, I want to give you a bunch of money to make this a different kind of ad network for individuals—which is a clever idea. It was a really good use case for the concept: basically you could sell your own ads from your own server using that technique and you could switch them out. So if Rolling Stone hosts a song of ours then, if we were so inclined, we could just switch up new ads all the time. I didn't really want to do that, because it's a waste of life. In the venture capital world, I know smart people who play in that universe, but in their world they feel that media distribution is largely 'solved'. Streaming's dealing with music, Facebook's dealing with content, why would we fund a cute activist project?

So it ends up just sitting there. I worked on maintaining it for some time, but after a while I just felt like a bit of a sucker.

If you go on GitHub there's a trail of tears there—incredible software projects that no one will ever learn about. The cryptocurrency world changed the funding landscape for those kind of projects with the ICO (Initial Coin Offering) model. In a weird way those crypto projects became the new art world for a while. You want to talk about crazy speculation around utopian gestures? Most crypto projects were/are just badly edited essays—when you look at the white papers, anyone who's read a few of them can distinguish between people who know what they're talking about and then just wildly speculative stuff that's nevertheless raising thirty million dollars overnight, you know....beyond how absurd that is, the ICO as a mechanism for supporting things is actually quite interesting, and there have been a number of projects that endure in that space and actually do interesting work now, where it's easier to find grants and co-builders to develop those projects. At the time of Saga, though, there wasn't really that option, so I just kind of let it die. I still found that time really useful though, because that was actually one of my first experiments in this kind of low-level protocol thinking. In a sense, now everything I do is based on what I learned from Saga.

RM: Then how about more recently in the case of looking at DJs, what kinds of protocols are in place there, and how that might be different? Again, here I'm interested in the disparity between a certain story that people are telling themselves and each other, and the reality of what's going on, and where that disparity comes from: Is it an ideology imposed upon them from elsewhere, or is it a spontaneous product of people's need to believe that the system they're a part of isn't fleecing them? Because some of the data I've seen you post on the disparities in income between 'star' DJs and the rest is shocking. It reminded me a little of the art world, where you have a huge pool of people at the bottom who are aspiring and striving, spending all of their time trying to meet the right person and say the right thing, and who spend decades of their life doing that while being very poorly paid and displaying their virtue by shouldering a lot of 'voluntary' labour. All of that on the basis of an aspirational story—that you have to be in the network, you have to be involved, and one day you'll have the opportunity to make those leaps up the ladder. So I just wondered where

you see that disparity being generated, and why you think people are so ready to propagate a narrative which their own professional life experience doesn't bear out.

MD: I think the parallels with the contemporary art world are really valid. There is a historical factor here, I think: it's only a very recent development that people expect their hobbies to somehow fully represent them and be a vehicle for social mobility. And you can attribute a lot of that to sixties liberalism, to the explosion of self-expression and so on. I wasn't there but I can only suppose that at the time it was a legitimate liberation from conservative institutions that needed to be shaken. The challenge we have now, though, is that you have this very hallowed, halcyon period of culture in which we were sold a story that plucky people in their garage could have a big dream, or that the broke musician drug addict could take over the world, and even though that *did* happen in certain cases, my argument is that, in retrospect, we're now imprisoned by that narrative.

I was talking to Lee Marshall, a sociologist at the University of Bristol. He did some research into vinyl sales, and it turns out that something like forty percent of all vinyl purchased is never played. He apologised to me because, at the time, I was the only musician in the room. But I said no, you saying that is wonderful to me, because that's closer to my understanding of things, which is that in a sense the greatest product of the music industry is *the music industry*—the mythology of the music industry *is* the product, is the lore. You can probably say the same for the art world, right? The closer you get to it, the more it reveals itself as a ruse, a trick. Not in some cynical way that implies that somewhere out there is some pure art that is being misrepresented by these nefarious characters who are dragging art through the mud. But in the sense that it's a kind of meme that play tricks with people's aspirations—and that mechanism itself is the source of value, that ability to mint, trade, and merchandise around genius.

These systems worked better in times of scarcity. You see that in music as in all media: if everyone can make music now, it's harder to stand out. All scarcity systems of that sort are dissolving. The great liberators of the twentieth century, though, they're not going anywhere. Their images will loom over culture until the last cent can be drained out of that era.

I struggle with that when I see well-meaning people dedicating their lives to career models that haven't been updated to reflect the new situation—and you can make the same criticism about universities and all kinds of different structures that have been shaken as a result of these shifts. I have a fair amount of insight into how the creative fields operate, and to me the most unethical thing I could possibly do is to perpetuate falsehoods, and not attempt to communicate to people exactly what it is they're getting into. Not in the classical art teacher way of 'You're just not good enough, I'm being cruel to be kind', nothing like that, but just saying: here is the best, most brutally analytical information I can give you about how this actually works to the best of my knowledge, and with that knowledge in mind, you have a better chance at carving out a niche for yourself in this ecosystem.

I joke with my students that, beyond the fact that I love what I do—and Holly and I both inject a lot of meaning into the artwork we do, as everyone does—the place we occupy in the music ecosystem is market testing. It's so obvious. If I just dissociate it from my own desires, it's clear that we exist in a pyramidal structure in which it's cheaper for us to take risks than it is for the people above us, and you can say exactly the same about the art world, right? It's cheaper for the student or the bohemian knocking about Berlin to take risks than it is for the exhibition-maker who has to spend one million pounds on constructing something.

Once you jettison the romance, it's clear that almost always, people are, in both earnest and cynical ways, contributing to the maintenance of a well-oiled infrastructure. I say that with little judgment, it just is. In fact I think often the people who are most judgmental about the arts tend to be those who are the most entranced by its mythologies, and perhaps do not have enough information to dispel that state. That can also happen at the top though, I guess: often successful people are the most oblivious as to how and why they became successful!

RM: Because success doesn't necessarily grant you any insight into the mechanisms via which you've been able to find success.

MD: Exactly. Many of the most successful people aren't going to be the best ones to ask about how things actually work. Firstly because many just don't

know, because they've been so graced by that infrastructure that they've never had to deal with the particularities of why they're successful, and secondly because for those that do know, why would they share it?! I think a lot of successful people peddle falsehoods selfishly.

RM: This brings me back to my earlier question: if you're really successful, you don't necessarily have any reason to look into it too closely—after all, it's great to believe that you've succeeded because you're the best! But why is it that those stuck at the bottom of the ladder are also not interested in understanding how things are actually working, why are they also buying into some rather disconnected and/or outdated idealism about how this culture industry works?

MD: Increasingly among younger people who are starting out, I've found that there actually is a lot of interest—I mean, the reason why I've been invited to teach is because there's been a lot of interest in that particular line of exposition. I think younger people, who have grown up in the hell of metrics and gamified expression, are far more aware of the omnipresent circuitry of culture than we ever were. For many older people who are more entrenched, and I don't know how to say this without it seeming mean, but I think there's often a kind of power relationship between the time someone has invested into a field and their readiness to concede defeat. Sometimes it's just too painful to someone's personal mythology to look too closely at the circuitry.

RM: Of course, that makes sense. So is the current infrastructure for the distribution of music just a statistical competition?

MD: The democratisation of tools has made it really easy to make mediocre art and to publish it to nobody, that's the base opportunity they've provided. Now, when you start talking about process hacks, there's a gazillion ways of trying to hack the Instagram feed, trying to hack SoundCloud or the Spotify playlist or whatever. There's a bunch of people out there trying to do that, and there's a subset of those people out there who win the lottery because their track gets on an ambient autumn playlist or something that makes them £100,000—that happens. When I look at the services, what I see is a basic promise that you

have a chance to build your own business with zero support, and the opportunity to pay for various scams. Maybe this is a separate conversation, but if you look at classic multilevel marketing structures and the new culture industry, it's hard to see much distance between the two models, honestly. Everyone is an individuated agent who's given this little bit of space, and then encouraged to pay to advertise and pay to crosspost, and pay and pay and pay...if you pay this weird ad company they'll get you exposure to this playlist...in the hope that one day that pipe dream will work out.

I figured out a couple of years ago that there's far more money in people willing to pursue a pipe dream indefinitely than there is in people willing to listen to the music that comes out of that process. Now I believe that Spotify has figured that out, and is acquiring all kinds of artist services companies. I feel that is a far more sober angle on that economy.

RM: That's a radical shift in how the industry works, for sure. And as you say, increasingly, this goes down to the level of the 'content' itself. Users are bombarded with solicitations that, maybe if you tweak your product like this, use this plugin, or pay someone to help you polish it, then you'll double your listeners.

MD: Absolutely, and it's all a kind of baiting, a continual carrot on the end of a string.

When I talk about the need to form institutions, of course we're aware of the mistakes or transgressions of previous models, the activities of labels and other older institutions—but at least things were clear. You know, at least there was an understanding of the economics of it, you didn't need a PhD in data science to understand what the game was.

The present moment is a field day for institutions with power and budgets. Everyone in the world is encouraged to publish their ideas freely online, and that information is only really valuable if you have the means to monetise it. Major labels and brands invest money into tools that allow them to harvest ideas and trends from poor teenagers online, and integrate them into their products before any regular person would have the chance to monetise them. Taco Bell won awards for their social media department in 2014–15, presaging this. They established a kind of Skunkworks-style surveillance unit called 'The Fishtank',

where basically they were using Twitter as an idea-generating machine, scanning all of these young people out there trying to make a name for themselves and trying to get attention, finding the best memes, and then devising ways to twist them into something Taco-Bell-related. The worst thing about all this is that it wasn't considered predatory, it was considered fun and hip…. You can also see that with where Vine went, with a lot of predominantly African American teenagers fuelling culture with new cool shit, and the only one who benefits from that is, like, Madonna or something…. So that's today's power dynamic as I see it, which is very different to the standard narrative.

RM: And is it at all possible to exist outside of that?

MD: I think yes and no. The problem is, as always, there's still privileged place-ment in the culture industry for those who can afford to move to London, New York, increasingly Berlin, increasingly LA. The connections and the freemasonry of those media-heavy cities still exist. It's the same with certain academic programmes, more so in the art world than in the music world, but it exists in the music world too: if you can afford to, or if you have the good fortune to be in the favour of certain programmes, you are still on an accelerated path. So if you go to Saint Martins, or if you're at the Stadelschule, you're closer to the action without necessarily having to participate in the ad platforms, and in some cases I think in the art world it's almost advantageous not to—that's the ultimate flex, that you don't have to promote yourself because you've already made those connections. But for everybody else, no. The trade-off is you're given the tools to do the bare minimum, to have the bare minimum access, and then you're invited to step on one another and figure out ways to scam and finesse one another, ultimately to figure out a way to provide enough value to the infrastructure in order to be able to leech some of it back for yourself.

This is why 'scenes', without being too romantic about it, are important. That's what I end up telling my students: at the end of the day, your best chance comes from earnestly contributing to creative scenes, working out a way to get involved and be a good person, and participate. This still, I would argue, is statistically more likely to succeed—you're far more likely to find some success

in the culture industry doing that than buying ads and trying to make songs that complement playlists. Most trad scene people in music can't stand me. It's funny, as I'm the one trying to vehemently defend them in quarters where no-one spares them a thought. Protecting scenes as fortresses that are somewhat insulated from abject populism is very important though.

So this is where I end up: the standard narrative is gatekeepers vs. democ-ratisation and opportunity. I'm in a completely different world, I don't see that as the battlefield at all. The battlefield is specialists having some say vs. there being one gatekeeper for literally everything, or five gatekeepers for all of culture, you know? I will defend labels. I mean there's obviously some gross stuff I wouldn't defend. But the idea of labels, and most likely galleries too, I'd probably fall on the side of defending them, but with the caveat that there are some significant improvements that could be made.

RM: Because all of these things can be seen as points around which a wider productive group can coalesce, a microculture that has space to breathe and to develop. That can be something as simple as just affording the suitable time and space to hang out and develop a shared vocabulary, new concepts, inventing new ways to use instruments...just not being an embattled individual for a while. Those microcultures are where new possible worlds develop, aren't they?

MD: Shaun Monahan wrote about a trip through the New York subway where everything in all of the advertisements are shouting about you basically having no commitment to the world around you: it's all apps for casual anonymous sex, dining at home in your bed, everything is attempting to further individuate you.[2] When I talk about interdependent—rather than independent—music,[3] I use a slide from an old anime where the quote is, '*as usual, you've confused isolation for independence*'. Which I think is beautiful, and very true.

2. S. Monahan, 'The Rise of the Personal Brand: How Selling Out Became Cool in the 2010s', *Dazed Digital*, December 2019, <https://www.dazeddigital.com/life-culture/article/47199/1/the-rise-of-the-personal-brand-how-selling-out-became-cool-in-the-2010s>.

3. See M. Dryhurst, 'Band Together: Why Musicians Must Strike a Collective Chord to Survive', *The Guardian*, 9 April 2019, <https://www.theguardian.com/music/2019/apr/09/experimental-musicians-must-strike-a-collective-chord-red-bull-music-academy-closing>.

I take that microculture point seriously, in the sense that Holly and I have a culture. Okay, it gets confusing because it sounds super-cheesy and corporate, because Google's very into their 'Google culture', companies talk about company culture, etc., but I don't revere them enough to let them sour the term! We're very deliberate about who we work with, how we treat people, how well people get paid. That's incredibly important. And it actually matters in a way that means that it would also be gross, and it would undermine the beauty of it, to make that a selling point, to make that a public thing. But the idea is basically that we don't fuck people over, that's a core principle of the project. It's simply the idea of commitment. And this gets more interesting when you think of how such things might be implemented in technical ways, if need be—that's something I'd like to see more of. In decentralised tech one of the things I find really compelling is the idea of an immutable ledger, an immutable transparent protocol that anyone has access to read and that you can't go back on: it's a good faith engine. When you have immutable cryptographic protocols that cannot be changed or altered, what you're talking about is enshrining good faith. And the idea of some kind of consensual adoption of good faith—and you see this in other areas like the effective altruism movement—the idea of being able to track where the money's going, who said they were going to do something and what, and whether they actually did it—I actually think that's a very beautiful idea.

So this idea of making commitments to one another is so much more powerful and also utopian and gets very dreamy for me, to be honest: I like the idea of making long-term commitments to people—I mean, I'm happily married, I love the idea of marriage: without attributing any kind of religious significance to it, the idea of a couple of people committing their lives to each other I find an incredibly romantic and beautiful thing.

RM: And you think there's a possibility of organising collective commitment through technology, to build cultural worlds other than the one we're struggling through at the moment?

MD: Yeah. The natural or dystopian perspective on that is to imagine a scenario where all human motivations are somehow marketised and surveilled, and of course I'm not advocating for that. But what I am suggesting there's greater

possibility for is the idea of encouraging people to publicly state their intentions and to deliver on them, and being able to tell whether that's happened. On the societal level, maybe that stuff sounds terrifying, it sounds like the social credit score. But on small-scale levels, in terms of putting together groups of people, this is what is beautiful about many of the DAO (Distributed Autonomous Organisation) models, or even some of the grant experiments taking place on Gitcoin. The idea of distributed groups of people who are not necessarily geographically connected to one another making commitments to one another in pursuit of a common goal, I think is a very beautiful idea. That interdependent approach, this idea of saying, what if we were to make a commitment over the course of a couple of years to try and accomplish something, completely flies in the face of what Monahan depicts in his article, the idea that technical systems are ultimately there to individuate us and to extract money from our loneliness.

RM: This seems also to connect back to what you were saying about the value of defining something, setting down a marker that can become a shared reference. If you're participating in a scene, though, don't those things happen ambiently anyway, if you have a history with a group of people, commitments emerge naturally, without having to be technically supported? I wonder how much this is really a question about time, about our time-perception and the amount of time commitment we feel able to give. In a sense we get the systems we deserve, given the way we inhabit time, and, inversely, people's sense of what is possible tends to shrink down to what is made available. So the question of possible worlds is also the question of experiencing and using time differently.

MD: I think that's true. Also, with regard to this liberal individualist mindset, the concept of feedback appears very often, and feedback in a sense is a kind of closed loop of time that just keeps repeating, it's a shortening of time over time: you're not setting forth with any particular long-term goal, you're just incrementally making adjustments to things in order to make them succeed at a very narrow task. Which is common currency in the realm of ad networks and so on, that shortening of time: people talk about this colloquially all the time: 'Can you believe that Fyre festival only happened in January, it feels like January was ten years ago in internet time.' But if you step outside of that and go for a

walk, then you think, What the fuck has really changed since January? Nothing really. Jay Springett talks about this in relation to climate: confronting the idea of the end of time requires a kind of long-term thinking that we are training ourselves out of. Again, this comes back to institutions, right? I'm not going to lionise dusty academic institutions that have been damagingly conservative to pretty much all of us at some point, but at least there is some kind of economic model for those that need to step outside of the marketplace of ideas and think on a longer timescale. How many people have that luxury? The only people who can actually enjoy the lives of bohemians any longer are the rich. Maybe they always were the rich, but the only people who can any longer render a simulation of counterculture in the highest fidelity are the rich. They can live in the cities, they can be punks during the day and not get a job, and they don't have to fear for their long-term future because they have inherited assets.

RM: We've talked about different possibilities within the industry, but how about music itself contributing to wider social change? Your live work with Holly Herndon increasingly seems to involve experimentation in the powers of the gig to effect social connection, collectivity, and participation. Are the two things connected?

MD: We try to make our performances reflect the ideals behind how we work. I'm sober about how much of a broader impact that makes, but we try to be consistent and committed for credibility's sake. Culture works in magical ways, as I'm sure you have experienced, so it is important to be consistent even when it doesn't immediately feel all that consequential. I've experienced multiple instances where a small argument we are having ends up in unexpected places. That is a feature of the culture industry; a reason to still be excited by it. It's imprecise to track their impact, but ideas do get through. They have to come from somewhere!

Amanda Beech

Art Beyond Identity: Constructive Identifications for Real Worlds

Identity vs Identification

Following David Bowie's death in January 2016, the airwaves were charged with recordings, songs, and interviews spanning his career. Driving in my car, I heard a snippet of an interview as I was pulling into a gas station. It was from the Ziggy era, some time before he recorded the farewell gig with the Spiders at the Hammersmith Odeon in July '73. Bowie was being asked about the genesis of the Ziggy character, and about what kind of impact the world that he'd produced had had on the music scene of the time. His response was memorable. He spoke about two options pop music presented to him. The first was to rework existing genres, hits, knowable rhythms, beats, and stock anthems—a kind of poststructuralist remixing of the known; the second was to make music that admitted that pop was producing its own death in an endless cycle of repetition—irony.

The limitations of the two options Bowie enumerated back in 1973 still resonate today, since artistic production in contemporary culture appears to be trapped in the same dilemma. Is this because this exclusive choice—between endless difference playing out in one and the same world, subject to the same conditions, and the end of the world, the exhaustion of those conditions and their undead playback—was an incorrect diagnosis to begin with? Are the alternatives of an inflationary vacuum and a cultural flatline really consistent and substantive, and are they really exclusive, the only options—or are they myths, ideological fictions that might be undone given the right argumentation? Or must we assume, like Bowie, that the vectors of infinite non-identicality vs. the identity of death are real constraints that govern our normative choices? For Bowie, these 'options' were real, and yet he sought to go beyond them. Even if

it reveals the potential pitfalls of such an assumption, maybe his attempt could offer a clue to moving beyond these exclusive options.

For Bowie, the way forward, it seemed, was to produce another space, another position, via a new construction in the form of the 'alien': Ziggy Stardust. But this fiction did not just present the figure of the alien as a kind of identity that would articulate the unknown in terms of known quantities—as if it was enough to say 'Ziggy is an alien'. Rather, and perhaps more poignantly, Ziggy's 'alien' quality involved another dynamic entirely, one that posed more profound questions about the location of the alien in thought and in the processes of production.

The Ziggy project showed how it was both necessary and possible to conceive of music from a different place. But this method of conceptualising another possible world itself had to come from *somewhere*, and indeed it did, as we can observe in Bowie's combining of Japanese costume, references to science fiction comics, the glam rock genre, etc.; the alien was constructed out of preexisting norms.[1] And yet at the same time, within this realm of appearance, Ziggy would hold to impossibility as a principle, resisting the mirroring of impossibility with the cliché of an alien identity as kitsch-pop, and thus preserving the alien as idea with and through the alien as form. This alienness-in-itself was something different, a kind of alien expression in Bowie's construction; not just the construction of Ziggy *itself* as a personality, but the expression of the mechanism of Ziggy's genesis *as construction*. This construction entailed an identification with the concept of the alien, with the real in itself as alien. Rather than identifying itself with or against something available to and in the image, Bowie's project entailed identifying itself via the unthinkable alien itself.

This introduces a key distinction between identity and identification. Where identity involves a reducibility between concept and image, collapsing the distinction between them, identification is the process of invoking the other in the name of equivalence, a principle of commonality. Identification, then,

1. This, of course, is the danger of any attempt to manifest what is alien; that which is yet to be seen and that which is thought yet remains unknown runs the risk of defaulting to kitsch and naive aesthetic modes of expression; the cliché of an alien identity as a cartoonish Marvin the Martian-style space traveller figure, where the unknown is depicted precisely by making use of a common shared language of 'otherness'. This is not alien, it is simply the identity of a known unknown; the labelling of material in the given as outside or different in terms relative to our field of value.

disrupts and produces identities/norms without formal identicality. The difference between identity and identification is significant in this construction in particular because Ziggy the alien did not solicit any sense of identicality with a preexisting conception of the 'alien' as form; neither was Bowie consumed by the character in a method-acting sense: there was no acting out of Ziggy beyond the stage, nor was there any Brechtian move to denounce Ziggy as a construction from the stage, i.e. to reveal that Ziggy was a *fake alien*. None of these debates on (in)equivalence were at stake within the construction of Ziggy, because the character's importance was not rooted in claiming an identicality with the alien. Instead, the construction of Ziggy invoked another 'way of seeing' that offered a glimpse of the possible via the eyes of the alien itself. Ziggy would become both author and subject of the eponymous concept album *The Rise and Fall...* as Bowie took on a fractured onstage identity, delivering songs in the guise of an alien telling stories about the life of Ziggy as a tragic superstar alien rocker. These fissures—who is narrating whom, who is author and who is subject—serve to glue together a more complex construction in which each part of the performative operation establishes identifications with the other. The construction is therefore initiated from the site of the plural. The possible becomes actualised and is set within a counterfactual cultural framework that requires us to take Bowie's strategy seriously as an idea.

This view of the alien allows us to pose a structural and methodological question about how new approaches to production and meaning take place within and against the normative proliferation of substitutes for the real that is intrinsic to capital; to ask how the alien as process and figure presents the challenge of an approach that expands our existing world, engaging revolutionary possibilities for new and other worlds in which we can also live.

The Limits Of Non-Identicality

The distinction outlined above, between identity production and identification as process of an immanent real, articulates abiding tensions between theistic and nonmetaphysical approaches to image production. The theistic view of the image, on the one hand, overdetermines the identity of all images, which are all seen as being endowed with an aleatory objective reality (in a Romantic sense, all representations manifest the alien, owing to their ineffable abstract

qualities—they lie beyond ordinary language and the knowable). On the other hand, poststructuralist approaches to the image prefer to claim that images are the contextual expression of a culture—human-made entities with no telos, constituted in a flat ontology: there is no vector to a real outside, nothing for language to 'point to'.

Adorno's politics of negative dialectics told the story of a totalising world of trivial difference in which the tragic had exceeded its Hegelian vocation as a struggle for truth.[2] His excoriating critique of capital however, turned out to override the dialectical operations that he had hoped would hold it in check. Subsequently, in poststructuralist critique and capitalism, the search to express a complex account of striving for and failing to achieve Truth in the face of capitalism's insidious control of minds and bodies simply became 'style'. This was poststructuralism's only possible response to the problem of identity and metaphysics, since nothing is outside of language, and the images we produce from language, the pictures and representations that we make, cannot be governed by or correlated with anything that lies beyond them. The legacy of negative dialectics, received in this way, predetermined all language to be coextensive with what is possible within the world that already exists, i.e. within the constraints of capitalist economies.

In this culturalised form, language—a language that takes the real as an impossibility—is understood at once as both *necessary* and *unreal*. This contradiction is underscored when a theory of non-knowledge—of alienation—is compelled to make a cut between a language that manifests the knowledge of the inaccessibility of the real, and a theory that thinks the real as impossibility; for how can it possibly hold open this fissure (between theory and practice, concept and image, explanation and identity) when the starting point of this

2. T. Adorno, 'The Culture Industry, Enlightenment as Mass Deception' in *The Culture Industry: Selected Essays on Mass Culture* (London and New York: Routledge Classics, 2001).'The Culture Industry' diagnosed the problem of the overdetermination of difference by a monocultural identity via the modernising and rationalising forces of technocapital. Norms of individuality become one uniform expression, in a unitary world that knows no other, and that replaces a genuine search for 'truth' with local and private expressions of freedom purchased by dancing the jitterbug or identifying with characters in the latest radio soap operas. Here Adorno writes that good or worthy art 'strives for identity' and that the 'great work of art', by 'exposing itself to this failure', has 'negated itself' whereas 'the inferior work of art has relied on its similarity to others, the surrogate of identity. The culture industry has finally posited this imitation as absolute' (103).

theory is precisely that language is all there is? And so we find ourselves in a final contradiction: no language can be adequate to this theory of inequivalence, and yet this inequivalence demands to be expressed in language.

If everything is equally unreal in the space of 'real fictions' (where all language is fictional, but it is all that we have), then there can be no serious epistemological work capable of producing theorisations or metacritiques—which indeed is precisely what poststructuralism desired. The problem, though, is that this commitment to non-identicality and the concomitant rejection of all transcendental or metacritical possibilities does not allow us to take seriously the kind of language that 'says something about something'—and yet this language still stubbornly exists. The view that *all theory is practice* ends up soliciting an impossible choice between the censorship of epistemology and the fantasy that we are always already in the flatland zone of equivalence despite the fact that, quite evidently, some expressions are distinct from others.

More seriously, to labour under the project of difference in the name of non-identicality is to prohibit the establishment of the necessary agreements, identifications, and social dynamics that are required to organise the political, and the ways in which expressive and explanatory languages produce and employ structures and rules. Without these, we are deprived of any tools with which we might legitimate certain forms of expression over others, while domination carries on regardless, and we try to sustain the contradiction that difference is simultaneously essential to all life *and* is a goal for the good life. This refusal of the real beyond its immanent appearance heralds the final end point of any useful dialectical operation that the structure of the tragic may once have harboured, as in Adorno. Representation, essentially constituted by the act of identifying beyond itself, is caught in a kind of narcissistic trap, unable to operate as a vector to any real-outside. A theory that refuses to navigate the structure of identity and identification therefore blocks any egalitarian hopes for an equality to come: it sees equality as already immanent, and therefore is unable to advance any good reason to labour for it.

The limits of non-identicality (in the form of this brand of antirealism) become visible, furthermore, when we regard the political and ideological conditions of Ziggy's expression as the alien 'other' as an aesthetics of non-identity as identity-in-difference. Looking at Ziggy as an identity in the marketplace of

culture, we see how this character formulated an alternative to the standard pop-culture expressions of gender and sexual identity available at the time, and how ultimately it foregrounded a basic kind of liberalism. This plays out in the way in which the concept of the alien as commodity aesthetic informs a symbolic and particular alien identity generically throughout Bowie's career—from the character of Ziggy Stardust to Aladdin Sane, The Thin White Duke, and 'The Man who Fell to Earth'.[3] Bowie's continual transformations essentially reinforce the figure of the 'chameleon' as the normative expression of difference, in a weak semantics of identity formation that is fully congruent with a libertarian identity politics. Ultimately, the gesture toward the outside ends up serving the logic of neoliberalism, in the form of a capitalist social realism.

It might be said that Ziggy's character, through its androgyny, symbolised and created actual possibilities for a more egalitarian future dispossessed of standard or fixed identities. And yet this future would not be for all; it would be *for the alienated*, for those liberal-minded enough to already identify with the generic non-identity of difference. An image of precarity does not lead to a sea change in the structure of society. The way in which such precarious identities contest the status quo sits quite comfortably with the logic of capitalist identity politics. The libertarian principles of an aesthetics of difference tolerate and enjoy identity, whether one takes on more normative 'stable' or heterogeneous 'peripheral' characteristics. In that sense, this problem of identity is not eliminated but doubled, for capital has a predilection for the question 'Who?'; namely, *who* is the alien, and *who* is identifying with it. Any kind of identifications that reaches beyond the given ends up subordinated to anthropocentric figures; alien encounters can always be reduced to the formats of the known; there is always *someone* behind the mask. Ironically, the quest to discover and overstep the limits of the field of identity politics ends up calling upon the production and discovery of new identities, eventually to find itself caught up in the logic of rights.

Moreover, today, in the context of Trump's US presidency, this identification with the outsider is increasingly found not so much on the socialist Left as among the factions of the Alt-Right. The concept of the alien found in the nuances of this kind of identity politics is in fact theoretically limited, politically prohibitive, and difficult to escape, because it makes claims for two different

3. *The Man Who Fell to Earth*, dir. Nicolas Roeg, 1976.

worlds irreducible to one another: the world that validates one's inner expression as an essential identity of difference, and another world 'out there' that is taken to be rigid, stable, and unaccommodating to such difference. This distinction, set within a misconception of the given and the real, has two primary effects: an expansion of the borders of the given, and an institutionalisation of new identity expressions in particular forms of force.[4]

In these various ways, the dilemmas addressed by Bowie back in 1973 are emblematic of a core problem rooted in poststructuralist theory, and which persists to this day in neoliberal cultures of the military-industrial complex. On the face of it, it seems quite appropriate to adopt the postmodern (antirealist) perspective that images have no rights to the real, because the alternative would be to propagate a world of hubristic nature-mythologies wherein dominant power monopolizes the real in the kinds of ideological formations discussed by Louis Althusser.[5] And also because identification is a process of construction via *non-identicality* (where the idea of seeing and being with others, and seeing ourselves as other, operates without any regulative ideal, it is irreducible to *any identity*). And yet this process remains essential to community.[6] This tension of identification as a both negative and constructive force, the question of the aleatory in the mechanisms of identification, remains key, since if the real is immanent to the process of becoming *self and community*, this leaves open the problem of what defines and orders the constructions that are born in this process. To understand the real as immanent means to leave this open, because there is no prospect of an analytics of, nor an identity with, *that which is not in-itself*: the question of identity in the last instance.

Culture today persists in the Romantic identification of artistic constructions in language with extralinguistic external forces such as the real, alienation, chance,

4. As we have noted, the production of new norms in the scene of the political might be useful for a progressive society but this production of identities serves to harden particular existent norms that are based on various myths of subjective exceptionalism.

5. L. Althusser, 'Ideology and ideological State Apparatuses' (1971), in *On the Reproduction of Capitalism, Ideology and ideological State Apparatuses*, tr. G.M. Goshgarian, (London: Verso, 2014) 232–73.

6. I draw this from Jacques Lacan's theory of group psychology where the subjective transfers to the inter-subjective and the trans-subjective towards inter-objective structurings or architectures of the social. See, J. Lacan, *The Four Fundamental Concepts of Psycho-Analysis*. tr. A. Sheridan. (New York: Norton), 1977, 256.

contingency, fate, history, and the future. This should be enough to convince us that there is work still to be done in navigating this relationship between the image that expresses an epistemology and the conceptual standards that subtend the way we approach such picturing. Artworks that claim to navigate the real arrive at their representations via different beliefs, discourses and perspectives; Are some more legitimate than others?

Bowie's approach raises the question of what the representational and propositional capacities of ordinary and abstract artistic languages are, and how they traverse the dynamics of ideality and invention, identification, and construction. Key here is the question of how the alien or, in other words, the conception of an outside, affects the very structure of the political; what should be attended to is how both identification and constructive processes involve such externality. When the alien as identity establishes difference via the oppressive force of libertarian expressions, and the disputation of identifications with the real trivialises claims to difference, to what extent does the alien—as a conception of the negative—play a role in how we forecast a future beyond the conditions of capital and its critiques?[7]

The Role Of The Aleatory

Quentin Meillassoux's speculative materialism has theorised the force of the aleatory in a radical way that exceeds and critiques the poststructuralist tradition of theorising the political outlined above. In Meillassoux landscape of absolute finitude, contingency functions as a guarantor for the eventual undoing of all stable and dominant forms of power, one way or another. Such a critique of antirealist or, more specifically for Meillassoux, 'anti-absolutist'[8] 'philosophies of access'[9] implicitly highlights a suspicion of the political claims funded by

7. Characterising the production of the new and the different either as a synchronic Platonic process (as an interpretative practice from an ideal concept), or as a Hegelian diachronic process of modifications and refutations (which imbue practices with the spirit of a metaphysics), present us with two views of change; that is how processes interface with and therefore are capable of changing the rules of the game that they play within. This is to ask how the ideal, or the spirit, can be understood as regulative, temporal, and pragmatic tools that play a role in the production of the type of changes that are capable of revolutionizing these abstractions themselves.

8. Q. Meillassoux, 'Time Without Becoming', talk presented on 8 May 2008, Middlesex University, UK, <https://speculativeheresy.files.wordpress.com/2008/07/3729-time_without_becoming.pdf>, 7.

9. Ibid., 2.

paradigms of openness. Precisely because poststructuralist correlationism *does not* present us with the predictive mechanisms or powers to determine alternative futures, it maintains the idealism of *what is not*, and it ultimately has only a weak idea of what might be 'otherwise'. This is because it undermines the possibility for language to mean anything in particular; 'it doesn't say dogmatically that there is no in itself, but only that we can't say anything about it'.[10] Inversely, by absolutising contingency and rescuing reality as the 'in itself' that can be thought by the subject without being correlated with the subject, Meillassoux argues that a radical disorder subtends life, one so radical that it is as capable of giving rise to long durations of stability as it is of producing extreme instability: things could *always be otherwise*, but they are equally likely to remain the same at the level of our everyday experience. By pushing poststructuralism to its (il)logical conclusion and asserting the necessity of noncontradiction, Meillassoux's 'radical unreason' eliminates the anxieties of fatalism that poststructuralism had smuggled in,[11] for according to him there is *nothing to cause* contingency: 'Everything can be conceived as contingent, depending on human tropism: everything except contingency itself.'[12] In other words, humans may or may conceive of a universal idea of contingency, but this does not change the idea that contingency is a fact and this fact is eternal, unlimited. This absolutisation of contingency returns us to the stark question of what thought can do at the level of conceptualising the mechanisms that produce worlds, and whether Meillassoux's understanding of objective reality leads to the production of worlds that are progressive. How the theory of absolute contingency enter into the political with direction or purpose is therefore at stake, so we might ask what traction this explanatory language, which claims knowledge of but remains non-identical to the real, might have upon the political.

Meillassoux's argument for reason in and of itself, as an explanatory tool that can think beyond identity (since 'the limits of my [rational] imagination are not the index of my immortality')[13] decimates poststructuralism's perspective-oriented correlationism. The absolutising of contingency productively divorces reason

10. Ibid.
11. This is the fatalism that surrenders human decision wholly to other larger forces reinscribing a theism as immanent to the world as language.
12. Ibid. 9.
13. Ibid. 7.

from its expression in the given, moving away from the ironic and correlative inclinations of poststructural theories of (in)access. But this claim to reason via a radical unreason also poses challenges for an eliminativist project according to which all representations produced in the world would be identical with the real vis-à-vis scientific rational explanation—for Meillassoux's project is not one of identity.

This fissure between a language that claims to be an identity of the real and a language of explanation risks a resurgence of semantic nihilism following poststructuralism's absolutisation of finitude, and this raises two further issues: Firstly, that any commitment to reason must understand how scientific realism is rendered in ordinary language; and secondly, that a project that retreats from analysing the sociopolitical dynamics of scientific reason risks foreclosing community *from reason*, since it risks maintaining reason only as a local or even psycho-philosophical private project belonging only to those that master it. A fissure between a language of explanation and a language of identity therefore means that one will struggle to account for the shared or common language that both occupy—the language that we hear in our heads and that we think with unconsciously. At the same time, a collapse between languages of explanation and languages of identity eliminates the possibility of claiming a rational identity with the real, because rational explanatory work that would adjudicate such claims shares the characteristics of myth or fiction. We therefore need to address the two languages implicated here—the language of thought that can think objective reality because it is not mystical but disclosed through a logical rational process, and the dominance of normative discourses of inaccess, honed in the context of a Baudrillardian hyperreal. These themes of inaccess have proliferated in the environments of poststructuralism, globalisation, multiculturalism, and late capitalism, and they have a dangerous tendency to define our world *and any critique of it* as given or natural, thereby precluding any real possibility of other worlds, other spaces, or the ability to realise the potential of engineering the imaginary.

Aleatory Empiricism

The idea that any language might be fully adequate to an objective reality intimates a horrific promise of meaning become banal: on the one hand, such an

equivalence could be seen as spelling the end of knowledge, as if everything that could be accomplished in its name is now complete; on the other hand, it might suggest that the maturity of a project of knowledge consists in its claiming to know itself through solipsistic self-invention. In the former case, this confrontation with the real pivots around the Judaeo-Christian theology of a reverse-terraforming of the material world by means of the principle 'On Earth as it is in Heaven'—the prayer for a humanity to come, but one which can only be realised beyond and after the phenomenal world. The real is seen as impossible and yet immanent to all experience—the surreptitious reintroduction of a theological paradigm, inflected through the absolutisation of language.

This spectre of an unconscious dogmatism haunting our poststructuralist 'inside-out' version of the real makes it significant to examine how materialist theories that commit to an empiricism inspired by the social and natural sciences resuscitate a similar dynamic, but in this case in an 'outside-in' form. The empiricist argument holds that there are proven and mathematisable ways to understand our primary observation of the properties of objects (thus sustaining the positivistic relation to a mind-independent reality). Unlike the modes of invention and subjectivity privileged in poststructuralist accounts of the new and the different, however, this inductivist approach that draws larger claims from specific observations commits to a methodology of objective and *a posteriori* discovery: the empiricist says something about the world, discovers truth in the world as a temporal complex field, and thus claims that the language that describes the world is appropriate to the facts it describes. Across these categories of invention, discovery and proof, we see how both empirical and antirealist (poststructuralist) materialisms struggle to manage the elision and conflation that identifications produce within these operations of truth, and how the operations of discovery and invention appear structurally within both paradigms.[14]

14. The predicament can be witnessed in Marx's historical materialism, and particularly in ideology critique, which argued that the unseen forces of social history (or even, as Lyotard would later argue, 'immaterial' processes, systems, and affects) condition our decisions as constitutive materialities, histories, and trajectories. This work brings the mysterious into the world of explanations, reasons, and causes, which is useful for the understanding of how the world is and also for thinking how it ought to be. But it is equally important not to overdetermine the explanations derived from formal and empirical accounts to a fully-fledged knowledge of the real. Althusser's critique of Marx's historical materialism in 'Underground Spirit of the Materialism of the Encounter' (*Philosophy of the Encounter, Later Writings (1978-87)* [London: Verso 2006], 163–207) clearly condemns Marx's social science for

Robert Brandom's analytical pragmatism usefully foregrounds the role of meaning in the use of various vocabularies, spanning, among others, scientific, normative, deontic, and modal languages. In particular, he points out the error involved in making a core distinction between analytical empiricism and modal vocabularies.[15] Modal vocabularies form extensions to 'possible worlds' and are meta-linguistic, since they extend from logic but surpass the bounds of both empiricism and logical explanation. The objectives of analytical empiricism, on the contrary, do not extend beyond explanatory systems, and they reject modal descriptions so as to claim a comprehensive identification of the facts.[16] Brandom's view serves to complicate the claims made in the name of analytical empiricism, allowing intrinsic modal capacities to unbind empirical science from its access to fact, but at the same time enabling science to make leaps forward when facts are not available. In this way, the twofold operation of modality tells us that there are no absolute identity claims to be made by science; that this is a fact. For Brandom, modal claims secure veracity because they are catalysed and supported by logic and reason, and purchase their creativity because there is no such thing as an *eventual symmetry* between ordinary language and science. Such symmetry is prohibited because an empirical scientific language and an 'interested' expressive language are, on the one hand, irreducible to one another and, on the other hand, part of the same genus. Modal vocabularies thus offer specific complexities owing to their spatiotemporal dislocation from proofs, both in the empirical domain and in their general presentation of irreducibility to forms of logical explanation.

manufacturing the problem of the working class as inevitable. This is as much as to say that the role of language in the explanations we need in order to communicate these maps of 'the way things are and have been' consists of this thinking the real as opposed to residing in history.

15. R. Brandom, 'Modality, Normativity and Intentionality', *Philosophy and Phenomenological Research* 63:3 (2001).

16. According to Brandom, empirical accounts that would gain traction on a future by positing 'what there is' and 'how it came to be', whilst necessary to the advancement of knowledge, tend to introduce problems when it comes to how proof-based languages providing such empirical accountings operate in a discursive community because for Brandom, empirical accounts risk making the explananda the explanans (since the phenomena to be explained is conflated with the language that does the explaining), risking a fatal ontological regression. Advancing empiricism and logic as protected (rehabilitated modal or even non-modal) categories therefore risks inventing non-dispositional referents, thus getting caught in the contradictory behaviour of using modal vocabularies to make non-modal claims.

This description of the modal properties of empirical claims is useful when considering 'new materialist' practices in the realm of contemporary art. The research and artworks of the group Forensic Architecture[17] present one example among others of the limits of empirical and materialist critique when we consider their research as Art. In various presentations of the group's work, materials manifest the operations of knowledge at work in a form of research stylistics, an aesthetics of reconstructive processes, discovery, and investigation of the truth of various global present-day and historical crimes against humanity, from Auschwitz to Iraq. These world-defining 'criminal' events that have presented the extremities of human violence, the spectacular oppression and victimization of peoples by other peoples, are mounted in detective-style frameworks. This scientific aesthetic undercuts the visceral nature of the violence that it circles with its own 'objective' and 'rational' process. The work allows materials synony-mous with everyday life, such as chairs, tables, walls—scenography—as well as string, tape, numbers—the paraphernalia of a *CSI* form of detective work—to act as operative and functional research tools. In this way, the work seeks to extend the knowledge situated by the art work to actual evidence in cases of political justice. Abstract phenomenal materials are elevated into equality with normative languages so as to become part of a truth-claiming system. In historical traditions of artistic critique, whether modern or postmodern, the expectation is that art should produce new forms of knowledge that cannot be correlated with empirical truth. Modernity, for example, brings with it the pri-macy of an investigation of the inner world of the human psyche as irreducible to the phenomenal world, while postmodernism presents the production of dif-ference upon an antifoundationalist (non-metaphysical) terrain where language is world and therefore there is no external concept of world for it to be adequate to. The work of Forensic Architecture might lead us to believe that empiricism produces a fresh, revolutionary paradigm for art, a new form of utilitarianism, practices of the image that acknowledge their functionality in the world as opposed to the drama of dysfunctional representation. However, when we look closely at the group's assemblage of knowledge-as-artwork, we see how these functional materials struggle to move past the stage of reconstruction toward

17. <https://forensic-architecture.org/about/agency>.

the construction of alternative forms of knowledge. This could also be seen as refreshing, since it acts as a counterpoint to the banality of art's claim to open interpretation: here there seems to be a unilateral force that drives forward to secure an empirical forensic truth. But this would be to forget that, while this production thrives on the abstract qualities of the materials that produce the event (otherwise why would it be situated as art?), it serves to delimit these abstractions in the service of a unifying conception of truth that is ultimately uninterested in how images constitute a discursive space. As such, there is a clear disconnect between materials that can play a part in truth processes and do not require any correlation between materiality and the identity of truth, and materials that reconstruct a truth a priori. A project of empirical truth as social justice is not a project of truth as justice per se.

To put this another way, Forensic Architecture's reconstructions act as theatrical assemblages that enclose the real; constructions of events that become artefacts for a truth that is already known but undemonstrated. Therefore the project of reconstruction goes to work with an already clear idea of the real as an experience of loss, since this empiricism can only gather up the accoutrements of the truth, showing us things and processes that appear 'truth-like' but which the work cannot and does not want to say anything about. The materials of truth that constitute the work and the truth gained in these processes are never called into question within the work itself. This approach to the image, at the nexus of aesthetics and politics, forms a morally charged project pursued in the name of global justice, one that asks us to observe how durational and sense-based materials constitute events and truths that cannot be explained by formal languages and evidence as 'present to hand'. In so doing, empirical materials unintentionally disclose a poetics, and we can see how, in this work, in Brandom's terms, non-modal claims are situated in modal languages that compromise non-modal intentions. Whether as a product of naivety or refusal, these projects (when considered as art) are anchored in a form of liberal pornographics; maximalising an aesthetics of scientific fact supported by a truth that hinges on the spectacle of the non-presentation of suffering. Here, the suffering of others is not given an identity as image—we do not *see suffering*, but instead we see the elimination of an aesthetics of suffering whose absence underscores its presence even more. Therefore, underneath and intrinsic to the

work, we are asked to empathise, imagine, and feel—emotions without ground: the other side of the forensic interrogation of matter.

Ironically, the project ultimately seems to propose that an artwork can produce knowledge as an expression of non-normative facticity. Via this evidentiary process of a deep forensics that works inside materials as events, truth is achieved by, but is ultimately irreducible to, the materials-as-image used to lay claim to this truth. Brandom's argument on the limits of analytical empiricism is therefore instructive in this case: in order to make good on its claim to justice via the complex testimonies of abstract materials, this practice, as art, must deny the allegorical content of the representational values of the materials that are used and the images that are produced. All of which serves to highlight the fact that empiricism, when put to use in and for artistic practice, acts as a naive renewal of anti-representationalist phenomenological traditions, which enrol materialist practices into aiding and abetting the concept of knowledge-as-mystery, because what is known is known a priori. In this sense, empiricism is not a suitable response to the problem that we cannot make distinctions between the production of a relation that supports itself (in the sense that different elements are made symmetrical with each other, as in the case of $x=y$); what we call 'identity,' and explanations that say something about identity. To assume that we can swap out the question of an identity of the real with an identity with fact is to leave the reasoning of a politics and structure of identification unaddressed.

Identity And Scientific Method

Wilfred Sellars's scientific naturalism is couched in the *scientia mensura* principle, which establishes science as the measure of all things—but this is always a science to come. Dionysis Christias[18] takes up Brandom's claim that, because scientific languages are also modal, the very idea of such a scientific naturalism must involve a question of identity. In other words, the Sellarsian proposition that there is no telos of identicality between the manifest image (the languages that present themselves to us as 'god-given' or 'natural' in the everyday sense) and the scientific image (languages that explicate and form a picture of the way

things are) is challenged by Brandom's use of the Kant-Sellars thesis on modality which proposes that even descriptive empirical accounts of objective reality, for example those of the natural sciences, are modally laden, and furthermore that it is modality that enables the project of the scientific image. Therefore, the idea 'that manifest-image objects cannot be identical to scientific-image objects violates the scientia mensura principle'.[19] Christias follows Brandom in remarking upon this internal tension in Sellars's work, wherein the non-identicality of the scientific and manifest images serves to undermine the *necessary but insufficient* theme of identicality that is vital to the project of an eventual science whilst, the fact that manifest images have modal properties suggests their potential, eventual identicality with objects specifiable in the language of natural science, and therefore with the project of a total science to come in accordance with the *scientia mensura* principle.[20] The hope for science that would reach an intelligibility of the real is thus located in either the transformation or the elimination of the manifest image.

The *scientia mensura* principle read through this lens of modality and identity speaks to the principle of progress and difference as simultaneous operations: on the one hand, difference describes the transformation of the given *in any direction*, while on the other hand, identity establishes a telos. The idea of an identity-to-come suggests that modal vocabularies of the manifest image are to conduct a self-purging operation or a purifying mechanics, that of reducing the phenomenal world to science, since all manifest languages, if they are to survive, must ultimately converge with science. But this identity view risks trivialising the operations of science, since if the scientific image to come is constituted through procedures that operate via manifest images, then the tools by which science can be constituted are always impoverished, i.e. the manifest is always striving but also always misrepresenting, and this risks bringing about an ironic relation with the materials we have to hand. If the language we use that identifies with our ideals is the same language that articulates our ideals, then can we trust the tools we have, and the ideal we labour under? The expansionist view that takes scientific claims to be manifest images (manifest owing to their claim of adequacy to the real) therefore risks pathologising science,

19. Ibid., 1.
20. Ibid., 5.

reducing it to the status of folkloric ideology, making the ideal of knowledge a mystical token. Without the discrepancy between explanation and identity, the concept of an ideal science-to-come quickly becomes a banal postulation, in so far as, if the scientific image were achieved, we would not recognise it because there would be no regulative ideals to establish verifiable differences between rational and irrational claims. If no measure or principle exists by which to gauge progress, then the project quickly becomes a habit of blindly conserving already existing norms.

How do we think of progress without eliminativism? According to Christias, the way to resolve this problem of identity whilst maintaining the *scientia mensura* principle is to understand that '[t]he explanatory relation [...] is not one of identity'[21] but one wherein the relation between the manifest and the scientific image must be constantly adjusted and redescribed as an operation of reason *within time*. This commitment to explanatory processes means that the structure of thought itself requires redescription. The descriptors cannot describe themselves, and therefore there is a constant expansion of yet more descriptions and explanations.[22] Through this distinction between identity and explanation, the space of the manifest is maintained against the scientific eliminativism promoted by the identicality thesis.

Christias argues that Sellars resolves this problem of the political, natural, and pragmatic necessity of identicality in so far as Sellars demonstrates how one can maintain the principle of science as an objective process, by viewing the manifest image in a revisionary 'identity-through-difference' that requires a historical account of (re)descriptive terms over time. This process ensures that the normative conditions of the manifest image are incommensurable with the explanatory operations of the scientific image, since manifest images are not explanatory in non-normative scientific terms. Scientific images may be the successors of manifest images, yet this mode of description does not claim identicality between the two, but rather an intimacy of shared commitments or materials. Manifest images, then, are normative to the extent that they are

21. Ibid., .10.

22. Brandom also argues contra Quine's formal semantics that descriptions of our reality from the present to hand or through non-modal logics do not escape unverifiable modal factors that are implicated within the exercising of descriptors and explanations of elements, behaviours and other observables.

described in non-normative terms: the manifest image cannot describe itself in non-normative terms. This approach to non-identicality *in time* preserves the ambition of a science to come and that of science as principle, but without impoverishing the idea that the manifest image has a scientific character, since the manifest image is *not unscientific*.

Christias argues for a recognition that these two images—one of how things appear and one of how things really are, one perceptible and one imperceptible—*do not share* a common referent. For Sellars, on the contrary, *even when* we assume that a scientific image is preceded by a manifest image,[23] the manifest is ultimately constituted by a scientific reality, and the work of the scientific image consists in revealing this reality that manifest images only approximate. Christias's distinction, then, maintains the non-identicality in Sellars's synoptic vision of absolute process that he would later characterise as the project of science.[24]

The non-identical relation between scientific and manifest images is under-scored in their distinctive modal properties, and also in the fact that the scientific image's explanatory and descriptive work operates upon and alters the condition of the terms of the manifest image through the act of re-description, but, as Brandom puts it, 'without pretending to reduce the content of (explicitly modal predicates) to the former (descriptive predicates), or explain the one in terms of the other'.[25] It is the scientific explanation of the manifest image that transforms the world of the manifest in this oblique relation.

This view serves to eliminate the suspicion that the scientific image may be merely another manifest image and also permanently suspends the event of identicality between the scientific and the manifest images that would render science obsolete once it reaches its goal. It also shows that the world of appearances must be taken seriously in the sense that we can understand changes in how we register phenomenal appearance as being affected by the work of the scientific image. Saying that explanations have identities then, is not to say that they share the same referent. Nor is this to say that using the same language as a tool for communication does not objectivise that language 'in general' as anything like a referent in itself.

23. Ibid., 13.

24. W. Sellars, "Foundations for a Metaphysics of Pure Process" The Carus Lecture, *The Monist* 64 (1):3-90 (1981)

25. Brandom, 'Modality, Normativity, Intentionality', 23.

While such perspectives offer a way of thinking through this problem of modality and identity in the last instance, art continues to struggle with its epistemic ambitions. The function of critical-objective explanations, principally in art practices associated with Conceptualism, took up the task of deductive explanatory processes, as opposed to staking art's claim as a correlate to the real or by following the realism of empiricism (of knowing objects as they appear to us, and leaving those that do not outside). Here in Conceptual Art, process-based works would 'say something about something'. But this method based in an art of non-representational commitments to produce analytical propositions struggled to exceed capitalist commodity aesthetics, as well as to overcome the problem of metaphysics and identification associated with capitalist dominance. This problem is confirmed when Conceptual Art's Brechtian approach of narrating itself as world unto itself *to itself*, by referencing its irreducibility to external rationalisations (since art would not give up the legacy of Duchampian negativity), as well as referencing its genealogy, served ultimately to eliminate the idea that art could extend to new possibilities. Instead, Conceptual Art's circular operations and regressive tautologies persisted in producing ideological identity formations, despite their claims to be exempt from such dominating forces. Art persists in this today, but now Brechtian techniques no longer imagine that exposing the construction of the self might translate back into informed political action, for the proposition that 'everything is constructed' acts as an alibi for maintaining the status quo, and is taken so easily as a banal platitude: everything is constructed, and that's just the way things are. Today, conceptual techniques assume that this circularity is the only possible outcome of explanatory practices. In these cases, the explanatory process becomes identity in itself, and Conceptualism largely claims the real as the intrinsic character of the artwork, in the name of a materialism that remains ignorant of its own latent, naive idealism. The underlying claims to art's affiliation with and access to the real is therefore underlined when the world we inhabit is taken as an infinite field of modal, situated vocabularies. Seeing the real in this way tells us more about the normative commitments claimed in these languages, and how these commitments turn out to be trivial, than about the condition of a reality we cannot access.[26] As such, if art universalises a modal (normative) vocabulary,

26. For an argument against world picturing and for the indistinction of the manifest and scientific

then it loses sight of the commitments that can extend beyond this vocabulary; it refuses to be a self-correcting enterprise.

If we can understand reason as the operation that indirectly dismantles the conflation of world with word, or reality with image, via the constructions of new propositions, we prevent the kind of dogmatisms described above, of the type that Althusser termed the 'Spontaneous Philosophy of the Scientists'.[27] But whereas for Althusser the response should be that philosophy works as materialist operation that draws a line of demarcation between correct and incorrect propositions, effectively separating idealist, scientific, and materialist methodologies in the name of a practice without object, for Christias, an explanatory language is required, in the name of reason, to bridge and divide the manifest and scientific images, implicitly guaranteeing that the identicality between manifest and scientific image is both a real impossibility and a necessary concept.

Art and Other Worlds

This essay began by re-posing the question that Bowie faced in the early 1970s, that of an impossible choice between the death of language and the language of death. For Bowie, conceptualising the alien was a way out, or at least a way forward. But this path also invited the entrapment of identity politics that inscribed the concept of absolute finitude as an aesthetics of failure, kitsch, horror and violence; a language of death that reflected the limits of human perception as this form of self-consciousness. This problem is captured in the relationship between negative dialectics and poststructuralism, movements that confirmed the elimination of difference as 'real difference' in their shared diagnosis of capital as the only world that is possible.

image, see B.C. van Fraassen, 'The Manifest Image and the Scientific Image', in D. Aerts (ed.), Einstein Meets Magritte: The White Book, An Interdisciplinary Reflection (Dordrecht: Kluwer, 1999), 29–52.

27. In Lecture I of this series Althusser discusses the distinction that must be made between science and ideology and scientific ideology and science. In particular referring to the human sciences, he castigates them for taking idealist philosophies as their alibi, exploiting such philosophy to produce truth claims without real science or without real philosophical intervention. Such philosophies become 'an ideological substitute for the theoretical base they lack'. L. Althusser, *Philosophy and The Spontaneous Philosophy of the Scientists and Other Essay* (London: Verso, 1974), 61. Significantly for Althusser, culture is destined to be 'a culture that cultivates the ideology of a given apparatus in the name of the ruling class. It is not the "real ideology" of the masses' (63) and is incapable of affecting power from the bottom up. It is 'ideology training' for the masses.

Critiques of the postmodern condition on the part of speculative materialism, Althusser's rejection of idealism in the name of a vigilant philosophical stance, and empirical materialisms all claim specific relations to reason and to the aleatory forces that inhabit our lives. The different trajectories and logics in these responses prompt us to consider whether art is capable of articulating some form of knowing and knowledge production that does not undermine itself, one which can think beyond itself and the conditions of dominant ideologies, as well as past myths and exercises in wish fulfilment and the fantasy of becoming scientific—a form of knowing that might lead toward the construction of possible worlds.

Through exploring these various materialisms, we also asked how art might arrest the real or claim 'non-fictional' validity as a form of truth process. Our conclusion here is that art's claims to adopt or participate in scientific practices have undermined *both empiricism and art*, since the artwork appropriately exposes the modal qualities of empirical work, often despite itself, and renders the representational capacities of such work redundant. Despite the failure of these efforts, though, we may remain sympathetic to their desire to restore art to the political through this desire to eliminate the relationship between art and the 'anything whatsoever', and equally sympathetic to the ways in which such practices have complicated traditional forms of exceptionalism, in so far as art is traditionally seen to be 'always already different', non-instrumental, and irreducible to reason. In the normative structures of materialist practices we see artworks distinguish themselves against images that mirror our lived reality, often refusing the distance of didactic or pedagogical commentary, and a reclamation of art against those practices that have established private island theatres, invented worlds in which to act out the way things are hoped to be. However, materialisms also run up against their own internal principles, which, as we have shown, either overdetermine explanations to identity claims (antirealist epistemics) or assume that, because languages are 'matter', they are free of epistemological concerns altogether (a traditionalist rejection of autonomy manifest in the false sublation of art into life). In the case of empiricism in particular, while it is admirable to propose that images are capable of proposing new possibilities that go beyond the weak hypothetical realm of probability, proposing that art has a special relationship to the non-modal is a self-limiting approach. Artwork appropriately

exposes the modal qualities of empirical work, often despite itself, and renders the representational capacities of such work redundant. It is therefore incorrect to propose that art or philosophy does the work of science, but equally incorrect to dismiss the idea that they share common questions and problems. This should indicate how both art, science, and philosophy need to establish a comprehensive view of the representational, modal properties of the languages that they use.

It is possible instead to think about the construction site for possible worlds from an anti-foundationalist position, of a kind that would offer no empirical security for knowledge. But as we have seen, for a serious epistemology to be possible, one that is able to recondition the grounds of the given, requires the pragmatic distinction between the manifest and the scientific image—which requires us to consider the role of identity in expressive and explanatory languages. This begs the question of whether art should be involved in any epistemic work at all, since, as we have seen, the theories that tend to mobilise the production of art have so far struggled, and largely failed, to produce either explanatory or expressive formats of knowledge that extends beyond narcissism. To see such a compliant against art's epistemological potential through, would be to support an erroneous conflation of meta-critique with immanent critique and an incorrect dismissal and ignorance of the role theory plays in the construction of art. In response, we do not make an over hasty disposal of critique in general and instead we argue that art has incorrectly hinged a theory of its agency on definitions of knowledge derived from particular philosophies that parse the image, language and an objective science in ways that consistently trivialize art and destroy the ideals that are necessary for building.

We know that art is not equivalent to science or to history, in terms of the way in which those disciplines produce truths and facts. Yet art, like philosophy, can see and think in two places at once.[28] Philosophy and art share the capacity to stake out this double vision, seeing across the conditions of the manifest and the scientific, identity and explanation, to present a proposition for truth and for the construction of other worlds. Crucially, though, in order to participate in this process art must observe the principle that reason has *no identity as such.*

28. I refer here to the example of Wittgenstein's Duck-Rabbit (*Philosophical Investigations*, 1953) an image that can only be perceived as being one thing or another in sequential time, but can be thought as being both, as being possibly either. Art has the capacity to produce this kind of thinking in abstractions which in themselves form new singular expressions.

A language that is capable of describing and therefore of producing the common knowing of an objective world expresses more than just the positing of *any possible* world. It is not free speculation. Likewise, the 'anything' of art does not constitute a permission to *do anything,* nor an injunction to make anything that occupies the genre of the 'otherwise' at the level of semantic difference. It is appropriate then to dispose of the terms 'anything and otherwise' that have underscored the character of art's politics of difference as novelty in the field of postmodernist 'open' possibilities—and to replace them with the terms 'commitment' and 'the real', as conceptual drivers and not things in themselves, because, following Althusser and Brandom, we understand the dangers of naturalising science as legitimacy in-itself. Art's languages include those of the senses, poetics, metaphor, and abstraction, so the rational construction it claims cannot be one consisting of proofs. Neither should this language follow in the tradition of what art has taken to be its scientific image, for instance in Conceptualism or in new materialist practices. Here the weaknesses of art's epistemology are historically defined by its failure to understand that modal vocabularies spring from logical processes (for otherwise they are simply products of myth); that the languages used by art are normative; and that non-identicality as a principle of equality and justice requires an epistemology. Instead, we argue here that art must navigate the categories of explanation and identity without assuming their reducibility to one other.[29] Now we can we picture another dynamic: images that speak to the possible without semantic pessimism, without mysticism, free of the fear of claiming the real, or the romance of an unrequited real. If reason is the motor of knowing, then the construction site for possible worlds operates via the process of identification.

*

As teenagers we would sit all evening, often freezing, on park benches; nothing to do. Cloaked by darkness in the recesses of privet-hedged walkways, we

29. This task is then to comprehend the logics at work within artistic languages, and to ask if any such logic is possible and how this might be understood. This is important since as we have said, saying that all languages obtain modal properties risks overdetermining art to the parameters of the sublime (the irreducibility to art to reason), and thus missing the relationships between art and its capacity for knowledge production. Alternatively attempting to force scientific (object-based) approaches upon art undermines art by rejecting its non-teleological structure and/or compelling art to the jurisdiction of prevailing ideological dominance.

would meticulously pick over lyrics to songs (an unknowing anticipation of future theory seminars). Bowie's *Life on Mars* led to a debate on whether it was Lenin or Lennon that would be 'on sale again'. Armed with no verification, no recourse to any external knowledge, no peers that were more nerdy than us, no internet, no library, Paula, Helen and I contemplated the possibilities. The logic of the lyrics offered both possibilities: the selling out of Leninism as a fashionable investment for the masses, or the return of old school populism dressed up as the new avant-garde. On the face of it, both options led to similar conclusions; whatever the lyric actually said, it gestured toward the dismal fate of politics or culture, in a schematics of the capitalist commodity form—achieving personal identity via mediocre identifications with the 'alien-like' status of celebrity fame. At the time, I wished it was Lenin who had appeared in the lyric—not so as to bolster any personal political stance of mine, but because it produced an idea: it meant that the workers who were on strike still had the site of the political in view.[30] For me, the possible world this song described was that of a future where Lenin 'sold' to the masses, and where the workers striking for fame would be striking for the fame of Lenin, which would meet their own desires... and where the concept of solidarity was still alive.

The question of how we can say that we know, when we have no means of verifying, legitimating, or proving the relation between our conceptualisation of the real and our observation of reality, leads us to understand how identifications structure our view of the world as it is and as it ought to be. A deontic gesture that commits to a belief as to how things should be is as destabilising as it is constructive, since identification in-itself has no transcendental order; but at the same time, in striving to explain this complex of percept and concept to each other, we produce a direction, *a line without object*. Our identifications therefore, are not solely expressions of anarchic, egocentric pathologies and libidinal desires, because a community that is guided by the principle of reason manifests explanatory paradigms. This dynamic of identity and explanation gives structure to our identifications; we produce pictures along the way that require narration by means of other languages and pictures. Would this picture of a possible world where Lenin was sold back to capital see the denaturalisation of

30. David Bowie, 'Life on Mars' (1971). In fact, the lyrics are: 'Now the workers have struck for fame / 'Cause Lennon's on sale again'.

capital and the construction of new ideologies instead? Would either force lose its power? There are processes of identification, idealisms, and necessities that remain structurally alien—non-identical—to capital. There are not just imagined worlds but *actually possible worlds*, where identifications exceed the claims of ungrounded hypotheticals and the trivialities of the speculative, exceeding the liberalist condition of the 'otherwise'. To take alternatives to neoliberal capital seriously, beyond the realms of the private or the fictive imaginary as new forms of knowledge, is to set in motion rational constructions not on the basis of a mythic identity of personhood as a form of atomised singularity, but rather on the basis of our being *plural*, a concept that precedes the identifications that figure both community and subjectivities. In this dissonance we form identities and explanations, in language. From the logic of an alien perspective that exceeds 'identity-in-difference,' alternatives are achievable that reconcile identification as the mechanic of the social with the ideal of progressive forms of knowing. Together, they act as the glue for our constructions and lead us finally to reconsider the way in which we decide what gets built, and how any model can be verified as a worthy realisation of the Good.

Jeremy Lecomte

Can the Possible Exist in Physical Form? On Architectural Projectiles, Computation, and Worldbuilding

Before I fall asleep the city once more rears before my closed eyes its charred walls with their blind windows, gaping embrasures that open onto nothing; grey sky, flatness, absent rooms emptied even of their phantoms. In the gathering dusk I draw closer, groping my way, to finally place a hand on the now cold wall where, cutting into the schist with the point of [a] broad-bladed knife, I write the word CONSTRUCTION, an illusionist painting, a make-believe construction by which I name the ruins of a future divinity.

—Alain Robbe-Grillet, *Topologie d'une cité fantôme* (1976)[1]

The world in which we live is at once packed with solutions and saturated with impossibilities. Despite the sense of transformative urgency with which it is increasingly imbued, the confusion that reigns between apocalyptic claims about the end of the world and the incapacity to envision real ways out of this particular world only bolsters the idea that, as the saying goes, it has become easier to picture the end of the world than the end of capitalism.[2] Although this is highly dependent upon where we look and what or whom we look at, the fact that there are still few signs of any crises that capitalism could not recover from is probably the most decisive reason why there still seems to be limited urgency, in practice, to actually take drastic measures to change anything about the way we collectively live.

1. A. Robbe-Grillet, *Topologie d'une cité fantôme* (Paris: Minuit, 1976), 13. The translation is mine. It slightly differs from the existing English translation: A. Robbe-Grillet, *Topology of a Phantom City*, tr. J.A. Underwood (New York: Grove Press, 1977).
2. See notably F. Jameson, 'Future City', *New Left Review* 21 (2003), 65–79; and M. Fisher, *Capitalist Realism, Is There No Alternative?* (Winchester: Zero Books, 2009).

Architecture is unfortunately no exception to this. At best, there are here and there small signs that something is indeed changing. At most, these appear to be very small bottles left drifting in an ocean whose apparent calm can no longer mask the many storms striking it like overwhelming rogue waves. Generally speaking, in the present context, architecture seems to be confronted by both an inflation of its ambitions and a deflation of its possibilities. On the one hand, the computational revolution supports the idea that architecture is a limitless engine for imagining and building new worlds. On the other hand, global warming and ecological crisis constitute global problems in the face of which these computational experiments appear largely disconnected, and in relation to which architects alone appear relatively powerless. Increasingly marginalised in relation to everything that actually gets built, architecture, taken here at once as a social field, as a discipline, and as a practice, tends to be perceived as a pretentious luxury that nobody, not even architects, can really afford.

In this context, how can we still consider that architecture may constitute a decisive construction site for the engineering of not only possible, but truly other or alien worlds? This question, I would argue, firstly boils down to reconsidering what, in architecture, is understood and meant by a *project*. Foregrounded by modernist architects as the grand, linear scheme through which architecture could and should engage in transforming the world—and this from the smallest to the largest scale—the notion of the project has, since the sixties at least, been overwhelmed by various criticisms. Confronted today with the profound impact of computation upon both architectural conception and practice, the notion seems to have lost the profound meaning it historically had in this field: while it still plays a central role in architecture, it seems that 'project' now serves only as a convenient word to name what architects do every day. Meditating upon what projecting could still mean in a context marked by both a decisive computational revolution and a major ecological crisis, this text explores the ways in which the notion of project might be reclaimed from both its modernist hypostasis and what we might call its postmodern deflation. To reclaim it from its postmodern deflation, this text contends, implies that we first reclaim the future, that is, that we state the importance of engaging in projections that are reducible neither to mere phenomenological perspectives nor to mere optimisation steps. To reclaim it from its modernist hypostasis, as I will further elaborate, implies that we more

profoundly question the anticipatory logic at work behind it and question what it means, in architecture, to project something that does not exist yet, given the tension that exists between the possible that a project articulates and its actualisation in the physical forms that are projected.

In contrast to what modernism framed as a project (from the autonomous exception on the one hand to the grand plan developed in a linear way on the other), this text seeks to foreground what may instead be called projectiles.[3] Projectiles, I aim to show, are not simply about harnessing the right means for the proper ends. Extrapolating from the mobility characteristic of projectiles in a common sense (i.e. a rock thrown from a sling, an arrow shot by a bow, a bullet fired by a gun, or a rocket on a launchpad), the notion of projectiles that I would like to conceptualise here further supposes no fixed reference points, no linear trajectory. Neither does it suppose any mechanical, step-by-step procedure. Yes, projectiles are future-oriented, but in dynamic and open-ended terms, consistently and almost constantly subject to revision, reassessment, and remaking. As such, neither do they aim at achieving any form of seclusive autonomy. The possible world they articulate is never a fully formed entity. As we shall see, what we may call projectiles are above all concerned less with envisioning what the future may or should look like than with relentlessly questioning the established order of things *according to and against which* their specific aim to practically construct another world can be conceived and formalised.

I. Problem

In a recent text about worldbuilding, Reza Negarestani put forward a number of propositions based on the analogical transfers that can be explored between philosophy and architecture. Based on arguments he had already developed at length in the philosophical realm, he started by articulating a fierce critique of contemporary architecture:

> Architecture is still too much beholden to worldly purposes, [to] Heideggerian *raums*, living spaces and conservative technological artefacts which should

3. My conception of the notion is profoundly indebted to Adam Berg's work. I thank him for the engaging conversations and exchanges we had about this. See notably: A. Berg, 'On Toy Aesthetics: Wittgenstein's Pinball Machine, part 1' (2018), <https://toyphilosophy.com/2018/04/02/on-toy-aesthetics-wittgensteins-pinball-machine-part-1/>.

perform a certain range of functions in the context of our given phenomeno-logical registers or *given* faculties of perception and cognition. [...] In this sense, the restriction of architecture to the urban-space, in the broadest possible sense, is simply to limit the prospects of building or worldmaking to the *established order of things.*[4]

It is true, and in fact probably has been for centuries, that urban space has remained architecture's fundamental horizon. It is equally true that, in this respect, architecture has most often remained a discipline concerned more with registering social and cultural change than with stimulating and engaging with it. It is also true that, when its potential to transform our existence finally started to be unleashed, this took place within limits that remained particularly conservative. Starting in England in the 1830s, the discourse on modern design that culminated in early-twentieth-century modernism is one that focused just as much on inventing a new man as it did on protecting a given human subject and image from the profound transformations the Industrial Revolution was bringing about.[5] Even more generally, the human subject that was placed at the centre of modern architecture, from Ernst Neufert to Henry Dreyfuss, from Pierre Vigné de Vigny to Le Corbusier, was a very specific one: an anonymous, white, lean, and fit body wearing medium-sized clothes that gave modernism its measurable standards. If modern architecture aimed to change life, arguably modernism can also be described as having ultimately constrained such change to within these limited parameters.

It may well appear about time for architecture to be freed from such paro-chial models. Understood according to the mixture of comfort and enclosure that Peter Sloterdijk framed in terms of 'immunisation' in his *Spheres* trilogy,[6]

4. R. Negarestani, 'A Philosophical Introduction to Raman Architecture' (2018), <http://sugarcontemporary.com/shape-shift/>.

5. See S. Butler, 'Darwin Among the Machines (To the Editor of the Press, Christchurch, New Zealand, 13 June 1863)', in *A First Year in Canterbury Settlement with Other Early Essay* (London: A.C. Fifield, 1914); See also *Report from the Select Committee on Arts and their Connection with Manufacturers* (London: Luke Hansard, 1836). Both texts are quoted in the great historical synthesis that Beatriz Colomina and Mark Wigley published in 2016: B. Colomina and M. Wigley, *Are We Human: The Archeology of Design* (Baden: Lars Muller, 2016).

6. See P. Sloterdijk, *Bubbles: Spheres Volume I: Microspherology* [1998], tr. W. Hoban (Los Angeles: Semiotext(e), 2011); *Globes: Spheres Volume II: Macrospherology* [1999], tr. W. Hoban (Los Angeles: Semiotext(e), 2014); *Foams: Spheres Volume III: Plural Spherology* [2004], tr. W. Hoban, (Los Angeles: Semiotext(e), 2016).

what Negarestani describes as architecture's Heideggerian cage continues to be as determinant as ever. Yet what I would like to argue here is that simple claims about *the need and possibility to construct more genuinely other worlds* are in this regard as useless as the claim that urban space can be simply equated with *an inextricable established order of things*. That urbanisation proceeds according to a relatively coherent project whose horizon may be not only limited but also disastrous does not mean that the urban condition it has constructed and continues to construct is necessarily limited to the same horizon. While it would most definitely be easier to give a plethora of examples showing how a greater number of architectural projects have enclosed the city and constrained the space in which we live than have achieved the opposite—Jeremy Bentham's panopticon constituting an exemplary case here—the many riots and social movements that, with increasing intensity and convergence since 2011, have recently transformed so many contemporary metropolises into social battlegrounds—from Tunis, Tripoli, Cairo, Sana'a, Damas, and Manama in 2011, to Algiers, Quito, Santiago, Beirut, Hong Kong, Baghdad, Port-au-Prince, Paris and Conakry more recently (this list being far from exhaustive)—show that it may be ultimately way too simplistic to equate urban space, or, more specifically, the continuous-yet-highly-heterogeneous urban condition in which we live, with a mundane horizon condemned to the *established order of things.*[7]

To be fair, the propositions made by Negarestani in this text are all framed in relation to principles that might at first appear to be rather contradictory to this initial critique. Basing his thinking on Nelson Goodman's work on worldmaking, Negarestani notably emphasises the latter's thesis according to which

> The many stuffs—matter, energy, waves, phenomena—that worlds are made
> of are made along with the worlds. But made from what? Not from nothing,
> after all, but *from other worlds*. Worldmaking as we know it always starts from
> worlds already on hand: the making is a remaking.[8]

7. See <https://www.architecturalnotes.org/>.
8. N. Goodman, *Ways of Worldmaking* (Indianapolis: Hackett, 1978), 6.

More recently, Negarestani himself further nailed down this argument by saying that

> to build a new world in which the possibility of disenthralled thinking and action coincides with possibilities of a world in which the individual and social problems and pathologies are resolved [...] is impossible without first responding systematically and rationally to the constraints of the world in which we already live. In this sense, I would say universalism is at its core concerned with world-building or more precisely world-engineering to the extent that our premise, resource and space of labour is always *this* world and not some imaginary world or an afterlife heaven.[9]

But what if this premise is precisely the urban condition we live in? What if this world is precisely the apparent urban totality in which architecture finds its limit? Put in this way, the problem can be further stated as follows: *How can architecture, understood as a potentially universal field, discipline, and practice of transformation, be considered a decisive site for resolving the very contradiction it seems to epitomise, namely, the contradiction between its capacity to imagine, conceive, and construct other, alien, future worlds, and the fact that it has been historically framed as the discipline that can only project these other worlds from, within, and according to the constraints of the existing world we are given to live in?*

Let me start by describing a painting that, I think, portrays this problem with remarkable acuity. In *Robbe-Grillet Cleansing Every Object in Sight* (1981), Mark Tansey pictures the famous French writer as an inordinate human subject entirely absorbed in cleansing a desert whose generic dimensions (at once calibrated to smaller bodies than his and perspectively more infinite than his own finite body could ever be) seem totally out of his reach. Looking more closely, one discovers a desert whose genericity is the product not only of a scalar manipulation, reinforced by the presence, at the bottom-right, of the same body at a much smaller scale, but also of the plane of indifference that this desert deploys. In Tansey's painting, the desert is not just a specific environment but a

9. F. Gironi. 'Engineering the World, Crafting the Mind. A Conversation with Reza Negarestani' (2018), <https://www.neroeditions.com/docs/reza-negarestani-engineering-the-world-crafting-the-mind/>.

Mark Tansey, *Robbe-Grillet Cleansing Every Object in Sight* (1981) (detail)

landscape whose abstract dimension is what renders it able to accommodate what appear to be at once simple rocks and recognisable figures, in which, in scale-independent terms, one can identify common objects, human subjects, and monumental buildings as well as remarkable landscapes. This painting, I would like to suggest, appears totally in line with the dilemma Alain Robbe-Grillet himself confronted in *Topology of a Phantom City* (1976). In this novel, Robbe-Grillet pictures a city that is supposed to have hosted several successive civilisations, each having deposited its particular topography, its sacred texts, its art, objects, and instruments, each with its own history punctuated by natural disasters or social massacres, in a given stratum. The reason why this city only *seems* to have hosted these different civilisations is that it is not simply the product of a given

stratification: the city in which the action takes place is not only the last layer in a given linear development that an historian could put into order; it is a cut through all of these strata, a spatial transitional configuration whose interpretation and navigation are entirely immanent—the traces left by its archaeologists always threatening to transform the profile of the entire cut. Similarly, Tansey's painting pictures Robbe-Grillet himself as the archaeologist of his own world, obsessively cleansing it and in doing so at once describing and excavating it as other than his own invention, navigating it as a world constantly and ever actualised as he proceeds. In the middle of a desert in which not only objects but entire landscapes, buildings, monuments, and people are themselves barely distinguishable from simple and indifferent rocks, in which the horizon collapses in infinity, and in which nothing indicates that the man we observe has not totally lost his mind, we discover an allegory which emphasises the distinction that must be made between Goodman's interpretation of worldmaking, bound to what are always implied to be artworks, and the way in which we can engage with worldbuilding as a cogent concept for architecture.

The reason why I find this painting particularly relevant to a further explo-ration of the problem articulated by Negarestani (following Goodman) is that it helps frame it in terms that are closer to what architecture deals with. Architecture, one must reckon, by contrast with other art forms, tends to be a naturalising discipline. It is a discipline whose practice consists in producing manmade formalisations whose realisation is also bound to becoming, over time—formations that take on a nearly natural status for those who happen to live in them.... In other words, Tansey's painting is one in which we can start to wonder where the demarcation line lies between a purposely designed building and a natural monument carved by years and years of wind, rain, and sunlight and, beyond them, by gravity, erosion, and entropy. It is one in which we can start wondering in what exactly consists the difference between an indifferent rock and a meaningful piece of architecture. It is one which, once architecture is recognised as a field, discipline, and practice that tends toward *naturalising*, asks how one can claim that it may also constitute the most experimental, concrete, and potent construction site for other possible worlds, rather than a discipline merely foreclosing possibilities it captures in physical forms.

II. History

The reason why such a question is only rarely asked in the architectural field is that architecture remains largely defined (at least by those who practice it and believe in it) as the future-oriented discipline par excellence, a discipline concerned at its core with imagining and shaping the future, with imagining and anticipating worlds that do not yet exist. The critique articulated by Negarestani may in fact appear ill-placed to a discipline whose first revered treatise, at least in the Western architectural tradition, was written by a man (Marcus Vitruvius Pollio) who placed the distinction between *fabrica* (i.e. the practice of building) and *ratiocinatio* (i.e. the conception of a building before it is realised) at its heart.[10]

While many architectural historians have also insisted on the fact that Vitruvius's *De Architectura* in fact described 'a building technology that, by the time Vitruvius put it into writing (in the early years of the Roman Empire), was already a few centuries old',[11] the central role that the notion of project continues to play in architecture must first be tackled as a nontrivial one, for it is in fact around this notion that architecture historically emerged as a discipline distinct from building practice. As Pier Vittorio Aureli puts it:

> Architecture is not only what is built. Architecture is a shared knowledge out of which every architectural project (and every building) is made. While in ancient times this shared knowledge was embedded directly in the practice of building physical artefacts, since the 15th Century architectural knowledge has taken the form of the project. (And) practicing the project means to put forward something that does not exist yet.[12]

10. P.V. Aureli, 'Intangible and Concrete: Notes on Architecture and Abstraction', *e-flux journal* 64 (2015), <https://www.e-flux.com/journal/64/60845/intangible-and-concrete-notes-on-architecture-and-abstraction/>.

11. M. Carpo, *The Second Digital Turn: Design Beyond Intelligence* (Cambridge, MA: MIT Press, 2017), 1.

12. In particular, Aureli mentions M. Cacciari, 'Project', in A. Carrera (ed.), *The Unpolitical: On the Radical Critique of Political Reason*, tr. M. Verdicchio (New York: Fordham University Press, 2009), 122–45. See P.V. Aureli, 'The Common and the Production of Architecture: Early Hypotheses', in D. Chipperfield, K. Long, and S. Bose (eds.), *Common Ground: A Critical Reader* (Venice, 2012), <http://www.arch.upatras.gr/sites/default/files/uploads/activities/4401/attachments/pv_aureli-22386.pdf>.

By foregrounding the fifteenth century, Aureli underlines the importance of the Renaissance and of the work of Filippo Brunelleschi in the emergence of architecture proper, as an independent discipline based on this act of antici-pation necessary to construct a reality yet to come—what is called a project. Trained as a goldsmith, Brunelleschi's approach to architecture was deeply rooted in his artisan knowhow. 'Arguably the first architect to practice as a freelance professional outside the guild of carpenters and builders', it was how-ever 'his profound knowledge of mathematics and his disregard for the builder's decision-making capacities in the execution of his designs', Aureli argues, that 'made him an exemplary case in the formation of architecture as a discipline clearly distinguished from the practice of building, which in its turn is henceforth relegated to the execution of the architect's project'.[13]

To foreground the role played by Brunelleschi in this transformation is to foreground the role of mathematics and geometry, which rendered architectural projections more accurate and more realistic than ever before. Further, as Aureli shows, it is precisely as projections that one can mathematically and geometrically trust that architectural projects have become realities in themselves, whose importance can be considered independently from their potential realisation.[14]

At the time, however, mathematics and geometry were not the sole forces through which this notion of the project was shaped. What mathematics and geometry allowed was the making of spatial projections one could measure and rely on. But the notion of project itself remained for a long time heavily imbued with religious if not mystical undertones, the origin of which should probably be sought in the episode of the Tower of Babel, that first moment in Genesis when humans rival God in projecting and building the first ever city.[15] As Alberto Pérez-Gomez argues in *Architecture and the Crisis of Modern Science*, such metaphysical assumptions continued to imbue architectural and scientific

13. Aureli, 'Intangible and Concrete'.

14. Aureli, 'The Common and the Production of Architecture'.

15. From the outset, God is precisely defined as an omniscient figure whose decisions are not distinguished from their consequences: 'God said, "Let there be light". And there was light!' By contrast, humans are defined as those creatures that soon cultivated the capacity to defy God. It is notable that the first challenge they bring upon God takes the form of a tower, whose description comes together with the notion that something is projected, that something is built, and that this something is called a city. The English translation only suggests a projective act behind the way this city is built, whereas the French translation explicitly mentions the term 'project'.

reason at least until Laplace, whose criticism of Newton's metaphysics in his *Traité de mécanique céleste* 'finally purified (astronomy) of traditional mythical connotations'.[16] It was only at this moment, Perez-Gomez argues, that 'the epistemological revolution ushered in by Galileo and Descartes [finally seemed] irreversible'.[17] And it was only at this moment that the practical independence mathematics and geometry had gained in architecture since Brunelleschi became also a rational independence: 'If everything can be explained by means of mathematical equations accessible to the human mind, the notion of God becomes dispensable' in the framing of the notion of the project too.[18]

Jumping over a few centuries now, it is arguably possible to see in the Maison Dom-Ino, the famous prototype image drawn by Le Corbusier and Max du Bois in 1914, the culmination of this trajectory. Regarded at the time as nothing more than a modernist model for the building of houses in industrial series, Maison Dom-Ino has since been recognised instead as a conceptual idea, an architecture deprived of any formal ornament, an architecture that modelled architecture in the most minimal, but also most general sense of the term, 'a self-referential sign' as Peter Eisenman put it, and as such 'an architecture about architecture' itself.[19] Similarly, Adolf Max Vogt described it as a quintessential architectural project given the sense in which—and here I extrapolate on purpose—it embodies at once the perfectly pure, the raw real, and a clearly articulated possible future.[20] As such, the Maison Dom-Ino constitutes the endpoint of the crisis depicted by Perez-Gomez. If 'the inception of functionalism coincided, not surprisingly, with the rise of positivism in the physical and human sciences',[21] then Maison Dom-Ino can be said to have elevated the functionalist logic at play in architecture into a manifestation of pure architectural positivism.

I would argue that it is precisely this positivism which, to paraphrase Eisenman, transformed the independence that architecture *qua project* acquired

16. A. Pérez-Gomez, *Architecture and the Crisis of Modern Science* (Cambridge, MA: MIT Press, 1985), 273.

17. Ibid., 272.

18. Ibid.

19. P. Eisenman, 'Aspects of Modernism, Domino House and the Self-Referential Sign', *Oppositions* 15/16 (1979), 194.

20. A.M. Vogt, Le Corbusier, *The Noble Savage: Toward an Archaeology of Modernism*, tr, R. Donnell (Cambridge, MA: MIT Press, 1998), 24.

21. Pérez-Gomez, *Architecture and the Crisis of Modern Science*, 4.

during the Renaissance into the autonomy it gained in modern times; and it is this same functional positivism that today is being restructured by the increasing ingress of computation into architecture. Speaking of 'computationalism', Philippe Morel stands among the rare architects who underline how any paradigmatic shift in architecture is conditional upon this profound change. Going well beyond the widespread use of computer-aided design (CAD) in architectural practice, computationalism is described by Morel as a concept 'linked to what lies beyond computerised rationalism', a 'concept having now acquired complete autonomy from human thought as the privileged framework of application', referring 'to the old algebraic turn as well as to the present day computational turn', and encompassing 'a new relationship between physics, mathematics and money'.[22]

To go back to Negarestani's initial criticism, the apparent gap that exists today between computationalism, seen as an entirely new scientific, economic, philosophical, and technological paradigm, and the formal experiments to which digital architecture generally remains limited,[23] is a rather puzzling one. Yet, looking into the Maison Dom-Ino again, and the debates that have recently reemerged

22. All quotes here are taken from P. Morel 'Notes on Computational Architecture. On Optimisation', 2003, Unpublished. My translations. See also by Morel, 'A Few Remarks on the Politics of "Radical Computation"', in D.J. Gerber and M. Ibanez (eds.), *Paradigms in Computing, Making, Machines, and Models for Design Agency in Architecture* (New York; Evolo Press: 2014), 123–40.

23. The idea that projecting a world that does not yet exist may be reduced to calculable parameters is not entirely new. The historical accounts of digital practices in architecture that have proliferated in recent years have opened up a territory whose limits are increasingly harder to define. Distancing themselves from the focus on uses of specific computer programs in architectural production, several authors have more recently attempted to acknowledge the broader cultural and technological change that computation implies in this field, in particular by showing, as Roberto Bottazzi does, that the extensive use of computers in architecture may be better understood 'as the most current manifestation of modes of thought and cultural practices that go back centuries'. But while authors such as Mario Carpo have gone so far as to claim that, based on sheer information retrieval, contemporary computational modes of prediction have already killed both modern science (based on inductive, inferential, and experimental logics of prediction) and the reign of the projected image (based on perspective and parallel projections), surprisingly, little attention has been paid to the common origins that may be identified for architecture, the notion of the project, and the developments that led to what we may define as an architectural computationalism. See in particular Carpo, *The Second Digital Turn*, and R. Bottazzi. *Digital Architecture Beyond Computers: Fragments of a Cultural History of Computational Design* (London: Bloomsbury Visual Arts, 2018). See also Frederic Migayrou's postface to Bottazzi's book, and Theodora Vardouli's review of it: T. Vardouli, 'Review: *Digital Architecture beyond Computers: Fragments of a Cultural History of Computational Design*, by Roberto Bottazzi', *Journal of the Society of Architectural Historians* 78:4 (2019), 496–8.

around it, may provide a few clues. For some, the Maison Dom-Ino formalises a positivist, industrial logic that digital architecture should finally be able to translate and actualise if it wants to come to terms with the promises and underpinnings of automation. For most, it remains the quintessential formalisation of a modern project that digital architecture may finally help in getting away from. In both cases, however, digital architecture seems to face a similar problem: namely, the fact that it is precisely the vector of abstraction that rendered architectural projects independent from actual buildings, and thus the object of a distinct and independent form of knowledge, that tends to make the notion of the project irrelevant within a computationalist paradigm whose positivism is grounded in pure information retrieval. The idea that projecting another world may translate into the optimisation of given and calculable parameters is one that places an even greater weight upon the tension exemplified in Tansey's painting: namely, the question of knowing whether it is possible or desirable to find a purely positivist reconciliation of the difference between worldbuilding understood as the invention of a truly other world (i.e. what continues to be called a project) and worldbuilding understood as the optimisation of calculable parameters grounded in the already existing world.

III. Phase Change

Confronted as we are with an ecological crisis the extent of which appears daily ever more evident, more profound, and more daunting in regard to what the future may look like, the entrenched biomimetics that pervades computational architecture poses questions that appear particularly relevant to knowing why a discipline so well versed in inventing the future today appears so incapable of imagining worlds truly (that is, modally rather than just formally) different to the one we already live in.

Having arguably started with Frank Gehry's giant Golden Fish sculpture built in Barcelona in 1992 (and designed using Dassault's CATIA software), the conjunction of digital architecture and biomimetics is probably as old as computational architecture itself. Since then, advances in evolutionary computation, computer-controlled architectural design and production (notably through the use of genetic algorithms), structural engineering, and laboratory techniques for tissue and genetic engineering have considerably enlarged the field of what

is designed by parametric or digital architecture. Certainly encouraged by the growing consensus around the idea that the ecological crisis we face necessitates a profound rethinking and transformation of our understanding of the nature and culture divide, a growing number of architects claim that we have now passed this early mimetic stage; that we have entered a more properly operational evolutionary, generative, or living architecture capable of finally overcoming grid-based twentieth-century urban architecture in favour of an architecture capable of building instead the kind of photosynthetically powered mangrove-based urban landscape we might happily desire to inhabit in the future. It is clear, however, that most of what is produced in the most technologically advanced architectural offices and architectural schools today remains, at best, biomimetic rather than properly ecological, and principally encourages the simulation and potential construction of increasingly complex forms rather than the invention of different worlds. For all its richness, formal diversity, and technological innovation, and the architectonic experimentation it drives, digital architecture remains limited to a stylistic game that seems far removed from the grand computational-ecological scenario it increasingly claims to enable.[24]

On a physical level, the entrenched biomimetics that characterises contemporary computational architecture resembles more what Art Nouveau used to produce at the turn of the twentieth century than any proper form of technologically-informed ecological avant-garde. Using the most advanced means made available by the industrial revolution at the time, Art Nouveau imitated nature in what was assumed to be a nostalgic representation of a lost harmony with nature. On that front, it seems that the contemporary architectural avant-garde remains incapable of using the most advanced means made available by the computational revolution to do anything other than to celebrate an ideal of nature whose destruction in fact began a long time ago. Rather than putting an end to the projected image (in the perspectival, properly mathematical, yet representative sense of the term) and exploring what may be termed a regime of simulation proper, such biomimetics limits computational architecture to projecting images

24. On this particular issue, see in particular the comprehensive and varied collection edited by Matthew Poole and Manuel Shvartzberg: M. Poole and M. Shvartzberg (eds.), *The Politics of Parametricism, Digital Technologies in Architecture* (London: Bloomsbury, 2015). On the gap between the architectural discourse on computation and what actually gets produced by the computational architectural avant-garde, Carpo's *The Second Digital Turn* is quite telling.

in the most representational sense of the term: producing cultural images that do nothing but represent their own power of cultural simulation.

On a processual level, this biomimetics raises even more profound and problematic questions. As Christina Codgell has been demonstrating for many years, it is often only the visible part of a 'breeding ideology that, [enveloping] parametric architecture, is but the most recent expression of a broader historic trend to biologizing [...] architecture'.[25] Here, the epistemic, political, and practical questions masked by the supposedly neutral use of genetic algorithms in computational architecture reveal an even more dangerous flattening, operated in the name of a supposedly necessary dissolution of the modern divide between nature and culture. As Codgell argues, one must here always keep in mind that

> [e]ven if one theoretically accepts the dissolution of nature and culture, in fact vast material distances separate digital DNA from deoxyribonucleic acid; evolutionary computation from actual biological evolution; architectural morphogenesis from the morphogenesis of developmental biological systems; simulation of the 'environment' in scripted code from the actual complexity of the multiscalar environment of cells, organs and organisms in dynamic interaction in the world outside the laboratory.[26]

It seems crucial that architects and architectural theorists acknowledge these differences. The sociopolitical and epistemic implications of the computational turn in this discipline cannot be underestimated. While Maison Dom-Ino remained bound to the notation means that had driven architecture since the invention of perspective, the conceptual principle it formalised involved a political, economic, and spatial redefinition of architecture. Similarly, the fierce critique that Adolph Loos launched against ornament was not, contrary to what has been repeatedly claimed since, a mere moral, stylistic, and formal question, but was bound to a conceptual and economic redefinition of what architecture

25. C. Codgell, 'Breeding Ideology: Parametricism and Biological Architecture', in Poole and Shvartzberg (eds.), *The Politics of Parametricism*, 123–37. This argument is closely related to Guiseppe Longo's work. See in particular G. Longo, 'Complexity, Information and Diversity in Science and Democracy, *Glass Bead* (Research Platform) (2016), <https://www.glass-bead.org/research-platform/complexity-information-diversity-science-democracy/?lang=enview>.
26. Codgell, 'Breeding Ideology', 127.

was about and what architecture was supposed to do. Echoing Morel on that front, I would like to argue here that digital architecture as it exists today lacks the rigorous conceptual, mathematical, but also political framework according to which what it should produce may be defined, and without which the operativity of a truly computational architecture cannot be considered.[27] The problem prompted by the ecological crisis we face today should constitute not yet another legitimation of architecture's computational biomimetics, but rather an urgent opportunity to precisely orientate (computationally driven) architecture toward the invention and construction of properly other worlds.

IV. Update

As the ecological crisis we face deepens and the consequent phase change seems to draw nearer every day, in so far as the proper potential of computational architecture to unleash new other worlds remains obscured by the absence of any proper definition of its object, the urban horizon to which architecture remains bound does indeed appear not to have changed much since the first Industrial Revolution and the invention of urbanisation.[28] Beyond the Maison Dom-Ino and the industrial city within which its concept was framed, it is the Crystal Palace that, as an iconic industrial building, an international exhibition, and a conceptual prototype of modern urbanisation, probably continues to best exemplify the urban horizon that, along with Negarestani, we can criticise.

The Crystal Palace was designed in 1851 by Joseph Paxton to host the first international exhibition ever held, in London. Although destroyed in a fire in 1936, today the Crystal Palace remains one of the most famous of all modern buildings. Entirely prefabricated and assembled on site, this building was a gigantic glass and steel greenhouse of nearly 92,000 square metres. Despite this monumental aspect, the Crystal Palace was perhaps less a monument than an infrastructure: presented, owing to its size and its innovative formal qualities (notably its internal transparency and external shimmer) as a monumental building, its principle of

27. Morel, 'Notes on Computational Architecture.

28. The term 'urbanisation' was coined by Ildefons Cerda in parallel to his project for an extension of Barcelona in 1867. See notably R.E. Adams, *Circulation and Urbanization* (London: Sage, 2019); P.V. Aureli, *The Possibility of an Absolute Architecture* (Cambridge, MA: MIT Press, 2011); and N. Neuman, 'Ildefons Cerdà and the Future of Spatial Planning: The Network Urbanism of a City Planning Pioneer', *Town Planning Review* 82:2 (2011): 117–43.

construction and its function made it more of a prototype, a pavilion that was not intended to remain in place, and whose main quality was precisely that it could not only be moved but also potentially reproduced. What must also be stressed is the global dimension of this prototype: the Crystal Palace was not only the archetype of an industrial construction system that could be put to various uses, but the model or formalisation of a technological, political, and economic infrastructure that aimed to extend its influence on a global scale. In short, what the seemingly limitless interior of the Crystal Palace formalised was the principle of a global interiorisation of the world under the dual industrial regime of technology and merchandise, of which the British Empire was at the time the epicentre.

Years before the Maison Dom-Ino achieved rational autonomy for architecture, then, the Crystal Palace formalised its urban horizon: a limitless structure whose principle of equivalence at all points unleashed architecture's capacity to interiorise the entire world in the image of man. This horizon, however, polarised responses.

Having visited the scaled-up version of the Crystal Palace near Sydenham Hill in 1862, Nikolai Chernyshevsky saw in it a utopian model against which a futuristic, non-hierarchical, and non-conflicting Russian society could be portrayed. In *What Is to Be Done?* (1863)—a book that inspired the title Lenin gave to his even more famous manifesto—he portrayed a world in which the opposition between city and countryside would disappear in favour of a continuous landscape made of gigantic Crystal-Palace-like buildings standing amongst 'fields and meadows, gardens and woods', in which would live a population 'satisfying all [of its] material needs through a collectivised, technologically advanced agriculture and industry, and [being] satisfied sexually and emotionally through the social policies of a benign, sophisticated and rational administration'.[29] Preceding all of the iconic urban projects that would be imagined by modern architects at the turn of the century, the utopia described by Chernyshevsky prefigured a common general principle: that of an architecture whose project would be primarily infrastructural, and whose proposal to improve living conditions for the greatest number of people would be articulated with the promise of a fully rational world, administered

29. N.G. Chernyshevsky, *What Is to Be Done?* [1863], tr. M.R. Katz (Ithaca, NY: Cornell University Press, 1989), 147.

as a harmonious whole and resolutely turned against the historical opposition between the city and the natural environment.[30]

Profoundly opposed to Chernyshesvky's vision, in *Notes from Underground* (1864) Fyodor Dostoevsky articulated a critique that, one could argue, appears more profound than those that would be articulated years later by postmodern architects and architectural theorists against the grand schemes devised in these modern projects:

> You believe in a palace of crystal that can never be destroyed—a palace at which one will not be able to put out one's tongue or make a long nose on the sly. And perhaps that is just why I am afraid of this edifice, that it is of crystal and can never be destroyed and that one cannot put one's tongue out at it even on the sly.[31]

This ironic critique was first of all a materialist critique aimed at an architectural project, but soon enough, in the same book, it proved to also be an existential critique launched against an entire (urban) world:

> You see, if it were not a palace, but a hen-house, I might creep into it to avoid getting wet, and yet I would not call the hen-house a palace out of gratitude to it for keeping me dry. You laugh and say that in such circumstances a hen-house is as good as a mansion. Yes, I answer, if one had to live simply to keep out of the rain.[32]

Once articulated with the concerns and problems discussed in this text, Dostoevsky's irony can be viewed as a critique of the implicit optimisation programme driving Chernyshevsky's interpretation, a critique launched against a new world

30. From the garden cities principle devised by Ebenezer Howard in 1898 to the hyperbolic *Continuous Monument* drawn by Superstudio in the seventies, from Le Corbusier's urban plans to those of the Constructivists, and from Hilberseimer's *Metropolis-Architecture* (1927) to Frank Lloyd Wright in *Broadacre City* (1934–59), this principle applies equally to projects that are very diverse in the way they physically, spatially, and materially unfold it.

31. F. Dostoyevsky, *Notes from Underground and The Grand Inquisitor* [1864/1869], tr. M.R. Katz (Boston, MA: Dutton, 1989), 123.

32. Ibid., 124.

that, according to Dostoevsky, was nothing but a mathematical extrapolation of what he saw as being an already highly problematic existing world:

> Then—this is all what you say—new economic relations will be established, all ready-made and worked out with mathematical exactitude, so that every possible question will vanish in the twinkling of an eye, simply because every answer will be provided. Then the 'Palace of Crystal' will be built. Then...In fact, those will be halcyon days. Of course, there is no guaranteeing (this is my comment) that it will not be, for instance, frightfully dull then (for what will one have to do when everything will be calculated and tabulated), but on the other hand everything will be extraordinarily rational.[33]

The indestructibility of the Crystal Palace that Dostoevsky criticises is not the indestructibility of a revolutionary infrastructure (in the technological and capitalist sense of the term, as in 'industrial revolution' or 'computational revolution'), but the indestructibility of a totalising project whose limitations threatened to become unquestionable precisely thanks to its mathematical totalisation.

V. Programme

Seen in line with the main question raised in this text (namely, how can architecture be considered a discipline decisive to the resolution of the contradiction it epitomises between the capacity to invent new worlds and the propensity to simply articulate and register already existing conditions), Dostoevsky's critique appears to be not a critique against optimisation as such, but rather a critique raised against a utopia based on nothing but the optimisation of an already given (and limited) world. Dostoevsky's critique is a critique made against worldbuilding seen in purely positivistic terms, a critique that discards at once the object of optimisation (the palace treated as a hen-house), its totalising logic, and the idea that it could be mitigated by marginal developments. Dostoesvky's fiction is one that opens up Chernyshevsky's totalising vision to its negative counterpart, it is one that breaks open its domesticating dimension, one that does not simply destroy the Crystal Palace, but rather destroys the foreclosed horizon it formalises, in order to make room for a totally different project.

33. Ibid., 51.

Much like Robbe-Grillet in Tansey's painting, Dostoevsky excavates the desert that lies beneath and beyond the urban horizon that the Crystal Palace totalises.

Seen in this way, Dostoevsky's critique is also not simply a negative one. It is one that relies on and constructs what Iris Young calls a 'desiring negation'[34] that mobilises the unrealised possibilities of the world considered, one that insists upon the fact that desiring something better implies not just the construction of an alternative vision, but the construction of an alternative building site. As Patricia Reed recently put it:

> It is not enough to rearrange the furniture in this current historical discursive home; freedom from this given domestic situation and the modes of domestication that conform to its logic, is dependent on the freedom to construct comparative fictions that serve as tools for building a new home from the foundation up, for new sites of positivity upon which thought and activity are based. The desire for betterment is itself entangled with fiction; since the better is always unactualized in the here and now, the better is not empirically available to direct experience. Accounting only for the here and now of what is given to localized experience and thinkability is to foreclose on the imaginative possibility of situated betterment. Betterment always belongs to an otherworld, another site, another situation, and it is through fiction where a counterfactual imagination of that possible world is enabled.[35]

Going back to Tansey's painting, what I would like to stress (in relation to what is articulated here between betterment, fiction, and otherworldly imperatives) is the need to confront the ways in which betterment, in architecture at least, can only become a true transformative engine once it is addressed in terms of a historically constructed desiring negation. In other words, the specific relation that architecture entertains with the world we inhabit (the fact that the possible projected in this field is always also imbued with its potential actualisation;

34. I. Young, *Justice and the Politics of Difference* (Princeton, NJ: Princeton University Press, 1990), 6–7. On this aspect and its relation to ideology critique, see notably S. Haslanger, 'Disciplined Bodies and Ideology Critique', *Glass Bead*, Site 2 (2019), <https://www.glass-bead.org/article/disciplined-bodies-and-ideology-critique/?lang=enview>.

35. P. Reed, 'Freedom and Fiction', *Glass Bead*, Site 2 (2019), <https://www.glass-bead.org/article/freedom-and-fiction/?lang=enview>.

the fact that the world envisioned by an architectural project not only exists in tension with the one we inhabit, but is imbued with the idea that it could *become* the world we inhabit) demands that we address betterment not only as something that is unactualised in the here and now, but as something whose positive formulation lies in its historical negation.

Such a relation to history may be as crucial today as it ever was, considering the Crystal-Palace-like urban totality to which contemporary architecture is bound. Grounded in the thesis according to which the making of a world is always a remaking, the many operations through which Goodman articulates the possibility of worldmaking (composition and decomposition, weighting, ordering, deletion and supplementation, deformation and reshaping...) may prove to be solid architectural operations. Owing to the discipline's tendency to naturalise the world we already inhabit, I would argue, however, that their successful adaptation to purposes other than marginal alterations of the Crystal Palace (considered here as a historical model serving to make explicit the urban horizon to which contemporary architecture remains bound) depends upon the extent to which they can rely on a critical gesture whose principal ground is a historical one. Here, Goodman's thesis may find a strong ally in Michel Foucault's archaeological/genealogical method. Goodman's thesis, based on the idea that the structure of appearance of a world consists in a complex dynamics of projections, is probably more intimately connected to Foucault's method than the constantly reassessed shortcut interpretation of his work as a critique of the existent may suggest. To see in Foucault's critical project only the continuation and, as an author such as Marshall Berman did not hesitate to say, the tightening of the negative, nearly paranoiac gesture exerted by Dostoevsky's narrator, is ultimately to obscure its properly emancipatory and future-oriented dimension. As Foucault articulated in his extremely precise and erudite reconstitution of Friedrich Nietzsche's conception of genealogy, the conception of history that the late Nietzsche foregrounded was no longer—as in his early discussions of the critical use of history—'a question of judging the past in the name of a truth that our present would be the only [site] to possess; but of risking the destruction of the subject who seeks knowledge in the endless deployment of the will to knowledge'.[36]

36. M. Foucault, 'Nietzsche, la généalogie, l'histoire', in D. Defert and F. Ewald (eds.), *Dits et Écrits 1, 1954-1975* (Paris: Gallimard, 2001), 1024. My translation differs from the existing English version,

In other words, what Foucault called genealogy is a practice of history that returns to the three modalities that Nietzsche recognised in 1874, but in a way that metamorphoses them:

> [T]he veneration of monuments becomes parody; the respect for ancient continuities becomes systematic dissociation; the critique of the injustices of the past by a truth held by man in the present becomes the destruction of the man who seeks knowledge by the injustice proper to the will to knowledge.[37]

For Foucault, 'risking the destruction of the subject who seeks knowledge in the endless deployment of the will to knowledge'[38] only mattered as a way to show how one could escape the implicit systems that constrain our most familiar behaviours.[39] As he further articulated in his introductory lecture to *Security, Territory, Population* (1978), the course in which he went the most deeply into architecture and modern urbanisation, biopower was never intended as a generalised theory of power, but rather as an attempt to articulate a systematic and rational analysis of the constraints of the present with the possibility of actively participating in transforming it.[40]

From this point of view, Tansey's painting is one that insists on the idea that worldbuilding is first and foremost bound to the necessity of revealing the project behind the existent, the formalisation behind the formation. The idea is that one cannot lucidly claim to be building another world without making first the effort to articulate it in this world—that is, in architectural terms, without questioning the resources available in this world, the things that this world is made of, and the logic according to which these things are articulated in this world. To reveal the project behind the existent, to reveal the formalisation behind the formation, is to perform a historical critical gesture that enables a given site

M. Foucault, 'Nietzsche, Genealogy, History', in D.F. Bouchard (ed.), *Language, Counter-Memory, Practice: Selected Essays and Interviews*, tr. D.F. Bouchard and S. Simon (Ithaca, NY: Cornell University Press, 1977), 164.

37. Foucault, 'Nietzsche, la généalogie, l'histoire', 1024.

38. Foucault, 'Nietzsche, Genealogy, History', 164.

39. J.K. Simon. 'A Conversation with Michel Foucault', *Partisan Review* 38 (1971), 201.

40. M. Foucault, *Security, Territory, Population: Lectures at the Collège de France, 1977–78*, tr. A. Fontana (New York: Palgrave Macmillan, 2007), 16–18.

to be transformed into a construction site, that transforms a given site in this given world into a launch pad for other worlds.

The first conclusion that this text proposes to draw on this matter, a conclusion that must be considered in provisional and propositional rather than in definitional terms, is to call such historically critically loaded projects (*architectural*) *projectiles*.[41] The second would be to call for architecture to engage in the design of such projectiles, abandoning the old, grandiloquent, and linear modern notion of the project but without retreating from inventing other possible futures; that is, in this context, to call their architects to hold on to both the target aimed at, and the shadow that the projectile in question casts on the site from which it originates, while en route to this target.

This said, the military echo should be discarded here, for the type of space in which the type of trajectory I am talking about can take place is not the Euclidean, linear space that unfolds between the weapon, the projectile, and the target on a firing range; it is rather a fundamentally topological space, in which the trajectory of the projectile must be considered at once from the point of view of the target and that of the firing point. In fact, one must even envisage both at the same time: the trajectory of the projectile is a trajectory that is only envisaged and designed in a stereoscopic way, both against the common understanding of the historian's work (which would only seek, on the basis of the impact on the target, to reconstruct the trajectory, the velocity and, ultimately, the point of origin of the shot) and against the common understanding of the work of architecture (which would focus on the act of imagining, from a given firing point and in a pure creative impulse, the target that should be reached and how to achieve it). As is the case in Tansey's painting, architectural projection must in fact be understood as a *stereohaptic* enterprise—focusing at once on redefining the site it occupies and on redefining the desert horizon of which this site is only one particular and contingent fold.

What we need are not premade, already imagined, already composed and already designed alternative worlds. What we need are the projectiles that can open, in the world in which we live, real possibilities of accessing new worlds. Alternative worlds are already built the moment they are described; they are

41. As mentioned above, for a detailed examination of what Goodman describes as such, see Berg, 'On Toy Aesthetics'.

already unified, already complete. The problem is that, as such, they usually also remain merely possible worlds, their actualisation being rendered impossible by their already given completeness. Other worlds can only be actualised vectorially—that is, as a consequence of more localised, regional gestures pointing towards a horizon that is not already given. Rather than grand, already unified projects, what we need are universalist-oriented projectiles. It is important here to note that the desert depicted in Tansey's painting is nothing like the tabula rasa that modernist architects longed for, but more like the contingent, indifferent space that lies beneath and beyond all already-existing worlds. To posit that behind any true constructive act there lie saturated ruins emphasises the fact that a construction implies a projection whose beams work at once forward and backward: any true constructive act is an act that not only envisions a future that does not exist yet, but that also posits, at the same time, the construction site from which this future might become possible. Rather than concentrating on vague, imaginary futures, today there is a need to first render the present more contingent than it is presented to be; there is a need to show, demonstrate, and prove that the world in which we live is neither necessary nor complete. Extrapolating from both Goodman and Negarestani, I would argue that, since the other world to be constructed is always constrained by the world it remakes, the proper description of the present moment from which it is launched is as important as the future-oriented claim it makes. Rather than trying to define what makes a project in terms of the difference between what already exists and what is proposed, we should focus on showing that the strength of a given projectile can primarily be gauged by the difference it makes in the description of the present that it proposes. In other words, the criterion should not, as in classical politics, be located between a consensual account of the present and the differences that exist between the different future-oriented propositions that are made from this standpoint, but between propositions that already differ in the way they define the starting point from which they set out.

Following Negarestani, I would argue that what we could call an architectural projectile is bound to a projective principle whose transformative trajectory can only be assessed and validated through the way it systematically retro-engineers itself so as to make as explicit as possible not its endpoint but its consistent yet revisable *aim*, primarily defined according to the way it transforms the site from

which it sets out into a launchpad. Conceptualised in this way, such projectiles should define design gestures that do not involve grounding ourselves in what may be articulated either as fixed departure points (such as human nature) or as idealised horizons (such as the classless society imagined by Marxism), but which instead involve orienting ourselves according to an open-ended yet rule-based horizon (in the sense in which rules can be explained and criticised) whose ultimate value can only be assessed through the practical implications it can actually have in *this* world.

Matthew Poole

Allography and the Baroque Agency of the Objectile

It has been over twenty-five years now since the publication of the first English translation of Gilles Deleuze's influential book *The Fold* in 1993.[1] In that time, a vast array of often hilarious architectural pastiches[2] apparently inspired by and often claiming to represent the ideas in Deleuze's book have been constructed around the globe, and much has been written in architectural discourse on folds, folding, points of inflection, tolerances, affordances, flows, blobs, etc.[3] Very rarely is the question of how to resolve the endemic fissure between conception and material process in the relationship of design method and the construction of 'designed' things addressed, or made apparent in the manifestations of designers and architects who claim to have embedded Deleuze's ideas into their constructions. This essay approaches several key questions about digital design processes of production, and the potential that digital electronic design and digital electronic fabrication tools have for creating 'non-standard seriality' or 'mass variability' as a viable mode of practice in design, fabrication, and manufacture that can address and theoretically overcome this fissure by considering the 'objectile' as a fundamental conceptual and material building format that has the flexibility and agency appropriate to the task.

1. G. Deleuze, *The Fold: Leibniz and the Baroque*, tr. T. Conley (London: Athlone, 1993).
2. Notable examples of geometrically 'folded/folding' buildings include: the Health Department Building, Bilbao, Spain, by Coll-Barreu Arquitectos (2004); Klein Bottle House, Rye, Victoria, Australia, by McBride Charles Ryan (2008); the Centre for Sustainable Energy Technologies, Ningbo, China (Nottingham University), by Mario Cucinella Architects (2008); and Kyushu Geibun Kan Museum, Fukuoka, Japan, by Kengo Kuma (2013). Notable buildings that 'flow' or are 'blobs' include: Galaxy SOHO, Beijing, China, by Zaha Hadid Architects (2012); Phoenix International Media Center, Beijing China, by BIAD UFO (2012); and Arte S, George Town, Penang, Malaysia, by SPARK (2018). There are many more examples to choose from.
3. Some good examples of volumes include: G. Lynn (ed.), *Architectural Design* 63, 'Folding in Architecture' (1993); M. Toy (ed.), *Architectural Design* 68:5, 'Hypersurface Architecture' (1998), S. Perrella (ed.), *Architectural Design* 68:6, 'Hypersurface Architecture II' (1999); B. Caché, *Projectiles* (*Architecture Words* 6) (London: Architectural Association Press, 2011); B. Caché, *Earth Moves: The Furnishing of Territories* (Cambridge, MA: MIT Press, 1995).

From this, questions arise concerning a specific model of ontology appropriate to these 'objectiles' (as design theorist/philosopher Bernard Caché [1958–] would call them), namely, *the Baroque*, as addressed in Gilles Deleuze's (1925–1995) reading of Gottfried Leibniz's (1646–1716) monadology.[4] In asking these questions, we can begin to consider the possible ways in which nontrivial examples of objectiles can be recognised as a form of practical language from which and into which worlds unfold, and within which all sorts of unusual occurrences enfold and unfurl toward a reconsideration of the practical overcoming of the problem of the 'translation' of design concepts into functioning constructions.

These questions include: What happens to our orientation with respect to a world and the things therein (including ourselves) when we consider a thing not as an object but as a brief snapshot of a process? How can we adequately describe processes of change from within a changing world in which we are situated, and within which *we*, and our perspective, are changing? And hence: What might agency look like in the light of such a pragmatist practice of living within a world that is constantly changing, where we accept that our perspective is always and already partial and contingent, and where the classical Cartesian relationship of objects to concepts, predicates, and principles is torn apart?

For context, we begin with art historian Mario Carpo's 2011 book *The Alphabet and the Algorithm*,[5] which presents an accessible first introduction to the concept of 'the objectile', to the work of Bernard Caché, and to Deleuze's work on this notion. The key issue in Carpo's book is the relationship between identicality and variability in architectural and mass production design. He argues that the innovative notational and diagrammatic design schemata of Renaissance architect Leon Battista Alberti (1404–1472) create a definitive break with classical and Gothic architectural practices, which Carpo describes as 'allographic', and in which typically a group (Greek *allos*, 'others') of collaborators (authors)—the chief builder (the 'architect'), the patron, the stonemasons, the carpenters, etc.—would have agential input over time, often considerable amounts of time, even several decades in the case of cathedrals for example, into the design (Greek *graphé*, to carve or draw out) of a building. He argues that Alberti, by

4. G.W. Leibniz, *The Monadology* [1712–14, originally published 1720], tr, R. Latta, <https://www.plato-philosophy.org/wp-content/uploads/2016/07/The-Monadology-1714-by-Gottfried-Wilhelm-LEIBNIZ-1646-1716.pdf>.

5. M. Carpo, *The Alphabet and the Algorithm* (Cambridge, MA and London: MIT Press, 2011).

contrast, is the first 'modern' architect/designer, in that Alberti invents a singular individuated 'autography' by innovating a complex system of diagrams (effectively blueprints) and even an alphanumerical coding (effectively an algorithm) of the designs for his edifices, to ensure faithful identical production and possible reproduction of them by builders other than himself. Carpo's book develops the observation that, after approximately five hundred years of autographical design of the Albertian kind, digital scripting design software today reintroduces allography into the design process, because it operates using rapid iterative methods that respond to changing flows of inputted data. Thus all aspects of the data, including how and by whom it was gathered and manipulated, the software (and its makers), designers, and the hardware (and its makers) are intricately imbricated in the processes of design that use these tools and the processes that they afford. From this, Carpo moves to the concept/phenomenon of 'the objectile'—a singular phenomenon with predicates that are malleable across time and space: what Levi Bryant has called 'the adventure of the object'.[6] Or, rather, a phenomenon or event wherein predicates, principles, or concepts may in fact not be absolutely predetermined.

The following quote from Carpo summarises his main thesis:

Modern architectural authorship came into being only with the rise of what I have called the Albertian paradigm—the definition of architecture as an *autographic* art, and of building as the notationally identical copy of a single, authorial act of design. Even though it was never really fully implemented, not even in the twentieth century, this paradigm has nevertheless inspired most of Western architecture for the last five centuries, as it is at the basis of the dominant legal framework that still regulates the global practice of the architectural

6. 'This concept of objects as events is the most difficult thing of all to think. Our tendency is to think objects as *substances* in which predicates inhere. Take, for example, Aristotle's categories. All of these categories are predicates that can be attributed to a substance. As I have argued elsewhere […] the concept of substance responds to a real philosophical problem. This problem is the endurance of entities through or across time as this object. I denote this substantiality of the object with the expression "the adventure of the object" to capture the sense in which objects are ongoing happenings or events. In other words, events are not something that simply *happen* to an object as in the case of someone being granted a degree while nonetheless remaining *substan*-tially the same. Rather, objects *are* events or ongoing processes.' L. Bryant, 'Objectiles, Differencing and Events', <https://larvalsubjects.wordpress.com/2009/09/29/objectiles-differencing-and-events/>.

profession. It was at the dawn of modernity that Alberti forcefully shaped that pervasive and essential tenet of Western humanism, asserting that works of the intellect, including architectural works, have one author, and one archetype, which executors are required to reproduce identically and prohibited from altering. And this is the paradigm that recent developments in digital technologies are now phasing out.[7]

What Carpo is referring to here, when he talks about the phasing out of this tenet of Western humanist autography and the waning of the paradigmatic agency of artists, authors, and designers—or in this case architects—is the reality that we see all around us today of the mass production of variable series of goods, or, in other words, cost-effective 'non-standard seriality' in digital fabrication processes. This technological capability has arisen with tools such as BIM (Building Information Management design software), parametric scripting design software, 3D printers, CNC (Computer Numerically Controlled) routers, laser cutters, etc. The processes of digital electronics controlled machinofacture are able to produce series of variable objects with the same efficiency as the production of identical objects. Also, the software that is used to model such things and to control the fabrication tools is capable of producing a series of objects that are not so much related by their outputted physical characteristics but rather by the key conceptual characteristics determined by an algorithm or algorithms—in other words, the parameters of a variable curve of possible physical characteristics determined in the last instance by data that is effectively flowed through the algorithm, or script, which presents a malleable determination of the myriad possible outputs in the first instance.

A simple example would be the production of a series of nominal 'cubes' via, for example, a 3D printer, where the first is what we typically consider a cube and the last what we typically consider a pyramidal form—with incrementally less 'cubey' and more 'pyramidesque' versions in between. In actual fact, of course, none of them would be considered Platonic cubes as such in this process, as they are all simply forms that operate as temporally halted diagrams or snapshots

7. Carpo, *The Alphabet and the Algorithm*, 117.

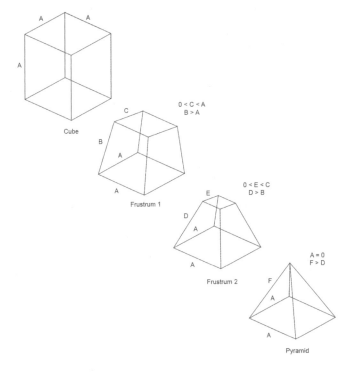

of the capabilities, or possibilities, of the algorithm's functional operation in process—i.e. of the differential calculus that relates to them all and places them all in relation to one another metastructurally.

As Carpo points out:

> Most mechanically reproduced objects and forms are unmediated indices of the imprint that made them; most handmade works of the pre-mechanical age, as well as most algorithmically generated items of the digital age, are not. The erratic drift of manual copies may distort or confuse the sign of the original archetype and, as a result, conceal the identity of its author, or make it irrelevant; the unlimited variances of high-tech digitally controlled differential reproduction may have similar consequences.[8]

8. Ibid., 101.

Carpo is correct that from a classical Cartesian humanist perspective the sign of the archetype and the status of authorship may be made irrelevant, or at best may be distorted or confused, in the possible drifting of the digitally controlled differential reproduction process, but he neglects to interrogate the possible nuances of what authorship is, can be, and has been, and also neglects to ask whether this 'drifting', 'distorting' or 'confusing' of the 'sign of the archetype' is a problem or not. It is clearly highly likely that it *is* a problem for him, and certainly for his hero Alberti, but it may in fact be that the classical Cartesian humanist perspective that he adheres to in this respect is a significant limiting factor in overcoming substantial and substantive problems in the construction of possible worlds other than the one within which we are now, today, seemingly trapped. In a neoliberal capitalist world of 'governmentality' where subject and object, consumption and production, and individual and collective, for example, are concepts that are substantively imbricated, and where the self and subjectivity operate as objects of exchange and components of capital, the dyads of classicist and/or modernist principles do not help solve the problems that exist, nor do they help in the production of possible solutions that are required to create future worlds in which those problems might be alleviated—precisely because they form the underlying tenets of these problems.

Carpo does, however, argue this point, which brings up an important issue:

> Nonstandard technologies promise to alleviate [a] tax on diversity [that Modern design/production identicality enforces]. But this is the very reason why some may resent or reject nonstandard technologies. An egalitarian society posits some degree of equality in the forms and functions of all items of consumption and use, and mass customization goes counter to this ideological tenet. Technologies for nonstandard production may also appear to expand and multiply the offer of some commodities beyond necessity, hence fostering artificial demand and consumption.[9]

But here Carpo misrecognises egality as equality, and should have considered equity. Equal access (egality) to, for example, resources for dwelling has to take into consideration the variable sizes of humans. A big person needs a bigger

9. Ibid., 102.

	CRAFT	MASS PRODUCTION	MASS CUSTOMIZATION	PERSONALIZED PRODUCTION
GOAL	SUSTAIN-ABILITY	SCALE	SCOPE SCALE	AFFECT VALUE SCOPE SCALE
CHARACTER-ISTICS	QUALITY	COST QUALITY	VARIETY COST QUALITY	EFFICACY VARIETY COST QUALITY
CONSUMER ROLE	COMMISSION	BUY	CHOOSE BUY	DESIGN CHOOSE BUY
SYSTEM	MANUAL INDIVIDUATED	DEDICATED SERIAL	RECONFIGUR-ABLE BATCH SERIAL	ON DEMAND NON-STANDARD SERIAL

space than a small person—it is more equitable. So in fact, metastructural variability (i.e. non-standard seriality) *should* be at the very heart of an egalitarian social architectural project for something like the efficient and equitable distribution of resources for the production of dwellings. What is needed in such a project is serial variability.

As for Carpo's point about consumption, he is right that consumerism is further fuelled by the ever more individuated baubles and trinkets made possible by such technologies (for example, personalised individuated fidget-spinners),[10] but it is not intrinsically driven by the existence of such possibilities. Rather, it is driven by the calculations of risk and profit by makers of and investors in such things, irrespective of whether such things are individuated or directly personalised or not. In an imaginary communist society, by contrast, a metastructural differential calculus would be crucial in order to calculate and apportion adequate equitable resources for each individual according to myriad fixed values that they themselves cannot change, such as various personal biological factors, or

10. In case the reader is reading this in a future where fidget-spinners are no longer in such high demand or indeed have been forgotten, they were a global phenomenon in 2017–18, selling in the hundreds of millions in almost every country of the world over a period of approximately twelve months. A fidget-spinner is a small handheld toy made with two or more ball bearings connected by plastic or other material in different shapes and colours. Held between the thumb and forefinger, the toy would spin very fast with very little effort; a charming distraction for children and adults alike.

local and global environmental factors related to where they dwell or where their activities have farther reaching effects, etc.

Whilst such obviously and explicitly practical matters are very important in this analysis, it is crucial first to understand the way in which such nonstandard series force us to change our consideration of the relationship of objects to predicates. As Carpo correctly identifies in his discussion of Deleuze's book:

> As Deleuze had remarked, Leibniz's mathematics of continuity introduced and expressed a new idea of the object: differential calculus does not describe objects, but their variations (and variations of variations). Deleuze even intro-duced a new term to characterise this two-tiered definition of the object—the 'objectile', a function that contains an infinite number of objects. Each different and individual object eventualizes the mathematical algorithm, or objectile, common to all; in Aristotelian terms, an objectile is one form in many events.[11]

Carpo also cites one of the key contemporary architects influenced by Deleuze, Peter Eisenman, stating that

> Eisenman replaces Deleuze's 'objectile' with the related and equally Deleuzian concept of 'object-event': the moving and morphing images of the digital age break up the Cartesian and perspectival grids of the classical tradition, and invite architectural forms capable of continuous variation—forms that move in time.[12]

To be fair, Eisenman's writing is more sophisticated than this citation from Carpo would have you believe, as Eisenman is able to think and embed in his buildings the atypical conceptions of objects and predicates—and also time—found in Deleuze's writings, to which we now turn.

Deleuze's book *The Fold: Leibniz and the Baroque*, written in 1983 and pub-lished in English translation in 1993, is essentially an explication of the metaphysics of his own philosophical edifice. In this book Deleuze enthusiastically elaborates upon Leibniz's metaphysics as outlined in the ninety short paragraphs of the *Monadology*, written between 1712–1714 in Vienna and originally published in German in 1720.

11. Ibid., 91.
12. Ibid., 87.

Leibniz's ontology seeks, as any study of being should, to account for the question of difference, i.e., how it is that things/objects/beings appear to be different, given that all things come from other things in one way or another, and hence are all related in a unity at some level somehow; essentially, he seeks to account for the idea that no *thing* can come from no*where*—things must come from somewhere.

But how to account for change? In this, Deleuze is fascinated by the folding, unfolding, and enfolding of things from the two types of monad that ground Leibniz's thesis: 'matter' and 'souls'. In the following passage Deleuze succinctly states Leibniz's ambitions:

> There we have a unique trait that is found only in Leibniz's philosophy: the extreme taste for principles, far from favouring division into compartments, presides over the passage of beings, of things, and of concepts under all kinds of mobile partitions. In the midst of this extraordinary philosophical activity, which consists of the creation of principles, we might state that it is the least of principles that there are two poles, one toward which all principles are folding themselves together, the other toward which they are all unfolding, in the opposite way, in distinguishing their zones. These two poles are: Everything is always the same thing, there is only one and the same Basis; and: Everything is distinguished by degree, everything differs by manner... These are the two principles of principles. No philosophy has ever pushed to such an extreme the affirmation of a one and same world, and of an infinite difference or variety in this world.[13]

In fact, much like *The Fold* itself—a book the chapters of which can be read in any order, as stated in the introduction by the English translator Tom Conley— this passage can also be (and is probably better) read backwards—unfolding its folds—starting with the last sentence, followed by the middle sentence, and finally the first sentence:

> No philosophy [other than Leibniz's] has ever pushed to such an extreme the affirmation of a one and same world, and of an infinite difference or variety in this world.

13. Ibid., 66.

[There are] two poles [in this philosophy]: Everything is always the same thing, there is only one and the same Basis; and: Everything is distinguished by degree, everything differs by manner [...] These are the two principles of principles.

In the midst of this extraordinary philosophical activity, which consists of the creation of principles, we might state that it is the least of principles that there are [these] two poles, one toward which all principles are folding themselves together, the other toward which they are all unfolding, in the opposite way, in distinguishing their zones.

There we have a unique trait that is found only in Leibniz's philosophy: the extreme taste for principles, far from favouring division into compartments, presides over the passage of beings, of things, and of concepts under all kinds of mobile partitions.

The 'mobile partitions' that Deleuze mentions here have a devastating effect on Platonic and Cartesian models of difference. As he explains:

Difference no longer exists between the polygon and the circle, but in the pure variability of the sides of the polygon; difference is no longer between movement and inertia, but in the pure variability of speed. Difference ceases being extrinsic and palpable (in this sense it vanishes) in order to become intrinsic, intelligible or conceptual, in conformity with the principle of indiscernibles.[14]

He then goes further, outlining the fundamental rupture with Classical reason characteristic of Leibniz's thought and his own, by introducing the Baroque function:

The Baroque solution is the following: we shall multiply principles—we can always slip a new one out from under our cuffs—and in this way we will change their use. We will not have to ask what available object corresponds to a given luminous principle, but what hidden principle responds to whatever object is given, that is to say, to this or that 'perplexing case'. Principles as such will be

14. Ibid., 74–5.

put to a reflective use. A case being given, we shall invent its principle. It is a transformation from Law to universal Jurisprudence.[15]

As a function, the Baroque, for Deleuze, shows how trivial and limiting the Cartesian-Modernist distaste for the Baroque has been. In the violent tumultuous waves of folding and unfolding within the function of the Baroque, Deleuze is describing not the mere transgressing of the frame, as in art-historical conceptions and categorisations of the Baroque, but a twisting and atomising of the very conditions for framing by the force of constant eruption of what may have been (incorrectly) considered to be held within a frame, to the point at which this presumed frame is unrecognisable. As he states very clearly at the very beginning of *The Fold*:

> The Baroque refers not to an essence but rather to an operative function, to a trait. It endlessly produces folds. It does not invent things: [...] Yet the Baroque trait twists and turns its folds, pushing them to infinity, fold over fold, one upon the other. The Baroque fold unfurls all the way to infinity.[16]

And in considering this proliferation of folds, or inflections from unity to multiplicity and back again, Deleuze is able to topple Cartesian reason, criticising its inability to recognise and account for the necessity of contingency in describing and accounting for the relationship of unity and multiplicity:

> A labyrinth is said, etymologically, to be multiple because it contains many folds. The multiple is not only what has many parts but also what is folded in many ways. A labyrinth corresponds exactly to each level: the continuous labyrinth in matter and its parts, the labyrinth of freedom in the soul and its predicates. If Descartes did not know how to get through the labyrinth, it was because he sought its secret of continuity in rectilinear tracks, and the secret of liberty in a rectitude of the soul. He knew the inclension of the soul as little as he did the curvature of matter.[17]

15. Ibid., 76–7.
16. Ibid., 3.
17. Ibid.

This metastructural ethics—essentially an eccentric form of pragmatism—where principles are effectively applied on a case-by-case basis, and are not considered a core or central point around which action is oriented—is also addressed by Ray Brassier in his reading of Deleuze and Félix Guattari's *A Thousand Plateaus*.[18] In an essay titled 'Concrete Rules and Abstract Machines', Brassier describes what he calls a 'machinic pragmatics' that is inherent in the materialist ontology outlined in *A Thousand Plateaus*:

> [T]he materialism laid claim to in *A Thousand Plateaus* is unlike any (other) [...]. It does not pretend to accurately represent an objectively existing 'material reality' (whether natural or social), just as it does not propose practical imperatives derived from universal laws (whether natural or social). It seeks to conjugate an 'abstract matter', conceived independently of representational form, with a concrete ethics, wherein action is selected independently of universal law.[19]

Brassier goes on to describe how

> [h]ere the abstract is no longer the province of the universal (invariance, form, unity) and the concrete is no longer the realm of the particular (the variable, the material, the many). The abstract is *enveloped* in the concrete such that practice is the condition of its development.[20]

Such a dissolution and reorientation of the dyad of *the abstract* and *the concrete* then has a profoundly disruptive and disintegrating effect on typical conceptions of authorship, or, in this case specifically, designing, because it posits no linear developmental track upon which one could locate a beginning, middle, and end of the given process of 'creation' or 'production'. Hence it submerges the author, or designer, in a surging, undulating field of forces that is at best only partially (if at all) under their control. Typically, we might

18. G. Deleuze and F. Guattari, *A Thousand Plateaus: Capitalism and Schizophrenia*, tr. B. Massumi (Minneapolis: University of Minnesota Press, 1987).
19. R. Brassier, 'Concrete Rules and Abstract Machines: Form and Function in *A Thousand Plateaus*', in H. Somers-Hall, J.A. Bell, and J. Williams (eds.), *A Thousand Plateaus and Philosophy* (Edinburgh: Edinburgh University Press, 2018), 1.
20. Ibid.

imagine that the role of the author or designer was to reveal the relationship

between the invariant unified *abstract* and the concrete particular which they
create (i.e. it is typically presumed that the concrete particular artefact that
the author/designer creates takes its form from predicates determined by the
supposedly extrinsic abstract or archetype to which the artefact aspires). We
might imagine this as a typical process of ascribing 'meaning' to that particular
concrete object. However if, as Brassier interprets Deleuze and Guattari as
saying, the abstract is no longer predicated upon invariance, form, and unity
and the concrete is no longer predicated upon particularity, then the location
of meaning as such—which includes practical functionality in the case of
designed functional phenomena such as buildings—is not only impossible to
locate, but is also impossible to prescribe (in the sense of recommending a
meaning or function to a thing) or proscribe (in the sense of determining or
limiting certain meanings or functions of a thing). This may mean that the five
hundred years of architectural practice as described by Carpo—from Alberti
to the present day—were not really practice at all, but rather some form of
sadomasochistic social delusion, a tyranny predicated upon the tenets of
Classical and Renaissance Humanism, which continue to underpin the tenets
of modern Western liberal humanism that Carpo briefly mentions.

Following the statement quoted above, Brassier explains the ramifications
of Deleuze and Guattari's edifice of 'stratification' (or foldedness) for our con-
ception of 'abstraction':

It is this development which is rule-governed, but in a sense quite independent
of the familiar juxtaposition of invariant rule to variable circumstance. Rules are
no longer abstract invariants that need to be applied to concrete or variable
circumstances. 'Abstract' now means unformed and ultimately, as we shall see,
destratified. [...] But the unformed is endowed with positive traits of its own,
traits which, from the viewpoint of the representation of 'material reality', are
initially confounding. Thus abstract matter is described as constituting a 'plane
of consistency' characterised by 'continuums of intensities', 'particles-signs' and
'deterritorialized flows'. Moreover, Deleuze and Guattari insist that this plane of
consistency (which they also call 'multiplicity') must be made, since it is not

given: [...] Consistency (or multiplicity) is made by mapping what is unrepresented in both thinking and doing.[21]

Hence Brassier is able to outline the function of Deleuze and Guattari's ethical model, which gives us some clear insights into what a properly DeleuzoGuatta-rian authorial (or design) practice might orient its operations towards:

[F]or 'machinic pragmatics', the efficacy of performance can no longer be subordinated to pre-established standards of competence. So long as practice is subordinated to representation, it can only more or less adequately trace a pre-existing reality, according to extant criteria of success or failure. But machinic pragmatics is not geared towards representation; it is an experimental practice oriented towards bringing something new into existence; something that does not pre-exist its process of production. It de-couples performance from competence. It does not engage in utilitarian tracing of the real; it gen-erates a constructive mapping (and as we shall see, a diagramming) of the real: 'What distinguishes the map from the tracing is that it is entirely oriented towards an experimentation in contact with the real. The map does not repro-duce an unconscious closed in upon itself; it constructs the unconscious [...] The map has to do with performance, whereas the tracing always involves an alleged 'competence'.[22]

Now, this brings us back to the question of predicates, and the way in which Deleuze is able to upturn the functional relationship of predicates to objects:

In short, in Leibniz we have an entire history of the concept that goes through the wholes-and-parts, things and substances, by means of extensions, intensions, and individuals, and by which the concept itself, in conformity with each level, becomes a subject. A rupture is opened with the classical conception of the concept as a being of reason: the concept is no longer the essence or the logical possibility of its object, but the metaphysical reality of the corresponding subject.

21. Ibid., 2.
22. Ibid., 4 (Deleuze and Guattari, *A Thousand Plateaus*, 13).

It can be stated that all relations are internal, precisely because the predicates are not attributes (as in the logical conception).[23]

Here, Deleuze's exorcising of the concept from the object invigorates the subject, creating the conditions for this 'machinic pragmatics'; what he calls a form of 'perspectivism' (one which, he later admits, he extrapolates from Friedrich Nietzsche's writings). If the concept is not the essence of the object, the bundle of invariant predicating attributes necessary for the partition of categorisation to distinguish one object from another, then it becomes necessary to site the process of conceptualisation as 'a world', literally.

In fact, Deleuze lays this out quite clearly:

The world is predication itself, manners being the particular predicates, and the subject, what goes from one predicate to another as if from one aspect of the world to another. The coupling *basis-manners* disenfranchises form or essence: Leibniz makes it the mark of his philosophy. The Stoics and Leibniz invent a mannerism that is opposed to the essentialism first of Aristotle and then of Descartes. Mannerism as a composite of the Baroque is inherited from a Stoic mannerism that is now extended to the cosmos.[24]

And because of this, because the world is predication itself, predication cannot then be considered as a typical stable attribute of a given object. Rather, predication is a state of changing affairs, changing in relation to the vantage point of the subject and its travelling from one predicate to another—'from one aspect of the world to another'.

To help clarify the above, it is worth noting that prior to this, Deleuze also states that

[p]redicates are never attributes except in the case of infinite forms or first quiddities; and even there they are more like conditions of possibility for the notion of God, nonrelations that would condition any possible relation. Now in all other cases the predicate is only a relation or an event. Relations themselves are types

23. Deleuze, *The Fold*, 61.
24. Ibid.

of events, and problems in mathematics. In antiquity predicates were defined by events that happen to figures. Events in their turn are types of relations; they are relations to existence and to time.[25]

And he reiterates, explaining this in respect of the Baroque function:

> Here we have a Baroque grammar in which the predicate is above all a relation and an event, and not an attribute. When Leibniz uses the attributive model, he does so from the point of view of a classical logic of genres and species, which follows only nominal requirements. He does not use it in order to ground inclusion. Predication is not an attribution. The predicate is the 'execution of travel,' an act, a movement, a change, and not the state of travel. The predicate *is the proposition itself,* and I can no more reduce 'I travel' to 'I am a traveling being' than I can reduce 'I think' to 'I am a thinking being.' Thought is not a constant attribute, but a predicate passing endlessly from one thought to another. That the predicate is a verb, and that the verb is irreducible to the copula and to the attribute, mark the very basis of the Leibnizian conception of the event.[26]

And this explains why he was able to state earlier in the book that

> [t]he Baroque is widely known to be typified by the 'concetto,' but only insofar as the Baroque *concetto* can be opposed to the classical *concept.* It is also widely held that Leibniz brings a new conception to the concept, with which he transforms philosophy. But we have to wonder about the composition of this new, Leibnizian conception. That it is opposed to the 'classical' conception of the concept—in the way that Descartes had invented it—is best shown in Leibniz's correspondence with De Volder, a Cartesian. First of all, the concept is not a simple logical being, but a metaphysical being; it is not a generality or a universality, but an individual; it is not defined by an attribute, but by predicates-as-events.[27]

25. Ibid., 59.
26. Ibid., 60.
27. Ibid., 48.

Which in turn is why it is necessary for Deleuze to abandon the dyad object-subject, replacing it with 'objectiles' (which he actually borrows from his friend and sometime collaborator Bernard Caché) and 'superjects' (which he borrows from Alfred North Whitehead), where the objectile itself is an event enfolded in a process of predication, and as such can be considered as a diagram of matter in and as motion. Also, as matter in and as motion—in the full dynamics of change—the objectile is inseparably constituted from its conditions of possibility (i.e. its context) and hence cannot be related substantively to an a priori stable universal concept.

So, for Deleuze our conception of substance has to be reoriented to accommodate the fact of change, and to consider substance as an enfolding. To this end, he says:

> Substance therefore represents the double spontaneity of movement as event, and of change as predicate. If the true logical criterion of substance is inclusion, it is because predication is not an attribution, because substance is not the subject of an attribute, but the inner unity of an event, the active unity of a change. [...] Leibniz shows that Descartes does not push the concept far enough: two things can be thought as being really distinct without being separable, no matter how little they may have requisites in common. Descartes does not see that even simple beings and even individual substances have requisites, even if it were in the common world that they express, or in the inner characters toward which they converge (form-matter, act-force, active unity-limitation). We have already seen that the really distinct is neither necessarily separate nor separable, and the inseparable can be really distinct."[28]

And then following this last passage, Deleuze lists the criteria of substance in this ontology:

> Thus there are five criteria of substance: (1) metaphysical, unity of being; (2) logical, inclusion of the predicate in the subject; (3) physical, inner unity in movement; (4) psychological, active unity of change; (5) epistemological, the requisites of inseparability. None permits substance to be defined by an essential

28. Ibid., 63.

attribute, or predication to be confused with an attribution. [...] Essentialism makes a classic of Descartes, while Leibniz's thought appears to be a profound Mannerism. Classicism needs a solid and constant attribute for substance, but Mannerism is fluid, and the spontaneity of manners replaces the essentiality of the attribute.[29]

It is in these comments, on the Mannerisms of the Baroque and their transitional destabilising function, that we can hear the harmonics of Deleuze's political positioning of this ontology. Since, as he states in this next quote, the Baroque is the force of making accords—of finding and folding along points of inflection, with dissonant, discordant, and divergent incompossibilities—by further folding, unfolding, or enfolding them, we can perhaps surmise that here, in a coded way (we might also say in an 'accelerationist' manner/mannerism), Deleuze is presenting a positive and hopeful understanding of how the dissonant, discordant, and divergent incompossibilities of societies infected/inflected by the virulence of capitalism's many and varied operative machines may move beyond or through current conditions, even if this comes at the cost of what, in the following passage, turns out to be the radical collapse of given epistemological systems:

> We can better understand in what ways the Baroque is a transition. Classical reason toppled under the force of divergences, incompossibilities, discords, dissonances. But the Baroque represents the ultimate attempt to reconstitute a classical reason by diving divergences into as many worlds as possible, and by making from incompossibilities as many possible borders between worlds. Discords that spring up in the same world can be violent. They are resolved in accords because the only irreducible dissonances are between different worlds. In short, the Baroque universe witnesses a blurring of its melodic lines, but what it appears to lose it also regains in and through harmony. Confronted by the power of dissonance, it discovers a florescence of extraordinary accords, at a distance, that are resolved in a chosen world, even at the cost of damnation.[30]

29. Ibid., 63–4.
30. Ibid., 92–3.

In the face of this epistemological collapse and simultaneous flowering (flores-cence)—this harmonics of forces—it is difficult now to describe or imagine the role of the author/artist/designer, even in terms of the allographic collaborative model discussed by Mario Carpo, because if we take this baroque monadological ontology seriously then the complicity of authorship in processes of change is total, and therefore the grapheme—what is carved out or drawn out—emerges because of the specific interactions of all of the elements of the conditions of possibility in a given point of inflection in a dynamic system, with no one element being more catalytic than another. In this way, we can see again how the locus of a proprietary authorial power or intent (even within a collaborative grouping of several or many other proprietary authorial powers or intents working together) is evacuated.

Even further than this, in a final quote from Deleuze we can see again the nuance of how Deleuze is presenting the Baroque function of a monadological ontology as highly corrosive to systems such as those within the various forms of existent capitalism, and that there is something extremely hopeful here:

> Finally, a monad has as its property not an abstract attribute—movement, elasticity, plasticity—but other monads, such as a cell, other cells, or an atom, and other atoms. These are phenomena of subjugation, of domination, of appro-priation that are filling up the domain of having, and this latter area is always located under a certain power (this being why Nietzsche felt himself so close to Leibniz). To have or to possess is to fold, in other words, to convey what one contains 'with a certain power.' If the Baroque has often been associated with capitalism, it is because the Baroque is linked to a crisis of property, a crisis that appears at once with the growth of new machines in the social field and the discovery of new living beings in the organism.[31]

If, in direct contrast to the basic and founding tenet of any form of capitalism, the Baroque function of folding/unfolding is, as Deleuze states above, the conveyance of what one contains/possesses 'with a certain power', then it is a function of centrifugal forces pushing what the one (a monad) contains/possesses (has) away from the central nodal point of the one (of the monad

31. Ibid., 125–6.

itself)—the folding/unfolding, spilling out, florescing/flowering. Quite unlike capitalist functionality, then, founded as it is upon classical Cartesian humanist ontology which functions in precisely the opposite way, with centripetal forces bringing all those things that the one possesses or has or desires toward the one, holding them in orbit around the central axis that is the locus of the humanist individual. We may therefore ask whether Deleuze is here proposing a possible postcapitalist world (a rethinking of communism) as a Baroque eruption from within the possible conditions of the existent crises of existing capitalism.

If we are to design, and therefore construct, possible worlds in and beyond a capitalist world, then some of the practical functioning steps to do so could be found here in Deleuze's understanding that any act of possessing (of having) is always also an act of being; that the functional ontic structure of any form of property (in the sense of an 'object' being owned by a 'subject') is a processual enfolding of other forms of property; that other property sits within and is held within it. In this sense, a form of property does not have properties that are invariant abstract attributes, but rather contains other subjugated, dominated, and appropriated forms of property enfolded within it, constituting it, and this collection of property is able to change, to be added to or depleted by degrees, and so is never categorically different to any other property. Properties, typically confined to the role of functional invariant abstract attributes of objects, making up a categorical array that defines any 'object' or form of property, must be then conflated with and as predicates (i.e. linguistic attributes) in the formation of property—here defined as the act of being. In other words, things (property) and their properties are simply (although it is always a very complex affair) the product of discursive force (i.e., what we can reasonably 'say' about them), which is always a dynamic and contingent field of activity.

Thus, if we accept that any 'thing' is an objectile, which is to say a functional and functioning diagrammatic field of force that must be simultaneously harnessed and unpacked (that is, simultaneously enfolded and unfolded, or refolded), then our designing of possible worlds must be literally a conversational process, which is necessarily always allographical, and will be a process of unpacking—a process of *de*-signing, of proliferating principles (as in baroque processes), as opposed to the more typical process of *assigning*, the radical deduction of principles (as in, for example, capitalist processes) that has haunted and constrained

design for five hundred years since Alberti's innovations in building, and which during that time underpinned the principles of Western humanism, and more recently Western humanism's reformation/deformation under capitalism as neo-liberal governmentality, the tenets of which must be simultaneously enfolded and unfolded, or refolded into any re-designing of our world that seeks to unconstrain us from the endemic and increasingly violent subtractions in all aspects of life we currently face. In this way, design would no longer be the solving of problems on the basis of extant given principles, but rather, by contrast, would become the process of *dissolving* problems in a tumultuous flow of the production of new principles; i.e. a truly imaginative process.

TERRITOIRE DE L'ART
TERRITORY OF ART

Drawings: HW Architecture

Elie Ayache
The Only Possible Project

Light

Down with the world.[1] It is no longer a question of finding an alternative to the world, but of bringing it down, together with any vision of an alternative. The world is so exposed to the light of capital, so heavily surveyed and surveilled by its searchlights, that any alternative construction, projected under the same light, cannot really qualify as an alternative. One even wonders whether possibility as such, as when we talk of 'possible worlds' and of other ways that the world 'could possibly be', is not itself the light that must first be turned off.

Speculation, or trying to mirror this world beyond its empirical evidence, trying to think what this world may possibly be made of in order to imagine other ways it can possibly be, is first and foremost a question of light. For this reason, speculation in this sense may not be the right way to construct other worlds. We are sick and tired of alternatives that seem to vary from the actual world only for us to realise that they are mere speculations, configurations of light coming from the present world but reflected differently, alternative possible worlds that only extend the range of possibility emanating from the same source.

It is not for another possible world that we should be looking, but for an alternative to possibility as such. If possibility is only a decoy, something that makes us feel confident we have changed the world only to better entrap us and recuperate us into that same world, then it is possibility as such, the very instrument of confinement within the present world (that which gives us the same under the guise of the different), that must be changed. And to make this change more efficient, it ought to take place literally without leaving the present world. Rather than changing the world, it is much more powerful to change that which makes us think we have changed the world when in fact we have not, i.e. possibility as such.

1. T. Chakar, 'Down With the World', *e-flux*, <https://www.e-flux.com/architecture/super humanity/68725/down-with-the-world>. In his public talk 'Let This Darkness Be a Bell Tower', delivered at Askhal Alwan in Beirut, 29 July 2019, Chakar says: 'The call to abandon hope in these hopeless times would seem like a call to despair, a call to resign from the world that we live in.'

The variation of thinking I have in mind is that, for instance, expressed by Blanchot as follows: 'In a literary work, one can express thoughts as difficult and of as abstract a form as in a philosophical essay, but only on the condition that they are not yet thoughts.'[2] When thought is confronted with its 'not yet', when we are urged to understand what goes faster than thought and prevents it from being 'yet thought', and when we understand that this gap is of course of this world and not of another world, then all questions of other possible worlds become secondary, if not irrelevant.

Pierre Menard[3] did not change the text; he changed the whole make-up of possibility. And he managed to do so with one possibility only, that of *Don Quixote*. What enabled him to do so was its written character, the vibration or variance that is inherent in writing, and makes us believe that although his logical text is the same as Cervantes's, his written text is different. By contrast, we will need the full extent of the derivatives market in order to deliver the same critique of possibility. What Borges could deliver thanks to literature and the regime of its 'not yet thought', we can only achieve technically with the full register of derivative writings.

Blanchot was preoccupied with works of literature, which are definitely of this world. Bergson, on the other hand, lays claim to another 'not yet': he says that 'a philosophy of the real has never, in the end, been constituted'.[4] This 'never' is more urgent than the 'not yet', yet it also is not something other-worldly—indeed, Bergson speaks of the very real, the present real.

My personal conviction has always been that the resistance to thinking according to the 'not yet' (the thing that diverts thought altogether from the metaphor of light, keeping in mind that the accomplishment and even the highest degree of thinking seem precisely to lie in thought being prevented from reaching its ultimate light, or rather, in light being prevented from catching up with thought) is the resistance of matter—and that the foray of thought into matter translates into writing.

2. M. Blanchot, *The Book to Come*, tr. C. Mandel (Stanford, CA: Stanford University Press, 2003).

3. Pierre Menard is a fictional author created by Borges in his 1939 short story 'Pierre Menard, Author of the Quixote'. Menard dedicated his life to writing two chapters of *Don Quixote*, using exactly the same original (Spanish) words Cervantes used. Menard's text has a completely different meaning than the original *Quixote* and, according to Borges, is in fact far more profound.

4. H. Bergson, *L'Idée de temps: Cours au Collège de France 1901–1902* (Paris: PUF, 2019).

Writing is faster than thought, and matter is faster than light. When thought adopts writing as its medium, it can go to places the light of thought has not yet reached, places where the thought in question is not yet thought. Light, conceptual thinking, involves fixity, according to Bergson, and a succession of states of rest. To join with the real and capture its instability instead of fixity, thought must find the appropriate speed. The thread of writing will precisely appear as the critique of possible states and their fixity, and will be at variance with possibility. I have personally tried to extract it from what looked, at first blush, like the epitome of capital, namely the financial market. As I said, changing the very logic of possibility is all the more efficient if done in this way.

Matter

The only other possible world worthy of the name, the only one that does not fall under the same light, is the one we attain by changing the possible as such. Once we get to that level, possibility no longer means the same thing, and we can no longer talk of alternative possible worlds. Meillassoux proposes, for instance, to constrain the possible in such a way as to obtain the un-totalisation of possibilities.[5] This means that possibility is no longer relevant and that we reach a new category, the necessity of contingency, which I call *matter* and to which probability doesn't apply.

Changing possibility as such yields a single world. This is because we generate a new notion of reality. The reality of the financial market, or the reality of the text written by the architect after the fallen architectural project (on which more later) are such that possibility is foregone and is no longer at play. All these manners of changing possibility and generating this new reality are not alternatives *but presentations of the same thing.* Indeed, what we want to show here is that this true manner of changing possibility, because it involves matter, is the *only* construction.

When we speak of construction, we suppose matter and a tool working on and in it. We want to *construct* the possible world and no longer to speculate; we want to make sure we are holding something (matter) in our hand such that construction, not speculation, will be the result; yet we are worried that this

5. Q. Meillassoux, *After Finitude: An Essay on the Necessity of Contingency*, tr. R. Brassier (London and New York: Continuum, 2008).

something we are holding, and which is therefore definitely of this world, might end up allowing us to be recuperated by that same world. But then, if we let go of anything relating to this world, how could we guarantee that our speculation is really a construction (that is to say, that it is constrained by any reality) and is not absolute speculation, totally unbound? How even to begin imagining another possible world with nothing in our grasp from which we could take our lead?

This, once again, is an argument to the effect that possibility itself is the thing we should be holding in our hand in this world, precisely so as to change it in such a way as to get somewhere else. It will even turn out that the *holding* of possibility, or capturing its very schema and make-up, is matter. We will be holding in our hand the very medium of contingency, which is faster than light and faster than thought and is, therefore, the true beginning of the only true construction.

I am trying to argue, from the significance of *construction*, which we intend to be different from speculation and pure hope, that there is only one possible construction, one possible world to come, such that the trip towards it, or our expectation of it ('not yet'), or the way it is supposed to fulfil our expectations (which are different from hopes) dispense with all thought of possibilities. The construction is such that it must start with possibility and change it. This means engaging with a 'not yet thought' such that this engagement will make every notion of possibility fade away.

When Bergson says that the philosophy of the real has never, in the end, been constituted, his statement is in itself equivalent to dismissing the imagining of all possible worlds and turning us, instead, toward the only world, the present one—except that the requirement is to think it as real, or in other words to stop thinking it *even as possible*. It is to stop thinking it conceptually and to think it totally at variance with possibility—something which goes against the natural tendency of thought and, according to Bergson, requires a great deal of effort.

Here, thought is fundamentally turning against itself—or toward itself, not in the manner of reflexivity but more effectively than that, in a graver manner than reflexivity allows, precisely with matter and without the light of reflection, speculation, or reflexivity (faster than this light). Our equation or thesis, indeed, is as follows: Conceptual thought is equivalent to the thought of possibility. Recognizing measurable events, what probability theory calls the *algebra of*

possibilities, imagining questions that may admit of answers—this is tantamount to conceptualising. Probability theory shows formally how this is achieved, by making the concrete sample ω an element of the event *A, B,* or *C,* or by saying that a well-formed question *A, B,* or *C* has been answered. To conceptualize, to abstract, to adopt a point of view (the predefined algebra *A, B, C, ...*) over the otherwise formless and abyssal concrete situation ω is perhaps the first real usage of set theory. In this sense, probability theory is the first real arithmetic and set theory.

Thought, in a sense, is equal to possibility. By dismissing possibility, not only do we turn toward the present world and no longer imagine possible worlds, we also turn against thought itself, or against what makes it complete and crystallised. It is to think the present world in a trip of thought that takes place exclusively within it, and yet to think it faster than thought (i.e., to write it), to insert in it a thought that is not yet thought or crystallised. This is the greatest challenge; this is what makes all other thoughts of possible worlds look frivolous and fade away, and what places thought—no longer conceptual thought, but the thought of the real—before its real challenge.

Still, what is the emergency? Bergson himself recognises that the meta-physics he is calling for is useless: so how can he call 'real' what is useless?[6] Is there a real opportunity here to at last constitute the philosophy of the real, or to write thoughts that are not yet thoughts? Is the emergency anything other than purely aesthetic or contemplative (something thought does only for itself)?

With the story of the architectural project, we will learn that the alternative reality, that of writing, is the most pressing one and, in a way, the most real. If there is anything real and pressing to be constructed, after the fallen architectural project (which was destroyed before it was even built, and turned to the reality of writing instead of the reality of realisation), it is the text, the book. This is because a new notion of matter is uncovered in writing it. We dive regressively into the black matter of the city of Beirut (its infrastructure, its sewage system) and we understand what it means for Beirut that it should only be constituted of the concrete abyss that swallows back into itself every structure; and that Beirut itself is not yet thought and is only a prototype of thought.

6. H. Bergson, *Histoire de l'idée de temps: Cours au Collège de France 1902–1903* (Paris: PUF, 2016).

But before getting to the architectural project, I have in mind a new reality that will make metaphysics real, and therefore urgent: a reconfiguration of reality such that the philosophy of the real will finally be constituted, albeit within a special domain. Precisely, we will retain the construction requirement, i.e. we will construct with matter, not with light; with writing, not with speculative thought.

Surface

In the special realm of finance, the exchange is substituted for the concrete abyss ω of probability theory and turns it horizontal. What is always implicit in probability theory is that something must be the case in order for event A to take place, no matter how refined and ramified the description of that event. Metaphorically, it is a random draw ω from a big urn Ω. Something must be the case in order to make one face of the die appear; and something must be the case in order to make a long, potentially infinite, sequence of faces appear. It is the same case, the same ω, the same 'it happens'.

This is the concrete lying beneath the abstract. It is an abyss because it is without measure and always regresses beneath the structure. If we could imagine an absolute and formless happening ω, without any point of view or relative description A, B, or C, i.e. without information, then there would be no such regression. *It* happens, always, all the time, immeasurably and irreversibly. Differentiation lies only in the structure and the point of view: Are we dealing with one roll of the dice or are we rolling it indefinitely? If we suddenly decide we are playing an infinite game, then for the abyssal and irreversible case ω, we have always been playing that infinite game. If suddenly the world ends, then this, too, was a further refinement of the same immemorial infrastructure, and the abyss regresses to encompass even that.

In finance, exchanging anything against money is the alternative to this implicit presupposition. The exchange replaces the concrete abyss ω which, as we saw, is always unexchangeable and impossible to turn around. The only way the world could now end is through hyperinflation and the disappearance of money. Money is the alternative abyss, only present at every step (this is what makes the abyss horizontal). Indeed, the flipside of the existence of a general equivalent is that, suddenly, this equivalent may no longer exist. Pending that 'permanent' event, all assets trade, indefinitely. We keep exchanging the stock

against money and then back again, because we are not sure which is going
to disappear first.

The schema of thought no longer goes from the case ω to the face A, in a
draw that regressively dives into the bottomless abyss. The trading pit becomes
the only concrete situation and the stock price the only abstraction (thanks to
money), which means that the concrete and the abstract now coincide, with
no residue. We cannot further refine the situation by saying, as with the dice,
that the dice board now oscillates randomly, or that the die is now randomly
loaded, or that gravity on Earth now randomly changes, or that the world now
randomly ends. Trading, whose conceptualisation is the volatility σ of the traded
price, already comprises the end of time and closes its circle. As for the end of
the world, it is equivalent to the general equivalent, so strictly speaking it cannot
be said to be random.

It is, then, suddenly realised that the volatility σ of the stock price, which is
now the unshakable ground and the only certainty (all the more so given that it
is equal to the very concept of trading and for this reason comprises the market
from the beginning until the end of times), *is otherwise quantifiable as the value
of a derivative written on the stock*. This is the discovery of Black-Scholes-Mer-
ton (BSM). The value of the derivative becomes the new unshakable certainty,
and for this reason, traders can now write it.

It is because of the certainty of the concept of trading of the underlying
stock and the certainty of the volatility of its price that market-makers write
(and potentially trade) derivatives on it, not because of the uncertainty. That's
the reason why BSM is unassailable. Since it belongs to the meta-level, where
the concept of trading lies and where it is bound up with the end of time, the
derivative could in theory 'trade' anywhere except in the same trading pit as
the underlying stock or in the same 'time'. It belongs to the semantics of the
underlying stock market, not to its empirical compass. Yet the trader who
manufactures it has no other place to trade it except in the same pit. This is the
amazing part. This is the real taking over the possible in a much harder fashion
than the realisation of a possibility. This is the implicit of money expressing its
abyssal nature, only horizontally so.

Trading the derivative is thus neither an accident (an event), nor something
that could have been predicted. The derivative exists, then is traded, *precisely*

because the pit preceding it was closed and had ended (had been conceptualised up to and including the end of time), not because we keep opening it. The appearance of its price is not a further refinement of the initial concrete situation. The fabric of the market is thus constituted knot after knot, closure after closure. The *difficulty of writing* is encountered from the beginning. Time is different. We never observed a time series of stock prices so as to be able to declare that volatility, at first constant (BSM), suddenly became stochastic, as when we declared that the dice board suddenly started shaking. The trading of the derivative, or the existence of its price, is at once the only statistics concerning the underlying stock price. In its turn, the derivative price is followed by the price of the derivative written on it. A price series, not a time series. An irreversible writing and engraving, not a succession of possible states. An endless writing surface rather than a bottomless abyss.

There is an exchange in the schema of the possible from the beginning, such that possibilities become spontaneously un-totalised and therefore irrelevant, no longer susceptible to being counted. This exchange of possibility is a 'constraining' of the possible in a space that is no larger than it, and in which there is no possibility other than this one. As a matter of fact, this must be a first requirement, for how could other possibilities offer themselves to the possible when the possible as such is being transformed?

Time is no longer chronological. The change of time is such that the architectural project can be demolished *before* it is constructed. And it is in the interval of this 'before' that the matter of writing is contained. Precisely, this is happening before projected construction, and for this reason it is the only construction, definitively at variance with hope and expectation, contradicting probability.

The reality of the surface of prices is of the same nature as the reality of the text written by the architect. They both fill all the space. The text replaced the project that was demolished before it was constructed. It was published precisely on the occasion and in the interval of this 'before', materialising it and filling it, expressing it, saying really what this paradoxical 'before' may mean: becoming equal to this 'before'. That the architectural project (a perfect design for the Beirut Museum of Art that blended both the light and the dark matter of Beirut in a single mass distribution) should be destroyed before it is even constructed,

this extreme opposition between what was most probable and almost realised (the project was selected by an international jury and widely acclaimed by the press) and its ultimate destruction or un-realisation, this revolutionary condition, this last-minute inversion of probability, becomes equal to the published text, *which acquires, therefore, a reality of a new nature.*

Usually, the architect has nothing to say; she doesn't write; the building that ends up standing represents all she has to say. We no longer need to inquire into the life of the project or its sense. The finished building realises all of this; it projects it further forward, and dispenses us from inquiring regressively or from understanding its sense. But this time is different: all of reality is there already, except for the realised building. The reality wasn't cauterised by the realised building, but lay open like a wound. It was precisely replaced by a text, in which the architect had no choice but to express and finally speak (albeit for the first time in the history of architecture) the sense of the project.

The architect experienced the *difficulty of writing.* The text was written against possibility, or after the regime of possibility had been exhausted. It was the only text. In contrast to the project, which is one among many possibilities, or the finished building, which is contingent and becomes necessary only because it is ultimately delivered there and imposed there, the text was necessary and unique. It was unique to its reality and its space was no larger than it was; it left no other possibility.

It is through a reaction that we understand that the published text, after we had gotten so close to the realisation of the project and this project was destroyed, is, for this reason and for the additional reason of the extraordinary sense it embeds for the first time, more real than the project was and ever will be, and more real than the building. We suddenly realise that the text is all there is, or all that remains. Hence the petition that immediately followed the publication of the text, demanding the reinstatement of the true architect, or rather, the true author, and the surprising public interest.

The text is not a possibility. The realm of possibilities, in the case of the architect, concerns projects and buildings. So the text is different. It obeys another kind of modality and even another kind of being. The architect is supposed to build the future in advance. She has a special relation with time. She visits the future before chronological time and projects the building from there. There is

already a sense of time travel and necessity (the only project, the only future) associated with the architect. Now, if she exchanges this for the text, through an unnatural act of procreation, the text that is born will be of a special nature (cursed in some sense). Its existential quantification is peculiar. It remains before it is. It never was.

It is through a similar reaction that the reality of the surface of prices is constituted. All possibilities are exhausted and for this reason the surface fills its space fully and exactly. It is also a materialisation of the *difficulty of writing*. It becomes the only text, as hard to penetrate as matter.

Future

The only possibility and only possible world is the future; the only necessity is the future. This is different from saying that the future is made up of possibilities, of all the possibilities. The only real construction is the future, and the only matter is the one the future is made of. The future requires a total engagement, that is to say a duty, a lack of choice, the *difficulty of writing*. Once we penetrate the interval of the 'not yet thought', the interval of the 'only book to come', or the interval of the 'constitution of the philosophy of the real', there are no possibilities left.

The void and the 'anything can happen' seem to dispense with possibility; however, they are only manners of speaking; we might even say that they lack matter, and therefore construction. The *pit* of probability has to be inverted into the *tip* of writing. Yes, we want the absolute happening, the abyss itself, ω. However, it should no longer be understood as lying underneath abstraction, waiting for the algebra of events and the descriptions of language. We want a form harder than language. We want the abyss; however, it must be spontaneous and plain like a surface, an abyss in which the exchange has been made initially and the dice has been thrown for all times. Hence the text, or the poem.

With the tip, anything can happen; however, we are holding the tip. This is manual, and therefore constructive, as opposed to speculative and absolute. The void becomes matter which we penetrate with the tip. The reality of the text written by the architect—the 'remaining' reality—is what constitutes the new reality: it is not a choice of possibilities that leads up to it. The way in which the architect falls upon that surface and produces the writing expresses a solid and

definitive reality, of the same nature as the reality of trading the derivative which was written as the result of a conceptualisation of the trading of its underlying. Both writing and trading fall on the *real surface* faster than the abstraction of states and the project.

It is said that the event creates its own possibilities or its own causes. However, the problem is more general and overall less 'dramatic' than this. As soon as the event occurs and is identified by language ('What happened?'), because language is always relative and differential ('This is what happened, as opposed to that and the other'), the information thus revealed cannot but appear as indexed by time. This is what is called 'filtration' in probability theory. The algebra of possibilities cannot but appear as having always been there, only indexed by time, and this is because the *fact that* the event has happened is absolute, and for this reason, must always regress behind the relative.

Information can only accrete in time, and because it is describable or measurable information, it can only form a single sentence whose running index is time, but whose draw can only be single and happen once and for all, *as opposed to happening for all times*. It is the necessary association between the absolute concrete (ω) and the relative abstract (A, B, or C) that commands this.

The way things happen in the schema of abstraction cannot but lead to regression: the event seems to lie in the future, but it has in reality always been in the past. The language of possibilities commands this, and possibility is nothing but language, or the exact interplay of the concrete and the abstract. Language is but a filtration; it causes the illusion that the future is revealed by time as the gradual manifestation of possibilities. For this reason, one must completely abandon the logic of possibility when dealing with the future. The future must be written, not predicted.

Pierre Menard produced a writing that is faster than thought and that goes places that thought can only subsequently visit and try to enclose. If Menard had not inverted the logic of possibility, if thought had caught up with Menard's writing, then what he wrote would have been equal to a trivial replica of Cervantes's text. But thought will never catch up with Menard's text; he has produced the very matter of writing. In this sense, he writes the future (not the one that is made up of possibilities, but the one that is the only possibility), and

it is only thought that makes us believe that he is writing an already existing text—that is to say, the past.

Pierre Menard has exactly uncovered the variance of writing (the matter of writing) which opens up the way of the future independently of, and even in contradiction with, possibility; however, the text he actually produced did not vary from the original. This is just a coincidence, or rather, a singularity. Far from depriving Menard's text of any variance and any access to the future, it is, on the contrary, the purest and most radical case of such access.

Pierre Menard's text is an indication of the real future that every literary text is supposed to write. Any true writer is, like Menard, also writing the only text (which does not vary in possibilities). The interval of the 'not yet thought' is, in each case, the same interval. It is difficult to identify, in the general history of literature, cases of writing of the future, or illustrations of the 'not yet thought', as clear-cut as Pierre Menard's. Blanchot has cited Joubert.[7]

The logic of possibility is also abandoned in the derivatives market. In order to understand its reality, its real fabric and real connexion with the future (how it writes the future rather than predicting it), we must also invert the logic of possibility: turn the pit into the tip, recognise the *trading of the derivative*, what I have called the 'way it falls back on the surface', as the only choice left, the only remaining reality once possibility has been dropped; recognise the horizon of trading that the derivative trader finds himself facing again as the only horizon, after the trading horizon of the underlying stock has been closed and conceptualised.

The need to abandon the logic of possibility has already been recognised by critics such as Meillassoux. However, he did not recognise the initial exchange in the logic; he didn't recognise the writing, or the substitution of the abyss of money for the abyss of the concrete. So he muddled the problem into that of the un-totalization of possibilities (when the whole logic of possibility should have been abandoned) and into the hope of constraining the 'possible as such' in such a way that un-totalization would obtain. In doing so, he didn't recognise that this constraining of the 'possible as such', or its selection among 'other possibles

7. 'He was thus one of the first entirely modern writers, preferring the center over the sphere, sacrificing results for the discovery of their conditions, not writing in order to add one book to another, but to make himself master of the point whence all books seemed to come, which, once found, would exempt him from writing them.' Blanchot, *The Book to Come*.

as such', could by definition no longer take place within a space of possibilities. The writing of the architect, the way in which it falls, is also a writing without hope, after all possibilities are foregone: writing as the only thing that remains.

Poem

Pierre Menard and the architect gave us the real lesson of writing. They did not resort to writing as a possibility; they resorted to it as the only possibility. It wasn't speculation on their part, but the penetration of the very fabric of reality, a fabric from which all possibilities had dropped out. Pierre Menard ventured into an exploration of the deepest level of reality, wanting to find something about the world not from the total of possibilities and the sum of variations, but from the opposite end, from the very infrastructure. It is an invisible reality: not the one that obtains at the level of the algebra of events and possibilities, not the one with a point of view or a project.

The architect is equipped with this invisible reality: seeing the whole world and the future all at once. This is how she manages to establish contact with the future and, ahead of time, to erect a building that will be the future of the city and the future of our time, yet 'remains' a building that is erected today. If the architect wasn't equipped with this way of writing the future and establishing contact with its reality, she couldn't *really* bring the future to us. Usually, her extraordinary contact with the real future is materialised by her building, and this no longer looks extraordinary to our eyes: we've all strolled through cities with existing buildings. But a shocking and untimely permutation of projects saw this virtue of the architect inverted, or perverted. Consequently, the architect found the text as the substitute and new materialisation of this invisible reality.

This is writing the future literally in a text, and no longer with a building. This is no longer a project, but writing as the only possibility left and as the only project, a very sad one indeed. There is extreme sadness in the writing of Pierre Menard too. Matter, and no longer light, or hope. There is the sacrifice of a creator who no longer adds a possibility or a state of the world to the world, but on the contrary reveals its invisible reality.

Can he be called a creator who gives us the real? Or an author? He explores the interval of the 'not yet thought'; there is only one, as I have said. So it seems there is no originality in what this sad author is achieving. Yet there is everything,

including the origin. What's most original in Menard's work is precisely that he is writing an existing text. In order to understand what subterranean and 'invisible' reality Menard is turning towards, I needed the example of the architect. When thus expressed by writing, suddenly this reality becomes the only one, and the written project becomes the only possible one. It becomes a poem.

Meditate upon the transformation of the word 'real' that is happening here. The future is thus literally written. The subterranean reality, at first regressive and sad, always resisting hope and possibility, becomes progressive and spontaneous; we get hold of the tip. This is what happens in the financial market. The sad and deep sense of reality that occurs when the architect turns towards writing and gives us the only real project—all the more really written in so far as it will not be built *and its sense is revealed instead*—is the same sense towards which Menard turns also.

There is no possibility or hope in Menard; yet we feel there is something very real and very deep; we feel it intuitively; we believe Borges; we instinctively get what Menard is achieving or at least attempting. Probably its hopelessness is what makes it so real. We feel that we are learning something unique and definitive about reality and, of course, about creation. Yes, creation without the adding of a state. Deep creation. This is the exact contrary of fiction; this is real reality. We have the same intuition concerning the architect. What she wrote also strikes us as very real, finally delivering the reality of the project instead of the project.

When the problem is posed in this way—how to construct a possible world without possibility, which can only yield a replica and issue from a catalogue—the problem is not just a problem; it is a problem that is an emergency. The answer can no longer be a possible world, but must be the only possible world. We have long overlooked the only thing left to do in this world: finding the philosophy of the real. We have to become writers. The sense of emergency is what drives us to unfold the real surface, the surface upon which to fall as writers, not speculators, with writing as the only thing left, and the text as the only possible project.

The surface of the real is recognisable at once; the vibrantly authentic tone of the architect is unmistakable too. I am fascinated by the instant of the falling,

by the moment at which the only remaining possibility is the one that remains, and by what happens to thought at that very moment. This is the fabric and the 'blind feel' of reality.

It is the emergency that inspires me to unfold the surface of the market, or the text of the architect (after the fallen project), more so than the selection and construction of a possible world. The emergency in the problem is such that the answer I provide is the only one. Dismissing hope and speculation is the only true emergency; it is getting hold of possibility as such; it is falling into the infrastructure, no longer regressively but spontaneously, producing it at last. The only construction is when the turn (or the falling) to writing occurs.

Writing is the only construction because it gets hold of matter, as opposed to light. Getting hold of matter is the same as getting hold of possibility as such (its make-up). This text does not bother with the construction of other worlds; it considers the only construction. It envisages the only thing left to do, which is to replace light with matter and to replace the whole of possibility—a much stronger notion than the total of possibilities.

In the movement from light to matter, there is the 'not yet thought', the faster than thought, and hence there is writing. There is matter and darkness in the 'invisible' work of Pierre Menard. There is matter in inverting the pit of probability theory. There is dark matter in the sewage system of Beirut, a city with no structure or architecture but only infrastructure. Or the city in which—no matter how this was achieved politically, sociologically, or economically—'they' managed to turn the architect into a writer and thus exposed the infrastructure—that is to say, replaced light and the project with matter and writing, with the only construction.

Appendix (Excerpt From the Petition to Reinstate the Winning Project)

After having won the Beirut Museum of Art (BeMA) competition and two years of pro bono work, HW Architecture was abruptly shunned away from the project without any justification.

Head of the jury Lord Peter Palumbo as well as other internationally renowned architects on the panel (Rem Koolhaas, Richard Rogers, Julia Peyton-Jones,

Hans Ulrich Obrist, Zaha Hadid) saw their decision overturned by competition organizer APEAL (The Association for the Promotion and Exhibition of the Arts in Lebanon) without any rational explanation.

The non-profit organization dedicated to the promotion of Lebanese art took the decision to bypass the ruling of the jury and appoint WORKac as the winner, completely disavowing the winner's original work.

The real polemic around the issue rises from the total lack of accountability of all parties involved in this decision who failed to provide any clear explanation for the complete dismissal of the jury's original attribution and the appointment of another winner.

Timeline of Events

14 October 2015: Open call for the competition.

4 January 2016: Closing dates for Stage 1 submission.

28–30 September 2016: Jury deliberation in Beirut.

13 October 2016: Announcement of Winner—HW Architecture.

11 September 2018: HW Architecture is ejected from the project.

18 December 2018: Announcement by the *New York Times* of WORKac as the 'new winner of the competition'.

19 December 2018: BeMA announces officially the appointment of WORKac.

23 March 2019: HW writes the text (poem) that will become more real than the project:

<https://www.lorientlejour.com/article/1163005/bema-le-dernier-trait.html>.

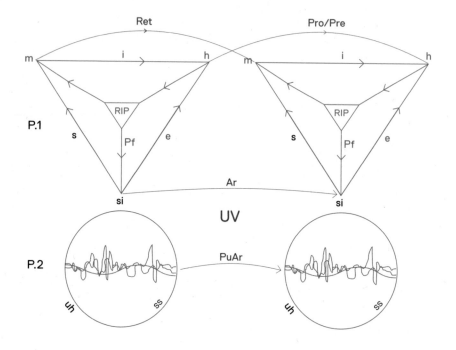

Umweltic variations in the implicit inferential space of semiotically structured cognition

Ret	Retention
Pro/Pre	Protention/Prediction
m	memory
i	inference
h	hypothesis
s	signal
e:	evidence
si	semantic information
RIP	relative induction probability
Pf	perception function
ss	sample space
uh	umweltic horizon
Ar	active response
PuAr	prediction under active response
P.1	probability$_1$ (subjective probability/implicit inductive logic)
P2	probability$_2$ (objective probability/relative frequency)

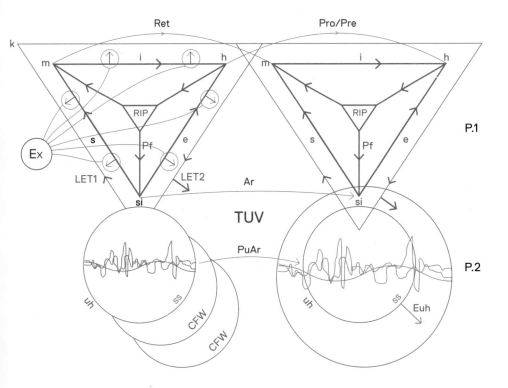

Trans-Umweltic variations in the explicit inferential space of syntactically and semantically structured cognition

Ex	explicitation/representative redescription
k	knowledge/resources of social archive +formal language
LET1	language entry transition
LET2	language exit transition
CFW	counterfactual world
TUV	transumweltic variation
Euh	expansion of umweltic horizon

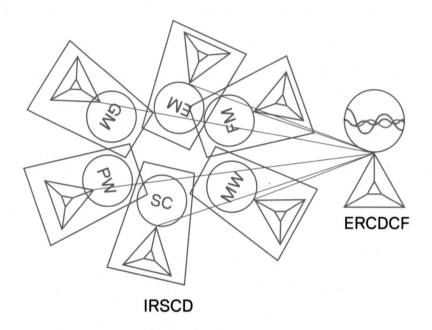

ERCDCF

IRSCD

Musicking facilitates representative description

Adapted from I. Cross, 'Is Music the Most Important Thing We Ever Did? Music, Development and Evolution', in S.W. Yi (ed.), *Music, Mind and Science* (Seoul: Seoul National University Press, 1999).

EM	emotion
GM	gross motoric
FM	fine motoric
PW	physical world
SC	social communication
MW	mental world
IRSCD	implicit representation in separate cognitive domain
ERCDCF	explicit representation in cross-domain cognitive flexibility

Inigo Wilkins

Improbable Semantics: Picturing, Signifying, and Musicking

Understanding a sentence lies nearer than one thinks to what is ordinarily called understanding a musical theme.

— Ludwig Wittgenstein[1]

Far beyond a simple representation and performance of elementary sound events, music is a narration of strong logical and geometric categories, or, at least: without such an intense existentiality, music would never reach the status of a valid antiworld which takes us to an autonomous time and space.

— Guerino Mazzola[2]

In order to discuss the language of possible worlds, it is first necessary to define what is meant by language, and this requires us to provide an account of how communication and representation stand with regard to conceptual thought, as well as to modal categories (i.e. possibility, necessity, impossibility) and their determination (which would concern probability, uncertainty, and risk). To do this we'll draw on the Sellarsian distinction between picturing and signifying, and see how it can be understood apropos language evolution theory, cognitive science, and computationalism. The aim will be to show how extralinguistic communicative practices such as music are able to express possible worlds and to act as a conduit towards their construction, while avoiding the tendency of such claims to fall into the myth of the given.

Defining language means both providing demarcational criteria for distinguishing between animal communication and properly linguistic interactions, and

1. L. Wittgenstein, *Philosophical Investigations* (London: Macmillan, 1953)
2. G. Mazzola, *The Topos of Music: Geometric Logic of Concepts, Theory, and Performance* (Berlin: Birkhäuser, 2002), 933.

constructing a satisfactory explanation that accounts for the development of the latter from the former.[3] The capacity for linguistic thought simply did not exist in the possibility space of sentient life, and yet early hominins, through the progressive elaboration of their *Umweltic* taskspace,[4] discovered or invented this unrestricted *Welt*—truly an 'adjacent possible' in the animal phase space.[5] We need then to identify the discontinuity that marks the specificity of conceptual thought, while taking care not to downplay the continuity between animal communication and the protolinguistically mediated 'imaginative configuration of sense' that would give rise to rational thought.[6]

Sellars takes the concept of picturing from Wittgenstein's *Tractatus*, where it is defined in reference to music as well as language: 'The gramophone record, the musical thought, the score, the waves of sound, all stand to one another in that pictorial internal relation, which holds between language and the world.'[7] Importantly, for Sellars, the picturing relation is not a direct correspondence but a 'relation between two relational systems' constituting a 'second order isomorphism' or structure preserving transformation, as analogised by the dissimilarity between the 'wavy grooves' of the record and the 'wiggly air' that is produced by playing it, and which requires 'rules of projection' that are internal to the representational system.[8] Sellars considers Hume to have produced the first philosophical account of the naturalistic isomorphisms between sensory experiences and the objects of the physical world, where the representational capacity of Humean impressions is built up through constant conjunction operating at the level of statistical probabilities. He stresses, however, that although

3. D. Sacilotto, 'A Thought Disincarnate', *Glass Bead* 1, 'Logic Gate: The Politics of the Artifactual Mind' (2017) (Research Platform) <http://www.glass-bead.org/>.

4. G. Tomlinson, *A Million Years of Music: The Emergence of Human Modernity* (Cambridge, MA: MIT Press, 2015).

5. L.B. Puntel, *Structure and Being* (University Park, PA: Pennsylvania State University Press, 2008), 276. G. Longo, M. Montévil, and S. Kauffman, 'No Entailing Laws, but Enablement in the Evolution of the Biosphere'. Invited Paper, Genetic and Evolutionary Computation Conference, GECCO '12, 7–11 July 2012, Philadelphia; proceedings, ACM 2012.

6. G. Longo, 'Information at the Threshold of Interpretation, Science as Human Construction of Sense', in M. Bertolaso and F. Sterpetti (eds.), *Will Science Remain Human?* (Berlin: Springer, 2018).

7. L. Wittgenstein, *Tractatus Logico-Philosophicus* (London: Routledge and Kegan Paul, 1922), 65 (4.014).

8. W. Sellars, *Science, Perception and Reality* (London and New York: Routledge and Kegan Paul, 1963), 215; W. Sellars, *Science and Metaphysics: Variations on Kantian Themes* (London and New York: Routledge & Kegan Paul, 1978).

such isomorphisms are 'a necessary condition for the intellect's intentionality as signifying the real order', signification, which pertains to the normative-linguistic 'order of understanding', should not be confused with picturing, which pertains to the causal-naturalistic 'order of being'.[9]

With regard to the specificity of signification, Sellars proposes a functional role account of semantics in which the meaning of a word, or the truth of a proposition, is not to be found in its relation to the world but in the internal conditions, or normative rules, that define its proper use or interpretation. Picturing constitutes an internal representation that captures causal-naturalistic uniformities or patterns in the world, a process that can be understood from the 'standpoint of the electronic engineer' (here Sellars gestures towards the nascent fields of information theory, cybernetics, and computer science), while signification concerns the following of semantic rules within the normative-linguistic domain or framework of intentionality, where the latter is an entirely self-referential system that necessarily tracks the former. As James O'Shea argues, this is summed up in his norm-nature meta-principle: 'espousal of principles is reflected in uniformities of performance'.[10] Sellars's commitment to a synoptic integration of the manifest and scientific images is sustained in his discussion of language and its relation to animal representation systems, since it provides the basis for understanding their continuity on one side (the space of causes) while maintaining their discontinuity from another (the space of reasons). The continuity pertains to picturing and will be described by evolutionary theory and 'engineering', while the discontinuity pertains to signification and will be described by language entry-exit transitions.

Having outlined Sellars's distinction, let us now see how it can be situated within the field of language evolution theory. Darwin's *On the Origin of Species* (1859) purposely avoided any sustained speculation concerning the origins of modern humans, since he knew it would meet with fierce resistance. One of Darwin's most forceful critics at this time, the linguist Max Müller, devoted an entire lecture series to the repudiation of an evolutionary account of man on the basis that 'language is the Rubicon which divides man from beast, and

9. Sellars, *Science, Perception and Reality*, 50.
10. J.R. O'Shea, *Wilfrid Sellars: Naturalism with a Normative Turn* (Cambridge: Polity, 2007); Sellars, *Science, Perception and Reality*, 216.

no animal will ever cross it'.[11] Moreover, the cofounder of evolutionary theory, Alfred Russell Wallace, argued in 1869 that the origins of language could not be explained by the mechanisms of selection and variation, since it displayed no adaptive advantages over simpler forms of communication. Around this time a flush of theories attempting to account for this evolutionary leap were proposed, but since speech leaves no traces in the archaeological record, many were rather speculatively unhinged, and in 1866 the Linguistic Society of Paris therefore instituted a ban on theories of the origins of language, following William Dwight Whitney's dismissal of any such attempt as 'mere windy talk' (a predicament that still besets the subject today).

When Darwin published his second book *The Descent of Man* (1871), he tackled these objections head on, devoting ten pages to theoretical conjecture concerning the evolution of linguistic communication. As William Fitch argues, many aspects of this account are remarkably prescient and not so far removed from current debates: Darwin claimed that the cognitive capacities of human ancestors must have been highly complex before the acquisition of language, argued that language displayed a cluster of characteristics demanding a multicomponent view of its development including both biological and cultural elements (for example, likening vocal learning in songbird subsong and infant babbling), and considered that speech could have evolved from an earlier musical protolanguage.[12]

When defining the specificity of human language within an evolutionary perspective, many accounts still refer back to Charles Hockett's description of the 'design features' of animal communication. Hockett argues that although many forms of animal communication display a certain number of these features, only human language exhibits all of them.[13] A staunch behaviourist, Hockett

11. W.T. Fitch, *The Evolution of Language* (Cambridge: Cambridge University Press, 2010), 395.

12. Ibid.

13. His initial proposal listed seven 'key properties of language', and this is expanded to thirteen 'design features' in his immensely popular and influential paper 'The Origins of Speech', and later supplemented with another three features, bringing the total list to sixteen, including: vocal-auditory channel, broadcast transmission and directional transmission, transitoriness, interchangeability, total feedback, specialisation, semanticity, arbitrariness, discreteness, displacement, productivity, traditional transmission, duality of patterning, prevarication, reflexiveness, and learnability. C.F. Hockett, *A Course in Modern Linguistics* (London: Macmillan, 1958); C.F. Hockett, 'The Origin of Speech', *Scientific American* 203 (1960), 88–111; C.F. Hockett and S.A. Altmann, 'A Note on Design Features', in T. Sebeok (ed.), *Animal Communication: Techniques of Study and Results of Research* (Indianapolis: Indiana University Press, 1968), 61–72.

brought together a stimulus-response account of language acquisition (through association and analogy) with insights from Shannon's statistical theory of information, under an evolutionary programme for a naturalistic theory of communication. His generalised definition of communication concerns how an organism's activity can trigger behaviour in another organism, where this can be treated scientifically using Shannon's measure of the statistical dependency between a source and a receiver (mutual information) without having to refer to purported mental events that behaviourism had eliminated from consideration.

Although he does not refer to Hockett, Sellars's discussion of 'animal representation systems' in terms of statistical-probabilistic regularities is almost certainly inspired by Hockett's similar theory of 'animal communication systems', and Carnap (with whom Sellars was in close contact) explicitly drew on Hockett's information-theoretic conception of semantic noise in developing his theory of semantic information.[14] Yet there is certainly a marked difference in their accounts, firstly because Sellars strongly distinguishes between picturing and signification, and secondly because the notion of picturing points to the deficiencies of a purely behaviourist approach by calling attention to the need for communication to be supported by some kind of internal representation.[15] Sellars's reference to the waggle dance of the honey bees in his discussion of picturing nevertheless fails to account for the (computational) specificity of those cognitive mechanisms that realise representation, and the problem is exacerbated in Millikan's claims that the bee dance displays intentionality and truth conditional semantics, an argument that Rescorla dismantles.[16] As Reza Negarestani observes, Ruth Millikan (and to some extent Sellars) fall for a 'myth of the syntactic given' in projecting syntactic structure (which requires specific computational mechanisms) into causal-naturalistic representational processes.

14. C.F. Hockett, 'An Approach to the Quantification of Semantic Noise', *Philosophy of Science* 19:4 (1952), 257–60; R. Carnap and Y. Bar-Hillel, *An Outline of a Theory of Semantic Information* (Cambridge, MA: Research Laboratory of Electronics, MIT, 1952).

15. C. Sachs, 'In Defense of Picturing: Sellars Philosophy of Mind and Cognitive Neuroscience', *Phenomenology and the Cognitive Sciences* 18:4 (2019), 669–89.

16. Sellars, *In the Space of Reasons*. 283; R. Millikan, 'On Reading Signs: Some Differences Between Us and the Others', in D. K. Oller and U. Griebel (eds.), *Evolution of Communication Systems: A Comparative Approach* (Cambridge, MA: MIT Press, 2004): M. Rescorla, 'Millikan on Honeybee Navigation and Communication', in D. Ryder, J. Kingsbury and K. Williford (eds.), *Millikan and Her Critics* (New York: John Wiley & Sons, 2012).

Johanna Seibt develops a more cogent position regarding the continuity, firstly by rejecting the Tractarian implications of picturing (as isomorphisms rather than homeomorphisms) and describing the representative relation in terms of non-linear causal processing, and then by proposing that such animal representation systems can be thought instead as exhibiting 'low-grade' normativity as distinct from the 'high-grade' normativity of signification.[17]

Although Hockett's theory emphasises the continuity between animal communication systems and human language, it strongly conflicts with recent research into the evolutionary origins of language (i.e., the best accounts available for such continuities). This highly cross-disciplinary field has bloomed over the last two decades, and draws on a number of resources that were not available to Hockett or Sellars (including contemporary genetics, neuroscience, computational modelling, and new archaeological evidence). The core problem lies in Hockett's behaviourist stance and its natural alliance with information theory, which leads him to focus on the signal medium and structural characteristics of animal communication systems rather than the underlying cognitive mechanisms that enable the functional realisation of linguistic thought (increased capacity for memory and anticipation, hierarchic and combinatorial cognition, abstraction, recursion, the construction of a phenomenal self-model and phenomenal model of the intentionality relation,[18] theory of mind, metacognition, recursive mindreading, etc.), as well as its social-interactive and artefactual elaboration (non-kin cooperation, shared attention, imitation of complex 'operational chains',[19] discretisation of signifying units, systematisation of symbolic reference, formation of syntactical rules).

Firstly, it should be noted that Hockett's decision to restrict the analysis of the origins of language to the vocal-auditory channel not only displays an unacceptable bias toward the hearing population,[20] but also closes off important

17. J. Seibt, 'Functions Between Reasons and Causes: On Picturing', in W.A. de Vries (ed.), *Empiricism, Perceptual Knowledge, Normativity, and Realism* (Oxford: Oxford University Press, 2009).

18. T. Metzinger, *Being No-One: The Self-Model Theory of Subjectivity* (Cambridge, MA: MIT Press, 2004).

19. A. Leroi-Gourhan, *Le Geste et La Parole* (Paris: Albin Michel, 1964).

20. Communication by sign language accounts for a significant proportion of any population (e.g. in India there are around 1.5 million signers); sign languages independently developed in many different locations (many more than the 121 different documented sign languages), they are processed using

research paths (e.g. 'gesture first' theories of the origins of language, which have become increasingly accepted within language evolution theory),[21] but furthermore fails to acknowledge the multimodality[22] and channel plasticity of linguistic interaction.[23] Secondly, the focus on external linguistic behaviour (medium and structure) corresponds to a phenetic classification of surface similarities between communication systems that engenders misleading continuities (between the capacity for 'displacement' in human languages and in the waggle dance of honeybees, for example) where a cladistic approach that attends to the functional realisation of communication at cognitive, social, and technical levels uncovers far more convincing connections (between the arbitrariness and semanticity displayed by human languages and similar cognitive capacities evident in the gestural intelligence of other primates or the syntax comprehension of bottlenose dolphins, for instance).[24]

From a Sellarsian perspective, a much better resource for providing adequate demarcational criteria is to be found in the contemporary work of Noam Chomsky. While his *Syntactic Structures* (1956) already took many of the steps that he would later explain under the rubric of *transformational generative grammar*, at this time Chomsky still adhered to behaviourist principles, and the full implications of his revolutionary computation-theoretic approach (in particular, the inward shift towards cognition) were only properly unpacked over the course of his rejection of Hockett's communication-theoretic linguistics.[25]

the same specialised brain structures as spoken languages, have parallel aphasias, display duality between cenematic and pleirematic planes, have similar developmental trajectories (e.g. infant babbling), and require complex hierarchic and combinatorial cognition. N. Evans and S.C. Levinson, 'The Myth of Language Universals: Language Diversity and its Importance for Cognitive Science', *Behavioral and Brain Sciences* 32:5 (2009), 429–48; discussion 448–94.

21. M.C. Corballis, *From Hand to Mouth: The Origins of Language* (Princeton, NJ: Princeton University Press, 2002); M.A. Arbib, 'From Monkey-like Action Recognition to Human Language: An Evolutionary Framework for Neurolinguistics', *Behavioral and Brain Sciences* 28 (2005), 105–67.

22. For example, co-speech gesture and facial expression play important roles in communicating linguistic content.

23. Examples of languages using other channels include: writing, whistled languages, sign languages, and tactile linguistic systems such as the Tadoma method.

24. V.M. Janik, 'Cognitive Skills in Bottlenose Dolphin Communication', *Trends in Cognitive Science* 17:4 (2013), 157–9; S. Wacewicz and P. Zywiczynski, 'Language Evolution: Why Hockett's Design Features are a Non-Starter', *Biosemiotics* 8:1 (2015), 29–46.

25. G. Radick, 'The Unmaking of a Modern Synthesis: Noam Chomsky, Charles Hockett, and the Politics of Behaviorism, 1955–1965', *Isis* 107:1 (March 2016), 49–73.

It was in repudiating such an approach that Chomsky thoroughly elaborated the significance of his celebrated hierarchy of formal languages, and as a corollary developed the position (held unwaveringly since 1960) that studies of animal communication are entirely irrelevant to the field of linguistics and would yield no insights into the origins of language.[26]

Chomsky argued that the 'Markov process conception of language' put forth by Hockett was an irredeemably inadequate account, and showed that the notion that words could be tied together like beads on a string by appealing to statistical probabilities yielded what he called a 'finite-state grammar' that could never match the generative complexity of actual language use.[27] Hockett's 'grammatical headquarters' would require an infinite amount of machinery if it were to be able to produce the kind of grammatically correct yet highly improbable sentences that any language user could generate, his famous example being 'colorless green ideas sleep furiously'.[28] The intuitively plausible idea behind Hockett's account—that the transition from animal calls to language was a matter of gradually building up structural complexity through probabilistic associations between a source and receiver—was shown to be hopelessly misguided: there is a radical discontinuity between the two orders that could only be accounted for by the development of novel cognitive mechanisms capable of generative transformational grammar.

Although Chomsky therefore demolishes the behaviouralist linguistics of Hockett and Skinner, his theory nevertheless suffers from several problems of its own. Firstly, it can be argued that the Universal Grammar it proposes as an innate genetic endowment of all humans is an ethnocentric over-generalisation of syntactic structures derived from the study of English and Germanic languages, where a more thorough analysis of the diversity of existing languages provides important exceptions to this supposed universality (even under its 'parametric' interpretation).[29] Secondly, besides the putative universality of grammar, Chom-

26. While already described in his *Logical Structure of Linguistic Theory*, completed in 1955, it was not the central plank in his argument and only featured in an appendix to a chapter on phrase structure. Radick, 'The Unmaking of a Modern Synthesis'.

27. N. Chomsky, *Syntactic Structures* (The Hague: Mouton, 1957).

28. N. Chomsky, 'Review of C.F. Hockett, *A Manual of Phonology*', *Int. J. Amer. Ling.* 23 (1957), 223–34.

29. As Evans and Levinson argue, these are not just superficial differences that can be brushed aside by appealing to a more fundamental grammatical bedrock, but fatal blows both to the universality claim and to the innateness claim. Evans and Levinson, 'The Myth of Language Universals'.

sky's claim for the innateness of these syntactic structures was widely accepted owing to the 'poverty of stimulus argument', which held that the 'language stimuli that children are exposed to are simply too noisy and incomplete to allow for reliable understanding of language through induction'.[30] There is however growing consensus in developmental psychology that social interactions along with a cluster of learning mechanisms provide a sufficient basis for the inductive acquisition of language without requiring an innate grammatical blueprint. Thirdly, the sharp discontinuity Chomsky presupposes (where syntax is considered an 'all or nothing' affair) contradicts nearly every account in the field of language evolution, and leads to some rather startling assertions, such as the claim that the faculty of language resulted from a mutation in a single individual and that its adaptive advantage lay in facilitating internal thought rather than communication.

Chomsky has been opposed to any gradualist Darwinian account of language evolution since his repudiation of Hockett in the late fifties, but the contemporary surge in evolutionary linguistics has prompted him to outline his position in more detail, and recent findings have compelled him to make some significant modifications to his claims (for example, up until 2005 he insisted that Neanderthals had no language but now considers this an open question, and he has pushed back his estimate for the emergence of language from 50,000 to up to 200,000 years ago).[31] In the nineties, he developed the 'minimalist program' of linguistics, which pares down the syntactic requirements for Universal Grammar to the highest level of abstraction so that, in the 'strong minimalist thesis', it can be captured by a single computationally efficient and 'perfect' operation, defined as set formation: *Merge*.[32] Merge is the 'simplest computational operation' since all other computational procedures (e.g. concatenation) presuppose it, and it is 'optimal' since the dyadic combination of two syntactic objects (X and Y) yields a new hierarchically structured syntactic object (the set $\{X, Y\}$) that does not specify any ordering and leaves them as unmodified atomic elements available

30. C. Kliesch, 'Making Sense of Syntax—Innate or Acquired? Contrasting Universal Grammar With Other Approaches to Language Acquisition', *Journal of European Psychology Students* 3:1 (2012), 88–94, <http://doi.org/10.5334/jeps.au>; N. Chater and M.H. Christiansen, 'Language Acquisition Meets Language Evolution', *Cognitive Science* 34:7 (2009), 1131–1157.

31. R.C. Berwick and N. Chomsky, *Why Only Us: Language and Evolution* (Cambridge, MA: MIT Press, 2015); N. Chomsky, 'Three Factors in Language Design', *Linguistic Inquiry* 36 (2005).

32. N. Chomsky, 'A Minimalist Program for Linguistic Theory', *MIT Occasional Papers in Linguistics* 1 (1993).

for further combinatorial operations. It can then be applied recursively to such sets so that this basic computational procedure is capable of constructing 'an infinite array of hierarchically structured representations'. Berwick and Chomsky's claim is that 'it is Merge that makes language something more than an animal communication system, through its unique property of allowing "infinite combinations of symbols" and therefore "mental creation of possible worlds"'.[33]

Unsurprisingly, since Berwick and Chomsky vitiate most work in language evolution theory, there have been a number of critical rejections of their claims. Most notably, the saltationist account of the faculty of language is generally held to have no evidentiary backing, and gradualist or coevolutionary accounts are advanced instead; the notions of optimality, efficiency, and perfection intrinsic to Merge are attacked as undefined presuppositions; the strong distinction between animal communication systems (captured by finite state grammars) and the discrete infinity of language is held to be unfalsifiable; and the notion that 'language evolved as an instrument of thought' with externalised communication serving only a secondary function is most vehemently rebuffed. Although some of these criticisms do indeed pose problems for Chomsky's theory, they are not insurmountable, and it is possible to maintain his syntactical demarcational criteria for language while allowing for a greater continuity with nonlinguistic communication.

Although Sellars's remarks concerning the possibility of an evolutionary explanation of logico-conceptual thought from animal representational systems may seem close to Hockett, the sharp distinction he makes between picturing and signification is much better explained by Chomsky's focus on the acquisition of syntactic rules and their computational realisation as internal cognitive operations. Furthermore, while Chomsky's argument that the language faculty arose principally as a 'tool for thought' is anathema to most work in language evolution, its emphasis on syntactically structured language as facilitating a special kind of cognitive function rather than merely expressing already existing perceptions, intentions, and volitions, provides excellent scientific grounds for Sellars's philosophical commitment to intentional awareness as guided by language entry-exit transitions, and his uncompromising attack on the myth of the given.

33. Berwick and Chomsky, *Why Only Us*.

As Chomsky points out, although humans and other primates have similar auditory systems, there is a marked difference when it comes to auditory cognition,[34] so any account that emphasises the continuity between animal communication and language will have to deal adequately with the development of those distinctive cognitive capacities. Nevertheless, a Sellarsian philosophy of language need not follow Chomsky's genocentric saltationist theory of its origins, since the step from picturing to signification can be understood as having gradually emerged through a process of artefactual elaboration. This is why a wider focus becomes appropriate, taking in the evolutionary origins not just of language but also of music and those other artefacts of symbolic culture, including mathematics and logic, that are not shared by nonhuman animals. As Mukherji argues, the most parsimonious account of the development of this 'hominin set' is that they share a common origin and underlying computational principles.[35] Indeed, just like language, music is a 'universal, species-specific capacity', it can be given a generative account,[36] it has combinatorial symbolic and syntactic structure,[37] displays discrete infinity or unbound productivity, hierarchical organisation and weak external control,[38] has a rich and multilayered semantics,[39] and (pace Chomsky) exhibits recursion.[40]

34. '[A]pes with approximately the same auditory system hear only noise when language is produced, though a newborn human infant instantly extracts language-relevant data from the noisy environment.' Berwick and Chomsky, *Why Only Us*.

35. N. Mukherji, *The Primacy of Grammar* (Cambridge, MA: MIT Press/Bradford Books, 2010), 189.

36. GTTM was originally restricted to Western classical music but has since been elaborated and extended to other practices. F. Lerdahl, and R. Jackendoff, *A Generative Theory of Tonal Music* (Cambridge, MA: MIT Press, 1983).

37. Musical sounds do not have precise external referents in the way in which linguistic symbols do, but it can be argued that musicking not only shares with linguistically structured cognition the property of enabling the systematised organisation of indexical signs, but also that it was a crucial facilitator of this development.

38. '[E]nvironmental conditions strongly influence the properties of perceptual systems; they only weakly influence, if at all, the properties of the language and the musical systems.' Mukherji, *Primacy of Grammar*, 196.

39. Mazzola, *Topos of Music*.

40. Although Chomsky, Hauser, and Fitch agree that music displays an unbound productivity they do not think it exhibits recursion. Mukherji disagrees, and shows how this is evident in the Indian raaga system, which 'crucially depends on the experienced listener's ability to periodically recover versions of the same chalan (progressions typical to specific raagas) and bandish (melodic themes specially designed to highlight the tonal structure of a raaga) through ever-growing phrasal complexity and at varying pitch levels.' Mukherji, *Primacy of Grammar*, 211.

Gary Tomlinson's description of the bifurcative coevolution of language and music as an artefactually elaborated biocultural epicyclic process explains not only the emergence of a properly linguistic communication but also its entanglement with 'musicking' and the preconceptual semiotic organisation of sense.[41] He argues that this occurred over a long period, ranging from 1,000,000 to 40,000 years ago, during which the indexical gesture calls characteristic of nonhuman animal communication systems, where meaning is conveyed by the emotive contours of the voice or hand, were on the one hand gradually winnowed into repeatable phonemic units with specific referents and increasing combinatorial ramification (i.e. rudimentary syntax), and on the other hand vocalisations were freed up from the immediate task of conveying signals (such as territorial marks, danger alerts, or fitness displays), allowing for other communicative possibilities and cognitive-perceptual functions. For Tomlinson there is thus a 'release from proximity' both in the burgeoning complexity of protolanguage, with its increasing capacity for referring to objects or ideas that may not be indexically co-present to the interaction (i.e. displacement), and in the social role of protomusic in the collective organisation of behaviour and meaning.

In Sellarsian terms we could say that protolanguage and protomusic represent a transitional stage accompanied by the development of auditory cognition and behavioural complexity, leading from indexically structured pattern-governed awareness and communication, through a systematisation of semiotics, towards rule-governed symbolically structured awareness. Protomusic is different from the musicality of animal calls because in protomusic soundmaking is freed from its immediate indexical function, and begins to enter into its own generatively extensible space of meaningful interaction. The biocultural coevolution of (proto) language and (proto)music progressively enables both systems to refer to 'that which is not'[42] in two very different ways: protolanguage enables an increasingly precise reference to external states of affairs (which will ultimately lead to conceptually structured phenomenological intentionality, with language proper arising with symbolic culture and the development of syntactical rules), while

41. G. Tomlinson, *A Million Years of Music: The Emergence of Human Modernity* (Cambridge, MA: MIT Press, 2015).

42. R. Brassier, 'That Which Is Not: Philosophy as Entwinement of Truth and Negativity', *Stasis* 1 (2013), 174–86.

protomusic simultaneously becomes unburdened from the task of determinate external reference and develops a purely internal form of signification allowing for a 'floating intentionality' or play of meaning that increases cognitive flexibility and facilitates cross-domain transfers through a process of 'representative redescription'.[43]

The reciprocal development or divergent actualisation of these two different systems amounts to the construction of a social technology for the organisation of sense not just at the level of co-present interactions, but also by structuring the space of possibility of thought and behaviour itself. In the terminology of Bloch, then, what we see here is the emergence of a *transcendental sociality* that differs from the *transactional sociality* of other intelligent animals: for example, the status of a shaman, a midwife, or a hunt leader is different in kind from that of an alpha male in a primate group since the social role that the former occupy transcends any co-present interaction in which they take part.[44] This shift away from co-presence is at the root of normativity, then, and all those developments that spring from it (including positive aspects such as the flowering of human culture and the capacity for critical thought, and negative aspects such as ritualised violence and oppressive socially instituted power relations). Both protolanguage and protomusic progressively diversify and organise meaning through the use of sound as a qualitative material that constructs or maintains a rule-bound (and rule-breaking) form of social organisation.

This protoconceptual capacity for negation, which allows for the structuring of sociality beyond immediate presence, is presupposed by the emergence of logico-conceptual thought proper. With the 'release from proximity' enabled by such a development, the present sense of uncertainty that is characteristic of an animal's vigilance to predation is both lessened (owing to increased cognitive control and behavioural flexibility) and extended by an increasing capacity for complex imagination and thus uncertainty concerning what is not present (e.g. possible gods and demons). Crucially, this transcendental negativity allows early hominins to use 'that which is not' in order to change the present conditions of uncertainty. Without falling foul of Chomsky's critique of the

43. I. Cross, 'Is Music the Most Important Thing We Ever Did? Music, Development and Evolution', in S.W. Yi (ed.), *Music, Mind and Science* (Seoul: Seoul National University Press, 1999).
44. M. Bloch, 'Why Religion Is Nothing Special But Is Central', *Philosophical Transactions of The Royal Society B: Biological Sciences* 363:1499 (2008), 2055–61.

gradual accumulation of structural complexity, we can then envisage how the artefactual diversification of protoconceptual indexical signs and their systematic organisation according to rudimentary syntactical rules led to the development of the concept proper and its logical inferential framework.

The artefactual elaboration of language can then be envisaged as a transition from the weakly systematised indexicality and recursive generativity of ancient hominin communications to the fully systematic symbolic cultures that followed, and ultimately to the conventions of written language and the formal operations of logic and mathematics that make computing possible, and which in turn allow for the reverse engineering of mind in artificial intelligence. The evolution of conceptual thought is therefore bound up with, and inseparable from, the nonconceptual heterogenesis of sense, where the latter must be understood as being amplified through its entry into a positive feedback loop with the essentially formal systems of the hominin set.[45] Whether it is Chomsky who is correct in arguing that syntax arose all at once in a single mutation, or it is gradualist evolutionary accounts such as Progovac's which argue for a paratactic protosyntax, or the truth is more along the lines of Tomlinson's biocultural coevolutionary theory, only an animal with grammar can generate unlimited possible sentences, and it is only rule following, or truth taking and making, that enables the organisation of thought and behaviour according to the propositional form of judgment and its attendant alethic modalities: actuality, possibility, necessity, and impossibility. Musicking is not just parasitically enabled by this transition, it is instrumental in the development of the cognitive and social capacities to think possible worlds.

Though these early protomusical gestures and protolinguistic utterances are transient sounds that do not themselves survive beyond their vocalisation, we can infer their development from the archaeological record, and there are two artefacts in particular that point to a threshold change in the evolution of intelligence: Firstly, a Neanderthal bone flute dating back to around 43,000 years ago (before any of the earliest evidence of cave painting), known as the 'Divje Babe flute', which not only demonstrates that auditory cognition in the hominin line had reached a highly evolved capacity for hierarchical and combinatorial organization, as well as abstraction, generalization, and systematicity, that far

45. A. Sarti, G. Citti and D. Piotrowski, 'Differential Heterogenesis and the Emergence of Semiotic Function', *Semiotica*, August 2019.

exceeds any other animals, but also supplies evidence for the beginnings of a process whereby those capabilities were bootstrapped by their artefactual elaboration in systems allowing for the discrete control and quantitative measurement of qualitative analogical phenomena.[46]

Secondly, the 'Lion Man', a sculpted figurine depicting a half-man half-lion chimera, dating back to between 35,000 to 40,000 years ago, indexes the development of a robust capacity for the stabilisation and externalisation of the imaginative flux of sense, enabling a second-degree causal reasoning that employs counterfactuals both for determinate task-related ends and for spiritual reflection or metaphysical speculation (which we might call local and global causal inference respectively). Judea Pearl asserts that it is the development of advanced causal reasoning that was the major factor in the sudden growth of human intelligence and its (rapaciously destructive) domination of every corner of the world.[47] As he explains, reasoning about causes is achieved by imaginatively inferring a set of possibilities and tinkering with the world in order to answer *how* and *why* questions regarding structural components and functional properties. Such a counterfactually enabled process of hypothesis formation and testing is thus what allows for a practical and theoretical elaboration of possible worlds at both the empirical and transcendental level. As Reza Negarestani asserts, it is the acquisition of symbolically and syntactically structured language that engenders the capacity for a systematic organisation of indexically structured pattern-governed awareness, and the counterfactual elaboration of thought, perception, and action.[48]

Many millennia of causal reasoning followed (an incredibly short time in evolutionary terms, thus necessitating, further to a biocultural coevolutionary framework, a historical analysis in terms of 'sociogenic' processes, at least

46. Whether the Divje Babe artefact is actually a flute, and whether it was made by Neanderthals are still matters of some controversy, but Tomlinson argues that musicking precedes symbolic thought, and evolved among several coexisting hominin species. He points to a similar artefact called the 'Swabian pipes' (around 40,000 years old) which also predates the 'cultural explosion' associated with the emergence of symbolic culture.

47. J. Pearl and D. Mackenzie, *The Book of Why: The New Science of Cause and Effect* (London: Penguin, 2019).

48. R. Negarestani, *Intelligence and Spirit* (Falmouth and New York: Urbanomic/Sequence Press, 2017), 301–12.

from this point)[49] in various more or less locally circumscribed cultures, during which this practical and theoretical elaboration continued apace across multiple symbolically structured domains (language, mathematics, logic, science, art, etc.) cumulatively adding to the inherited cultural archive that constitutes our artefactually constructed intelligence. What remains relatively invariant over this historical period, with the diverse blossoming of knowledge in different geographical regions, is a separation between what could be understood and explained within the framework of anthropically available causal processes (and interventionally tinkered with) and what remained the province of chance, fate, or the gods. Of course, during this time various techniques for navigating chance were developed—methods of divination and astrology, for example. However, it was not until around four hundred years ago—not coincidentally, around the same time as the colonially fuelled emergence of capitalism—that the mathematical treatment of probability allowed for the formalisation of uncertainty and the objective calculation of risk.

As Ian Hacking argues, the triumph of probability theory and statistical analysis over the classical image of deterministic necessity represented neither a diminution of scientific knowledge nor a decline in the capacity to regulate and manipulate nature, but both a massive expansion of the explanatory-descriptive power of science and a prodigious escalation of technologies of social control.[50] Pearl notes that the development of statistics as a science began with causal questions such as Francis Galton's inquiry into the hereditary nature of intelligence (motivated by racist beliefs), and ended up (following Humean convictions) in rejecting the notion of cause as metaphysics. Instead of asserting a causal connection, the science of statistics concentrated purely on facts of the matter (data, or givens) and an ongoing inductive assessment of the strengths of association between variables. Causal connection could then be redefined, without reference to the empirically problematic notion of cause, as follows: if x then y with probability 1. We should recall that this gesture was recapitulated in the statistical-behaviourist framework of Hockett's linguistic theory, and that

49. F. Fanon, *Black Skin White Masks* (New York: Grove Press, 1967); S. Wynter, 'Towards the Sociogenic Principle: Fanon, The Puzzle of Conscious Experience, of "Identity" and What it's Like to be "Black"', in M.F. Duran-Cogan and A. Gomez-Moriana, *National Identities and Sociopolitical Changes in Latin America* (New York: Routledge, 2001).

50. I. Hacking, *The Taming of Chance* (Cambridge: Cambridge University Press, 1990).

Chomsky's repudiation of this move was the spark that ignited the cognitive revolution in linguistics.[51]

In order to understand this shift and its contemporary repercussions, we need to contextualise it in relation to the new understanding of information that was constructed at the beginning of the twentieth century. Information had previously been a nebulous concept bound up with diverse objects and their meanings, but at this point it was given a precise mathematical definition with regard to its transmission (Shannon) and elaboration (Turing). Both Shannon's and Turing's accounts provide a completely new understanding of information, where it is conceived in formal terms as independent both from its material realisation in a given medium and from its semantic interpretation.[52] Shannon's definition follows from the technological implementation of probability theory and statistical induction while Turing's follows from formal logico-mathematical rules or recursive functions. Both represent major advances in knowledge that would lead to huge technological and social transformations, but the purposely and necessarily restricted notions of information that they propose give rise to ideological distortions when they are extended to domains which they were not intended to cover (e.g. the biological, social, or economic), and both are bound up with and facilitate a new form of social control. Neither cover the full sense of information, which must further include semantic interpretation and linguistic interaction. But as we shall see, it is possible and indeed necessary to achieve a computational understanding of these.

A certain sense of possible worlds, albeit a limited one, emerges from the application of the probability calculus in the calculation of risk, the statistical analysis of data, and the transmission and computation of information. One might say that the language of possible worlds in this restricted sense is the language that Capital speaks—it is the language of insurance and (neo)colonial ventures,

51. 'It is natural to understand [grammatically] "possible" as meaning "highly probable" [...] [and to replace] "zero probability, and all extremely low probabilities, by *impossible,* and all higher probabilities by *possible*" [...] [but] there appears to be no particular relation between order of approximation and grammaticalness [...] [and] we are forced to conclude that grammar is autonomous and independent of meaning, and that probabilistic models give no particular insight into some of the basic problems of syntactic structure.' Chomsky, *Syntactic Structures*, 17.

52. A.M. Soto, G. Longo, and D. Noble (eds.), *Progress in Biophysics and Molecular Biology* 122:1, special issue 'From the Century of the Genome to the Century of the Organism: New Theoretical Approaches' (2016).

speculative finance and the derivatives market, Big Data and AI (e.g. ethical choice trees for self-driving cars), the language that denies and prevents the construction of alternative worlds. Pearl's argument is that current AI (including the rapid advance of neural nets, in which he played a prominent role) has been based on the success of this statistical paradigm, in which probabilistic analysis is taken to supplant the need for causal analysis (i.e. theory or hypothesis generation), and that as a consequence it is not yet able to tell the difference between statistical correlations and causal connections. This is a necessary distinction for any intelligent agent (in the Kantian sense of agency as defined by self-reflexive responsibility for action) since it concerns the regulation of behaviour according to the difference between observing or imagining an event and making it happen, or between being probabilistically correlated with certain causal regularities and causally contributing to those regularities, and between the causal regularity itself and the causal consequences that follow from it, not to mention its social-interactive significance, which would require full-blown logico-conceptual intelligence and historically situated understanding.

At this point we should interrogate the generalised notion of probability that informs many current computationalist models of cognition (and parallel developments in AI) and distinguish, as Carnap did, between two different senses of the term: probability$_1$ refers to the degree of confirmation that some evidence (e) provides for a hypothesis (H); probability$_2$ refers to the relative frequency of an event over a random series.[53] The probability$_2$ of receiving a full house in poker is an objective quantity independent of belief or any particular outcome, while the probability$_1$ that a certain player has such a hand given their slight smirk concerns degree of belief relative to theoretical framework and available evidence (where the probability is a matter of inductive logic and is independent of the player's actual cards).

The latest turn in cognitive science, called predictive processing (PP) philosophy, is inspired by the recent success of neural nets, and understands cognitive systems as predictively tracking the causal structure of the world through the continuous calibration of a generative model of its estimated dynamics within a bidirectional (top-down and bottom-up) hierarchically nested architecture of

53. R. Carnap, *Logical Foundations of Probability* (Chicago: University of Chicago Press, 1950).

Bayesian priors and hyperpriors.[54] Any deviations from expectation are registered as prediction error signals and ascend through the hierarchy until they are 'explained away', so that the function of cognition is long-term average prediction error minimisation, and the content of experience is an inferentially 'controlled hallucination' synthetically woven from the current best top-down statistical hypotheses and its precision weighted interplay with the ongoing bottom-up stream of sensory input.

Many PP accounts take Kant as their philosophical antecedent, most notably in the 'Copernican turn' which shifts from the image of the mind as passively receiving structured sensory impressions like a wax seal, to that of the mind as an active (top-down) 'structuring or configuring point'[55] that constitutes the phenomenon through the projection of transcendental rules that are not derived from experience (pace Hume, and Flores's PP account of Hume).[56] The transcendental framework of cognition can further be understood in terms of priors and hyperpriors (e.g. form of space and time, unity of apperception), and perceptual schemata as generative models functioning through 'analysis by synthesis'.[57] Another important precursor here is Helmholtz, who operationalised Kantian philosophy for a new science of perception,[58] in particular his notion of perception as hypothesis generation and testing (unconscious inference) and his discussion of kinaesthetic modifications, which partially anticipates the concept of 'active inference' in PP (i.e., the way in which active movement can be recruited for uncertainty reduction).[59] Seth argues that the emphasis on homeostasis and double-loop predictive control in Ashby's cybernetics provides a more developed predecessor for the notion of active inference, for Friston's free energy principle (FEP), and for what he calls the 'counterfactually equipped

54. T. Metzinger, and W. Wiese (eds.), *Philosophy and Predictive Processing* (Frankfurt am Main: MIND Group, 2017).

55. Negarestani, *Intelligence and Spirit*, 49.

56. K. Flores, *Metavariations on Prediction and Imagination: A Response to Fodor's Hume Variations* (Portland, OR: Portland State University, 2014).

57. L.R. Swanson, 'The Predictive Processing Paradigm Has Roots in Kant', *Front. Syst. Neurosci.* 10:79 (2016). doi: 10.3389/fnsys.2016.00079.

58. T. Lenoir, 'Operationalizing Kant', in M. Friedman and A. Nordmann (eds.), *The Kantian Legacy in Nineteenth Century Science* (Cambridge, MA: MIT Press, 2016).

59. M. Sheets-Johnstone, *The Primacy of Movement* (Amsterdam: John Benjamins, second edition 2011).

predictive model' linking potential actions to expected sensory consequences.[60] At this point it should be noted that not only does the computationalist account of mind put forward by cognitive science vitiate the behaviourist perspective of Hockett and Skinner, but for PP in particular, simuli precede and exceed stimuli for any cognitive system. In the case of linguistically enabled thought, those simuli are made available for explicit cognitive control and counterfactual reasoning.

Finally, Sellars's conception of picturing has also been advanced as anticipating elements of PP.[61] That Sellars's picturing theory moves beyond behaviourist principles and towards probabilistically structured internal representations seems clear, however his vague nod towards 'engineering' hardly constitutes a compelling prototype theory of PP. Nevertheless, it is his distinction between such an information-theoretic or cybernetic notion of picturing and the normative-linguistic or rule-governed domain of signification that remains pertinent, precisely because it points to serious limitations in PP's explanatory-descriptive purchase on the wider world of social-interactive thought (i.e. beyond its theorisation in terms of neurocomputational cognitive processes). Accounting for the rule-governed specificity of signification (both in language and in musicking) does not mean rejecting computationalist accounts of cognition or naturalistic explanations of their evolution, it rather requires transforming our understanding of both along artefactual lines.

Semantics and syntax are barely discussed in PP, partly because it shifts from older computational models of cognition in several ways that align with developments in neural nets, so that neurocomputation is no longer seen as symbol manipulation but as a hierarchically nested generative model in which there is a continuum between perception, cognition, and action. All three are processed in a nonmodular 'common language' (predictive coding) and there is a pervasive cognitive penetrability of perception, in contrast with the domain-specific proprietary languages of the modularity of mind thesis (which

60. 'Biological systems act on the environment and can sample it selectively to avoid phase-transitions that will irreversibly alter their structure. This adaptive exchange can be formalised in terms of free energy minimisation, in which both the behaviour of the organism and its internal configuration minimise its free energy.' K. Friston 'Life as We Know It', *Journal of the Royal Society, Interface* 10: 20130475 (2013), <http://dx.doi.org/10.1098/rsif.2013.0475>; A.K. Seth, 'The Cybernetic Bayesian Brain—From Interoceptive Inference to Sensorimotor Contingencies', in T. Metzinger and J. M. Windt (eds.), *Open MIND*: 35 (T) (Frankfurt am Main: MIND Group, 2015).

61. Sachs, 'In Defense of Picturing'.

is a central assumption of Chomsky's 'language faculty'). In order to understand how semantics is figured in PP, it is helpful to shift focus to the wider paradigm of compression that informs the notion of the generative model. This is best summed up in Baum's assertion that 'semantics comes from compression, from Occam's razor. If one compresses enough data into a small representation, the representation captures real semantics, real meaning about the world'.[62] Baum goes on to explain such compression in terms of Bayesian induction and the notion of minimum description length formulated in algorithmic information theory. It is further explained by Tishby's 'information bottleneck theory', which uses information-theoretic mathematics (against Shannon's original bracketing of semantics) to describe such compact representations as abstracting and generalising over its predictive objects through the extraction of a minimal sufficient statistic that 'forgets' irrelevant information (where the latter may also be explained by drawing on renormalisation group theory).[63]

The problem with such accounts, and with the PP framework, is that they confuse natural and non-natural semantics, or representation and signification, as well as the different senses of probability distinguished by Carnap. This failure is crucial when it comes to the application of such mathematical models, and their implementation in neural net technologies, at the social level. When these models are used for correctly classifying dog images or for generating classical piano music the consequences are relatively innocuous, but the distinction between relevant and irrelevant details has political implications at the social level (for example, in algorithmic procedures regulating social media content, or in predictive policing)—these cannot be understood in the terms of probability$_2$ alone since the pertinent observed regularities refer to normative attitudes and beliefs, and to socially constructed categories.[64] In making probability$_1$ calculations, current AI, or algorithmic governance, while presented as neutral, may often perpetuate socially embedded forms of domination and oppression, and precisely

62. E.B. Baum, *What is Thought?* (Cambridge, MA: MIT Press, 2004), 102.
63. N. Tishby and N. Zaslavsky, 'Deep Learning and the Information Bottleneck Principle' (2015), arXiv:1503.02406. 'The central goal of RG is to extract relevant features of a physical system for describing phenomena at large length scales by integrating out (i.e. marginalizing over) short distance degrees of freedom.' P. Mehta and D.J. Schwab, 'An Exact Mapping Between the Variational Renormalization Group and Deep Learning', *CoRR*, vol. abs/1410.3831 (2014).
64. S. Haslanger, *Resisting Reality: Social Construction and Social Critique* (Oxford: Oxford University Press, 2012), 70

begs the question as to which theoretical framework and evidence the inductive generalisation ought to be relative to.

Compression is a powerful way of understanding how representational functions capture uniformities, and also how language abstracts and generalises over a broad range of phenomena and thus 'reduces the size of the agent's internal model while increasing its complexity';[65] this can be further specified in terms of the duality of compression and regularity formalised in Solomonoff's computational account of inductive inference.[66] However, just as Sellars distinguishes picturing and signification, so we must also distinguish prediction from description and explanation, where the latter must be understood not merely in terms of compression, but as the construction of new theoretical frameworks that selectively organise those compact representations.

More recent work in PP and in AI has begun to approach the oversight of linguistically structured intelligence, yet it remains entrenched in a generalised Bayesianism that fails to recognise the specificity of theoretical construction as opposed to probabilistic mapping. At the practical level, steps are being taken to mitigate the unaccountability and opacity of deep learning by providing a linguistic interface to its black-box operations (XAI), however there are major challenges not merely at the level of interpretability, but also in terms of ethical responsibility and malicious manipulation. Ultimately, conclusive solutions for such problems cannot be provided since they operate at the political and therefore historical level.[67] It has also been recognised that despite recent advances in deep learning, the kind of compact representations they are capable of generating are tied to task-specific goals, and DNNs have a limited capacity for transferring learning across different contexts, while human learning is massively facilitated by the construction of 'general-purpose reusable representations'. Attempts are therefore being made to unify deep learning capabilities with those of symbolic AI, using 'an end-to-end differentiable neural network architecture that builds in propositional, relational priors in much the same way that a convolutional

65. Negarestani, *Intelligence and Spirit*, 66.

66. '[A]nything that can compress data is a type of regularity, and any regularity can compress data'. Ibid., 312.

67. W. Tjoa and C. Guan, 'A Survey on Explainable Artificial Intelligence (XAI): Towards Medical XAI' (2019), arXiv:1907.07374v3.

network builds in spatial and locality priors'.[68] The notion that all cognition is simply prior expectation seems fatalistically mired in the reproduction of already given perspectives, as if the possible worlds over which thought ranges are some kind of algorithmically generated *Westworld*-style simulation wherein the appearance of novelty is always depressingly scripted.

At the theoretical level, Lupyan and Clark, for example, argue that within the PP framework language serves as a 'domain-general prior-setting tool' or 'flexible "programming language" for the mind'.[69] This goes some way towards an understanding of how language transforms the conditions of cognition, but since it maintains the image of thought as facilitating homeostatic control by predictively tracking statistical probabilities, it does not grasp the way in which normative-linguistic thought constructs (rather than tracks) its own conditions and is therefore essentially historical in a sense that lies outside of any kind of probability estimation. The power of the concept, as opposed to the picture, lies not just in its general-purpose and reusable flexibility, but in its entry into social-interactive historical discursive ramifications of meaning. In Sellarsian terms, picturing may permit labelling, but language enables description, where the latter is not just flexible across given learning contexts but also has conse-quences and entailments that can be discursively unpacked, and leads to the overturning of contingent historical givens and the generation of entirely novel contexts for perception, conception, and action. Though it provides an excellent account of cognition, PP as it stands remains restricted to an individualistic and conservative perspective and is therefore unable to think language not merely as a powerful 'artificial context' for uncertainty reduction, but as a social-interactive logico-computational process in itself, which has the capacity to construct unprecedented, entirely improbable, and yet possible worlds.

It is important to recognise that this emphasis on intelligence as linguistically enabled does not mean that the transformative power of thought lies solely in the discursive 'space of reasons'. One advantage of the PP account is its acknowledgment of bidirectional inferential processes throughout perception, conception, and action, and this can give further support to Sellars's conception

68. M. Shanahan, K. Nikiforou, A. Creswell, C. Kaplanis, D. Barrett and M. Garnelo, 'An Explicitly Relational Neural Network Architecture' (2019), arXiv:1905.10307.

69. G. Lupyan and A. Clark, 'Words and the World: Predictive Coding and the Language-Perception-Cognition Interface', *Current Directions in Psychological Science* 24:4 (2015), 279–84.

of the framework of intentionality in terms of language entry-exit transitions, or the way in which all perception is suffused with conception, but several linked claims must be made here: Although sensory states may nonconceptually picture the 'compact structure' of the world, the intentional awareness of a phenomenon as *x* relies on and occurs within the normative-linguistic order of signification (to claim otherwise is to fall for the myth of the given). Nevertheless, the logical distinction that Sellars makes between picturing and signifying does not hold in practice, either at the level of the cognitive scientific description of perception (where there is a pervasive cognitive penetrability of perception), or at the level of phenomenological experience (for example in the act of listening). The condition of possibility of thought, i.e. the transcendental framing of the phenomenon, is constrained at multiple levels (materially and biologically but also socially and historically, and through processes of subjectivation), but these constraints are open to transformation at all of these levels, i.e. not just through propositionally structured reasons. Shifts in transcendental perspective, or trans-umweltic variations, are linguistically enabled but not exclusively logico-conceptual in origin.[70]

Besides pragmatic discoveries, there are numerous examples of musical practices that have induced such shifts, and that not only express an 'anti-world' that escapes 'the physical "tyranny" of real time',[71] but act as a 'conduit through which a world can emerge'.[72] There are too many to mention, but just to make the assertion concrete, here are a few examples of music that has brought forth worlds that previously did not exist: Halim El-Dabh's 'The Expression of Zaar', Cecil Taylor's 'Unit Structures', Eliane Radigue's 'Vice Versa, etc.', Iannis Xenakis's 'Gendy3', Sun Ra's 'The Futuristic Worlds of Sun Ra', Autechre's 'Chiastic Slide', Florian Hecker's 'Acid in the Style of David Tudor', Ursula Le Guin and Todd Barton's 'Music and Poetry of the Kesh', Maryanne Amacher's 'Sound Characters', and Zuli's 'Terminal'. Musicking is different from the musicality of other animals because music belongs to the order of signification, even though its significance is to be differentiated from language (its syntax and semantics have distinctive

70. G. Catren, 'What is Ensoundment?' in F. Hecker, R. Mackay (ed.), *Formulations* (Cologne: Koenig Books, 2016).

71. G. Mazzola, *The Topos of Music: Geometric Logic of Concepts, Theory, and Performance* (Berlin: Birkhäuser, 2002), 933.

72. M. Fisher, 'Memorex for the Kraken: The Fall's Pulp Modernism', in D. Ambrose (ed.), *K-Punk, The Collected and Unpublished Writings of Mark Fisher 2004–2016* (London: Repeater, 2019).

self-referential characteristics and it displays a 'floating intentionality'). Neither language nor music express already existing thoughts, they engage specific computational capacities and constitute definite modes of *thinking* having to do with the rule-governed organisation of pattern-governed regularities and the construction of alternative worlds. As Negarestani says, 'sound engineering *as* worldmaking is tantamount to an emancipatory position [...] The "world" of my experience is only real to the extent that it enables me to postulate and imagine new worlds—worlds that may be impossible, but can be rendered possible, or worlds that are possible, but can be made actual.'[73]

73. R. Negarestani, 'Out of Bounds of Sense'. Talk given at *Regenerative Feedback: On Listening and its Emancipatory Potential.* Quoted in N.J. Scavo, 'Against Worldbuilding: Fight the Snob Art of the Social Climbers!', *TinyMixTapes*, 2018, <https://www.tinymixtapes.com/features/2018-against-worldbuilding>.

a prop-
osi-
ti-on

LOgic
+
sEx-ed
bOdies

Christine Wertheim
On the Relations Between Bodies and Deductive Thinking: An Artefactual Perspective

Introduction

In today's popular imaginary, 'possible worlds' are often presented as apocalyptic settings in which fleshy sentience is displaced and slowly erased by some form of artificial intelligence, whether embodied in machines or not. In these scenarios AI is assumed as the inevitable next step in an evolutionary process whose controlling force, at least for this one important step, is no longer nature, but humanity itself. According to this fantasy, once we have created our own successor we will no longer be necessary, and natural selection will again assert itself through a survival of the fittest mechanism in which humanity is destined to lose. One wonders, in this dream, why we humans should play the game at all.If all that AI can offer is our own demise, why should we bother to spend time and resources bringing it into being? Unless we have a collective species' death-wish, or at least a massive inferiority complex?

One rationale posited for pursuing AI is that in order to understand the universally necessary conditions of thought—rather than those determined by our humanly-embodied version of intelligence—we need some other kind of mind with which we can compare our own. The implication here is that this other mind would not be embodied, at least not in the sense that we are, for initially it would be inseparable from the hardware in which it is housed.

An anthropological perspective on this question might posit that we have already met many other minds with intelligences quite different from ours, in encounters with the many indigenous peoples whose modes of thinking now appear just as complex as, but fundamentally different from, our own.[1] If understanding the necessary conditions of mind requires comparative study, we may

1. See E. Viveiros de Castro, *Cannibal Metaphysics: For a Post-structural Anthropology*, tr. P. Skafish (Minneapolis: University of Minnesota Press, 2017).

thus already have comparators to hand, without the need to create an artificial Other ourselves. From this perspective, the project of creating an artificial mind is motivated less by philosophical aims than by more mundanely psychological reasons. However, the project of understanding mind's functioning—whether this be conceived as a (minimal necessary) universal or not—is, I think, one important factor in determining how we might move forward to create potentially more just and verdant futures, or at least ones different from the nightmares in which we currently imprison ourselves.

For me though, the import of this project lies less in trying to determine the necessary conditions of thought, than in developing ways of thinking about thinking that do not disconnect it so thoroughly from the body and from its external contexts, both social and material. What is important is to overcome that terrible image of (in)humanity in which the head is caught, dazzled, in the Cloud, refusing to look at its feet stuck in toxin-infested corpse-strewn clay, the very opposite of Klee's ruin-acknowledging Angel; to reconnect the head with the big toe, thought with embodied, socialised mobility, in real time and real space.[2] The implication here is not that we can manufacture images of thought to suit our tastes (as in some new materialisms), but rather that rigorous models already exist in which intelligence, and specifically its logical part, is indissolubly wedded to embodiment. I would argue that without this reconnection, as a species we will only recreate more of the same disasters, not radically new and different worlds. This paper presents a view of the logical aspect of thought as indelibly embodied, and thus as a useful tool in working towards less asymmetrical potentialities where the head-in-the-Cloud image no longer dictates our futures, either possible or actual.

*

The term 'logic' itself is often taken to designate eternal ideal truths, separable from the contingent material variables in which these are often found, e.g., natural languages. However, as Catarina Dutilh Novaes and Reviel Netz highlight in their 2017 conversation with *Glass Bead*, historical study demonstrates that

2. See Walter Benjamin's essay 'Theses on the Philosophy of History' for a description of how Klee's image presents history as a single catastrophe which keeps piling wreckage upon wreckage, rather than a story of progress.

both our conceptions of logic and its formalisations have changed radically with time.[3] Even the initial appearance, in the Occident, of an interest in the subject was rooted in contrived debating practices that emerged in Ancient Greece from historically unique conditions, rather than from universal truths pervading ordinary discourse.[4] Since 'Classical Greece' was a relatively young society composed of a variety of immigrants who shared few common beliefs, it had become necessary to *discuss*, rather than simply inherit, ideas about what a polis and its structures might be—hence the interest in the principles of debate and argument as topics in their own right. Given its apparently arbitrary origin, how can the formalisms developed from these practices over two thousand years later possibly analyse contemporary problems, to the degree that, via computers, they now underpin practically every move we make, from shopping and travel to healthcare and entertainment? Or, as Netz puts it in *Glass Bead*: What is the relation between 'the contingent historical development of *logical formalisms as concrete artifactual technologies* and the necessary truths that logic is supposed to grasp'?[5]

This shift of focus, from questions of truth and universality to the concrete artefactuality of formal logical technologies (however contingent) is a necessary first step on the path towards addressing relations between logic and bodies, for it posits a link between logical thinking and capacities for making and doing; capacities that will inevitably be embodied. It highlights the fact that logic, whatever it is for now, is not wholly concerned with dematerialised ideas, but also with bodies interacting through time and space with other materials and objects, including other persons and bodies. As Charles S. Peirce said, logical formalisms are prostheses of the mind: when I use pen and paper to draw a diagram or write an equation, this object, that surface, these inscriptions, are parts of my overall thought process, and thus are parts of my mind. From this artefactual perspective, not only is mind, or at least its logical portion, something inseparable from bodies and materials, it actually requires these to function, and even perhaps to appear in the first place. Furthermore, from an artefactual view-point the main question is not whether logic points to some mind-independent

3. *Glass Bead*, Site 1, 'Logic Gate: The Politics of the Artifactual' (2017), <https://www.glass-bead.org/article/formalisms-formalizations/?lang=enview>.

4. Ibid.

5. Ibid (italics mine).

reality, eternal or otherwise, but rather how certain forms of knowledge, along with their distinct artefactual technologies—diagrams, equations, notations, etc.—developed, or were made possible at diverse times and places. Indeed, a focus on the artefactuality of knowledge is inevitably historical, because here knowledge itself is nothing more or less than artefactual technology, and, since such technologies change, so too must our comprehension or knowledge. At least prior to computers, the primary technological artefacts of logic were notations: scripto-algebraic or diagrammatico-topological. The engine of change for ideas about logic and its practice, in the artefactual perspective, is thus simply the constantly updated reconstruction of such mental prostheses.

The creation of artificial systems to accurately describe complex structures such as musical arrangements, electrical circuits, or chemical compounds and their transformations not only aids our capacity to reproduce these phenomena, it enhances our ability to analyse and explore them. Furthermore, as different systems appear, new, or at least different aspects of the described structures and their transformational potentialities may also come into view. What appeared as the only possible set of valid deductive arguments in the Middle Ages now figures as a limited and almost arbitrarily selected cluster of simplistic configurations. Indeed, the development of modern notations brought about the understanding that logic itself is not merely a (set of) static structure(s), but rather a mode of transformation that enables (certain kinds of) structures to be *translated* into other structures within a specified domain. Different logical technologies conceive these structures and their transformations in different ways.

Although the edifice of (classical) deductive argumentation is now well understood, and its notations quasi-standardised, nineteenth-century logicians worked hard to create new formalisms with which to capture their evolving sense of its configuration(s). Boole invented one system, De Morgan another, neither of which can be said to be absolutely right or absolutely wrong. Each simply highlighted different aspects of an emergent construction that was not yet fully clear. Whitehead and Russell, along with Frege, are credited with inventing the first fully formed deductive notations. However, it is now known that Charles Peirce preceded them both by some years.[6]

6. D.D. Roberts, *The Existential Graphs of Charles S. Peirce* (Berlin: Mouton de Gruyter, 1973). See also F. Zalamea, *Peirce's Logic of Continuity: A Conceptual and Mathematical Approach* (Docent Press, 2012).

The point here is not to argue historical precedence, but to present a notation vastly different from the contemporary standards based on the work of the established pioneers, for although operationally Peirce's system validates the same arguments as the standards, and disallows the same paradoxes, the 'image' of logic upon which it is based—or from which it emerges—is fundamentally different to that which results from, or founds, the set-theoretical methods. Of particular note here is the fact that Peirce's notation overtly recognises that it is itself an artefact, for its first axiom is: 'This piece of paper on which I inscribe my propositions and arguments is to be taken (here, now), as holding the value of Truth.' Without quashing the question of external reference entirely, by beginning with a recognition of its own artefactuality, this technology offers a perspective on logic different to that of systems whose artificiality can only be contemplated at a meta-level. To use another discourse, it could be said that Peirce's system is immanently, rather than transcendentally, constructivist. But before moving on to look at this marvellous object, a few words on what is meant here by 'logic'.

Formal Deductive Logic

In this essay 'logic' is taken to mean: *the criterion of necessary truth preservation in classical deduction.* (Though the matter will not be discussed here, this definition can be extended to the more complex contemporary developments in modal and linear logic.) 'Logic' here means the analysis of the *transformations* that preserve truth in the species of argument known as Deduction; no more, no less.

Deduction can be distinguished from two other classically recognised types of argument: Induction and Abduction. The cases below exemplify the distinction:

Deduction	*If* all the beans in the bag are green
	and this bean is from the bag
	then this bean is green
Induction	*If* this bean is green
	and this bean is from the bag
	then all the beans in the bag are green
Abduction	*If* all the beans in the bag are green
	and this bean is green
	then this bean is from the bag.

The central focus here is the *transformational structure of the if...then... relation*, and in the deductive species of argument the significant *value* is not truth, but validity, or truth preservation. The following deduction is valid no matter the value of the propositions we put in the places of variables A and B:

IF [If A, then B
 and A]
THEN B

Classically called *modus ponens*, this argument can be summarised as:

[(P implies Q), and (P is asserted to be true)], therefore (Q must be true)

A *valid* deductive argument has this essential feature: It is necessary that *if* the premises are true, *then* the conclusion is true. However, the argument itself says nothing about whether the premises actually are true or not. It only states that, *if* they are true, *then* so too will be the conclusion. As the study of the forms of valid deductive arguments, logic is the study of the *forms of deductive truth-preservation*.

In deduction, the *if...then...* relation is called *material implication*, and it is one of the basic logical operators, or binary connectives. For just as (basic) arithmetic has a finite set of operational signs, +, -, ×, ÷, =, etc., so the connectives can be seen as the basic signs of logical operations (at least at the first propositional level). Since the early twentieth century,[7] it has been understood that the formalisation of deductive arguments (at the propositional level) is a discrete system involving sixteen connectives, all of which can be derived as variations from any other two.[8] Because it is not necessary to use all sixteen, most formal notations use only a few. Commonly used connectives include: negation (not), conjunction (and), disjunction (or), material implication (if...then), and biconditional (if and only if).

The connectives are 'binary' because each constitutes a specific *relation between two propositions only*. Formalisations of classical deductive logic thus

7. Christine Ladd Franklin, a pupil of Peirce, was the first to realise this.

8. Or even just one, if you choose the right one.

inscribe all complex propositions as nestings of relations between pairs of simpler propositions. For example, we can construct the complex: 'IF [(if (A and B), then (B or C)), AND (either A or B)], THEN [conclusion].'

Doing logic consists in determining, by the laws of deduction, what follows from such an original assertion, in a manner not dissimilar to the way in which equations are solved in arithmetic. That is, it consists in determining what other (consequent) propositions the original (antecedent) can be validly transformed into. To put it another way, the consequence of a deduction is a proposition *equivalent* to the antecedent originally inscribed. While this means that in some sense nothing new is *added*, in another sense, something new is *learnt*.[9] Though it took the Occidental world over two thousand years to work this out, very specific rules determine what follows deductively from what—or what can be *validly* transformed into what. All notations of standard non-modal deductive logic allow the same transformations, no matter what symbols they employ; and there have been hundreds of such notations invented over time, using quite different signs. At least in the formalisation of classical deduction—i.e., non-modal, non-linear, non-fuzzy, non-inductive, non-abductive, etc., forms of argument—the difference between notations is not which transformations they do or do not allow, it lies merely in the 'image of thought' they (re)-present.

As many have realised, the sixteen connectives form a symmetry group. For this reason, formal logic notations can put the symmetry into the signs for the connectives by using the *graphical* capacities of inscription to mimic, or *iconically* represent, the spatial relations of symmetry and rotation between the connectives. This use of the iconic capacities of graphemes, rather than the merely symbolic power of conventional (algebraic) signs, is a radical technological departure from the standard scripts used today; though, as Peirce understood, iconicity was key in both mediaeval and ancient logic schemas such as those of Aristotle and the Stoics, as well as the so-called Syllogisms.

Although at least five other logicians constructed notations on this principle, Shea Zellweger has taken it furthest in his 'Logic Alphabet'.

9. This raises the very interesting issue, frequently discussed by Peirce, that many structures or complexes, both in the real world and in representations, contain latent relations obscured by the manifest presentation of the original complex, relations that can only be discovered by literally playing with the complex to see how it can be transformed. Hence his emphasis on the non-symbolic elements of notations.

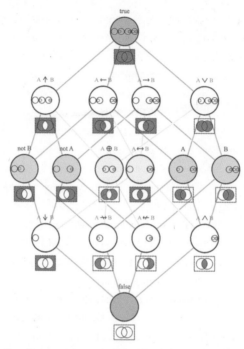

Haas Diagram of the sixteen connectives in Venn diagram form.

No.	Truth Table	In Words	PWR	Polish	McCulloch	Logic Alphabet
1	FFFF	Contradiction	Contradiction	O	✗	o
2	FFFT	Not-A and Not-B	~ A · ~ B	X	✗	p
3	FFTF	Not-A and B	~ A · B	M	✗	b
4	FTFF	A and Not-B	A · ~ B	L	✗	q
5	TFFF	A and B	A · B	K	✗	d
6	TTFF	A	A	I	✗	c
7	TFTF	B	B	H	✗	u
8	TFFT	A equivalent B	A ≡ B	E	✗	s
9	FTTF	A or else B	A ⋏ B	J	✗	z
10	FTFT	Not-B	~ B	G	✗	n
11	FFTT	Not-A	~ A	F	✗	ɔ
12	FTTT	Not-A or Not-B	A/B	D	✗	h
13	TFTT	if A, then B	A ⊃ B	C	✗	Ρ
14	TTFT	if B, then A	B ⊃ A	B	✗	d
15	TTTF	A or B	A ⋁ B	A	✗	կ
16	TTTT	Tautology	Tautology	V	✗	x

Shea Zellweger, chart of different notations developed using the symmetry properties
of the connectives, <http://www.logic-alphabet.net/notation_systems.htm>.

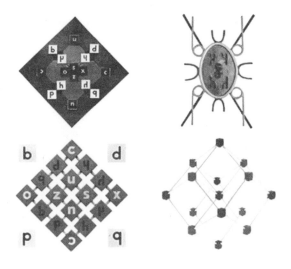

Image of tools developed by Zellweger for teaching logic,
from G. Clark and S. Zellweger, 'Let the Mirrors Do the Thinking', *Mount Union
Magazine*, Spring 1993, 2–5.

With Zellweger's tools, one can learn the system as a group of transformations, without the need to apply (logical) meanings to these, by merely rotating appropriate physical objects in one's hands, and watching how the graphemes move from one position in the crystalline group to another. As Zellweger notes, this means that, at least potentially, even small children could learn the primary transformations involved in doing logic. Though such notations will not likely be adopted in the near future, for the same reason that more efficient typewriter keyboards have not—users don't like change—recognising that the logical connectives constitute a transformational symmetry group has enormous consequences for our understanding of mind, logic, and their (collective) story.

When understood as a group of symmetry transformations, the structure of (deductive) logic *taken as a whole* appears as less concerned with external reference than with spatiality, and the rotation of objects in space. In this case, perhaps the overarching structure does not represent any ideas or ideals at all, let alone universal ones. Perhaps rather it *indexes* a time in human history—that long (prehistorical) period—when our minds were literally, and collectively, *being formed,* or even *being trans-formed (into minds).* Perhaps it indicates

a (mythical) epoch when (proto)-humans spent, or created, their (own) time and proper (mental) space by *actively constructing it* through the rotation of simple objects in their hands. The multidisciplinary Viennese scholar and some-time 'space-time sociologist' Bernd Schmeikal suggests this possibility when discussing archaeological research on some early human artefacts: small stone quadrated circles whose only apparent purpose is to enable hands to flip and rotate their four points from one position to another, permitting the (emerging) mind to study the group of moves that make these transformations possible.[10]

In a paper entitled 'Logic from Space', Schmeikal argues that

classical logic, or Boole's 'laws of thought', can be derived from an original con-cept of orientation that [...] emerged in human cognition during Palaeolithic wor-ship activity. The original concept of orientation represents a genetic structure of orientation in both physical and social space. This [...] concept of orientation in its exact mathematical form is a symmetry in space, strictly a subgroup of the rotation-group D_3.[11]

In other words, the (emerging) mind does not merely *study* the group of moves that make these transformations possible, (the) mind itself, or at least its logical aspect, comes into being by constituting itself *as* this group of transformations. From this perspective,

[p]ictograms, ideograms and logograms signify two phases fundamental for the later emergence of the linear writing and time as history and thought. [And] [t]he nowaday operational structures of cognition appear as rooted in prehistoric thought, meaning, vision, ideas [...].[12]

10. This four-point group is directly related to the group of the sixteen logical connectives. Piaget, among others, worked on this matter, and believed gestural play with orientations in space to be a fundamental part of early childhood learning and the development of mind. See J. Piaget, *A Child's Conception of Space* (New York: Norton, 1967).

11. B. Schmeikal-Schuh, 'Logic from Space', *Quality and Quantity* 27 (1993), 117–37. See also 'Space-time Sociology', Institut Für Höhere Studien, Research Memorandum no. 313, <https://www.ihs.ac.at/publications/ihsfo/fo313.pdf>.

12. B. Schmeikal-Schuh, 'The Emergence of Orientation and the Geometry of Logic', *Quality and Quantity* 32:2 (May 1998), 119–54.

Thus, Schmeikal contends, the structure of deduction develops from an embodied orientation of logograms whose essential features are symmetry, mobility, and transformationality.

For Schmeikal, logic, in the form of elementary first-order propositional calculus, is *derived from a specific and embodied orientation or symmetry* in space, developed over aeons in which early humans literally beat a structure into their minds by playing with the patterns of graphically-marked objects in real time and space.[13] (Here the question of priority over presence or representation is quite irrelevant.) And it is the specificity of the actual object chosen, a four-point configuration, that determines the eventual structure of cognition we constructed for ourselves. Had our ancestors used, say, a six-part rotational object, then our mental structure, or the logical part of it, would now be governed by completely different forms, with different ideas about, and formalisations of, logic. However, the artefactuality of this hypothesis does not imply that what we think through the lens of this particular transformational assemblage, i.e., Deduction, is purely subjective. It simply implies that other forms of mind and logic, other transformational mental assemblages, are possible. It does however explicitly rely on the premise that mind is body-dependent. Indeed, from this perspective, the capacity of bodies to move in space, and to observe themselves moving, is necessary for mind to emerge at all. Furthermore, from this standpoint, Logic qua transformational assemblage lies in the same realm as myth, as redefined by Eduardo Viveiros de Castro, after Claude Levi-Strauss.[14] That is to say, *qua* transformational assemblage, Deduction is less a form than a content (its own); one that reflects upon itself, just as myth does in Viveiros de Castro's account. In Peirce's notation, this self-reflection of the *trans-form as* (its own) *content* is made explicit.

As previously stated, this transformational structure is merely a model of valid motions, i.e., truth-preservation. To deal with truth, something more must be added: information, often of a quantitative kind, that *indexically* links the content of propositions to external referents. But this concerns the relationship between propositional content and its reference, not the mobile figures of deduction. At least from the perspective outlined here, truth is an extra-logical matter, the

CHRISTINE WERTHEIM / ON THE RELATIONS BETWEEN BODIES AND DEDUCTIVE THINKING

13. Ibid.
14. Viveiros de Castro, *Cannibal Metaphysics*.

province of observation and science, which can also be used to construct new devices and phenomena, as in chemistry and electrical circuit design. What all this means for AI, we can only surmise. For now, I shall move onto another formal deductive notation which, while still seeing logic as inextricably linked to bodies, has different implications for how we think the relations between the two.

Charles Peirce and the Existential Graphs

Charles S. Peirce was the Picasso of logic, and developed many extraordinary new notations for highlighting different aspects of logical structure. By his own estimation, his *chef d'oeuvre* is the notation he called the *Existential Graphs* or *EG*. Although EG looks quite different from the notations currently in vogue, as an apparatus for logical calculation it is equal to any other. This has been formally proved.[15] All tautologies or logically true propositions in any standard notation are true in EG, and all non-tautologies in other notations are logically false in this system. What is valid in any standard notation is valid in EG. The difference subsists in the underlying, or emergent picture of what logic 'is', for not only does EG *take the proposition of its own spatiotemporal matrix, its own artefactuality, as its first axiom*, it depicts thought processes as morphisms on continua, and is therefore based on topology, not set theory. With the emergence of category theory, we now know that transformations or equivalencies can be made between different mathematical 'objects'—for instance, between a group, a topological surface, and a formation of sets. The choice between models is thus simply a choice of perspectives. Aspects of logic highlighted in one model might fade or be totally obscured in another. The significance of EG lies not in its calculating power but rather in its *perspective*. Before presenting the basic structure, let us give a few notes about the very general view of logic on which it is based, for even this is slightly different from the way in which the field is often understood today.

There are two levels to classical deduction: the more general propositional logic or propositional calculus, and the more specific predicate logic or predicate calculus. Propositional calculus deals only with the *relations between propositions taken as wholes*. Propositions are the basic units of logic, and

15. Roberts, *The Existential Graphs of Charles S. Peirce*. See also Zalamea, *Peirce's Logic of Continuity*.

they include complexes such as 'The sky is blue' or 'All cats have legs'. However, at the propositional level we do not look at their internal structures, we just take them as wholes, and designate these wholes with variables: A, B, C, etc. In propositional calculus propositions are linked by connectives to form larger complexes such as, '*if* A, *then* B', '*either* A *or* B', or '(*if* (A *and* B), *then* (B *or* C)), AND (*either* A *or* B)'. Although there are sixteen such operators, most notations use only three or four, because all can be constructed from any two. As stated, doing logic involves applying the laws of deduction, which transform combinations of connectives into other combinations, to see what other simple, or complex proposition follows—that is, what other propositions are equivalent to the original premise. Thus a whole argument has a structure of an implication:

IF [(if (A and B), then (B or C)), AND (either A or B)]
THEN [conclusion].

Predicate calculus adds to the mix relations *inside* propositional complexes. Examples include:

The sky—*is*—blue
The sky—*is*—*either*—blue—*or*—green
Either (the sky—*is*—blue) *or* (the sea—*is*—green)
All skies—*are*—blue
Some skies—*are*—green
If (Socrates—is—human), *then* (he—*is*—mortal)
(The elements in *italics* are the logical portions of the propositions.)

We can see that there is a level of recursion involved here, for the connectives are also used in the internal structures of propositions. However, something new is added at this second level, namely 'predication' or the *attribution of predicates to subjects*, either in groups, or as individuals. 'The sky *is* green', 'All men *are* mortal', etc.

In all the standard algebraic notation, many different symbols must be added in order to create a fully formed predicate notation, including signs for both individuals and their quantities, 'some', and 'all'. (In classical logic 'some' means

'at least one'.) This is not the place to elaborate the full structure of standard formalisations. Suffice to say that they all represent individuals as members of sets; and allow that properties such as 'greenness', 'humanness' and 'mortality' can be attributed to either *some* member of a set, or to *all* of its members. The conceptual relations 'some' and 'all' and their signs are known as *quantifiers*. To produce a fully formed predicate calculus thus requires, as well as the connectives, at least signs for sets, signs for set membership, and signs for the quantifiers. What is important is that all standard notation is based on the premise that the transformational assemblage known as deduction can be conceived and represented as sequences of *operations upon sets*. Although obviously the very concept of a 'set' must also be specified, some notion of set-hood is involved. And all standard notations model sets and their transformational relations using algebraic scripts; they use what Peirce calls symbols—signs whose meaning is merely conventional. In his own EG notation, *neither* of these principles is taken as a foundation for modelling logic. In EG, 'individuals' are not represented as members of sets, but rather as existential continuities. And the basic principle of the notation is iconicity rather than symbolism.

Among his many differences from prevailing contemporary perspectives, Peirce believed that, while formalisations of both logical and mathematical 'objects'[16] could not avoid using some purely symbolic aspects (as well as some indices), they should at least aim to use as much iconicity as possible. Excellent examples of such notations are electrical circuit and chemical diagrams, for in both cases the relations between the parts of the diagram are *exactly* the same as the relations between the equivalent parts of their real-world referents. This is the principle of iconicity—not visual similarity, but relational exactitude, for by repeating exactly the relations between the parts of its referent, an iconic diagram can be navigated by its user exactly *as if* the user were navigating the referent. Think for example of subway maps—no doubt train lines are not green and red, and neither are stations circular blobs, but all the black circles lying on the green line in the map (diagram) lie on its real-world referent, and where the green line crosses the red line on the map, it also crosses in reality. Without this factor, the map (diagram) would be useless. Both chemical and

16. This is a technical term used by contemporary mathematicians to describe large-scale mathematical structures or assemblages.

electrical circuit diagrams function in this manner, and were the inspirations for EG. For Peirce, logic and mathematical notations should aim for the same level of iconicity. A mathematical example would be the geometric versions of the Pythagorean Theorem, which quite literally *show* (*de-monstrare*) how the proof works, whereas the algebraic counterpart is a pure convention showing nothing, just a formula to be learnt by rote.

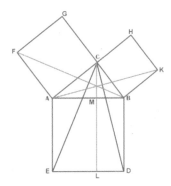

Peirce desired a diagrammatic notation for deduction that would be just as iconic, a 'moving *picture* of thought'. This meant that he had to conceive of deduction as a spatial structure. He had already done this with the development of his own symmetry group notation. But this only allows a formalisation of propositional calculus. Such models cannot be extended to predicate logic. However, because Peirce was aware that mathematical objects can be modelled in diverse ways (his own experiments with other notations had taught him this) he realised that the symmetry group of logic had a topological equivalent in a particular type of surface, and that operations on this surface could be used to model the connectives. These operations are cuts and regluings, which enable a surface to be divided and (re)-connected in different ways. From this perspective, doing logic consists in cutting and rejoining parts of a surface, and the notation developed on this principle is a two-dimensional graphical icon of these manoeuvres. With this approach, it then becomes possible to also topologically model predicate logic, for now individuals can be conceived as lines or 'threads' that tack onto different points of the surface connecting different areas in different configurations. We are now ready to look at the diagrammatic

notation for the Existential Graphs, possibly the most artefactually radical deductive notation ever created.

The Existential Graphs

There are four levels to the iconic, diagrammatic, and graphical notation of EG:

- Alpha Graphs = propositional logic.
- Beta graphs ≈ predicate logic /w identity w/o constants, function symbols.
- Gamma graphs =
 – Modalities (possibility, necessity, knowledge, time…,
 'tinctures', 1908).
 – Higher-order assertions.
 – 'Graphs of graphs', abstractions.
 – Interrogatives, imperatives, absurdities…
- Delta graphs (1911): '…to deal with modals'.[17]

I shall discuss here only the first two levels, which are roughly equivalent to standard propositional and predicate calculi.

The First Axiom

Unlike most logic scripts, EG does not begin with the connectives, but with the fact that all notations, for any phenomena, whether linguistic, mathemic, or diagrammatic, *must be inscribed on something, namely a surface.* (Though this surface and the signs drawn on it may have thickness, we shall treat both surface and marks as ideals—without thickness, and infinitely pliable.) The first axiom is the assertion of the being of the surface itself, and the *assignation of its value*. In the existential graph notation the inscribing surface is called the *Sheet of Assertion, or SA*, and in ordinary non-modal logic it asserts: 'Every graph inscribed on this surface is deemed to be (necessarily) true, in this universe of discourse (the universe represented by *this* sheet of paper).' No doubt this is trivial in the extreme, but it has to be stated, otherwise how would

17. A.-V. Pietarinen, 'Independence-Friendly Existential Graphs', presentation to Department of Philosophy, University of Helsinki, 29 April 2004. See also, A.-V. Pietarinen, 'Peirce's Magic Lantern I: Moving Pictures of Thought', *Transactions of the C.S. Peirce Society* (2003).

we know? One effect of this system is that every graph, every instance of a proposition, however simple or complex, is overtly presented as an instance of the *making of an act of inscription* (or the making-of-a-statement) within a particular universe of discourse. Of course, the inscribing sheet might be used to represent other values, such as 'Every graph inscribed on this surface is deemed to be *possibly* true', or 'Every graph here is *impossible*', etc. This is why, at the Gamma and Delta levels, Peirce conceived of sheaves of sheets with different modalities, between which the graphist could move. In ordinary non-modal deduction, though, the value of SA *is deemed to be* Truth.

Because any graph inscribed on SA is deemed to be true, it follows that to inscribe

A B G-H Z

is to assert that the propositions represented by A, B, G-H, and Z are all simultaneously true (in this universe of discourse). Thus, the composite proposition, 'A + B + G-H + Z' is also true. SA is thus also the operator of conjunction, 'AND', represented in some notations by the sign Δ , but in EG we don't need a separate sign.

The Second Axiom

In the existential graphs, it is easy to surmise the operator for negation, or 'NOT', for we simply sever an area of the surface from the value of truth. This is done by a singly enclosed loop called a 'cut', or 'single cut', because it literally *cuts* or *severs* this area from SA. Thus, the graph

 asserts: '(the proposition) A is Not-True'.

It is *never* allowed to draw an empty single cut directly on SA, for this would deny its truth status as a totality, and create a paradox. However, it is *always* allowed to draw a 'double cut', or 'scroll', in any manner we please:

If we consider that each loop negates what is inside it, and that the blank surface is the sign of conjunction, we see how these diagrams may be seen as the operator for the consequence-relation, '*If... Then...*'. An empty scroll cut may be read as asserting: '*Not (and (not))*', or '*If* Truth, *then* Truth'. Because this is a tautology, adding nothing that is not *logically* true, it is always permitted to draw a scroll on any portion of SA.

The graph:

 may be read as '*Not (A and (not B))*', or '*If* A, *then* B'.

By starting with a scroll and inserting or erasing single cuts according to the rules governing valid transformations, *the rules describing what can be inserted and erased from graphs*, we can derive all sixteen binary connectives to pro- duce a complete propositional logic. For example:[18]

$$\varphi \lor \psi := \neg(\neg\varphi \land \neg\psi)$$

is a graph representing the proposition:

Not ((not A) and (not B))

which is equivalent to

either A or B

This is why *the scroll cut is the second and only other axiom* needed to develop a fully-fledged propositional logic.

18. Pietarinen, 'Independence-Friendly Existential Graphs', 'Peirce's Magic Lantern'.

But though implication, and all the other connectives, can be reduced to series of '*nots*' and '*ands*', Peirce was insistent that the '*if... then...*' form of implication, or what I prefer to call 'consequention', is primary, and that all other connectives are derived through deformations of this principle. This is so because, being a tautology, an empty scroll is the minimal graph that asserts nothing that does not follow directly from SA itself. (Peirce defines negation as the consequence of a hypothesis from which *everything* would follow, hence it must be negated. In this view, a negation is thus a degenerate form of consequention.) We begin to see here how very different is Peirce's understanding of logic from the standard accounts, even though as a calculating device or tool for performing proofs, it works just like the others.[19]

(2) **The self-distributive law of material implication. This is stated in** *'rincipia* **notation as follows:**

$[P \supset [Q \supset R]] \supset [[P \supset Q] \supset [P \supset R]]$. In EG it looks like this:

One last point on the Alpha level of EG: though the scroll of consequention can be degenerated into two nested loops, Peirce describes it as properly being a single cut around the Sheet of Assertion, SA. This means that SA has a very particular topological shape. I have not found any place in Peirce's papers where he overtly speaks about the topological structure of SA, although we know that much of his work was lost, when faculty at Harvard, where his original papers

19. Diagrams below from Roberts, *The Existential Graphs*, 45.

are kept, were encouraged to use them as notepaper in periods of materials shortages that occurred during the two world wars. However, he was well versed in the topology of surfaces and knots, and developed his own massively generalised Euler formula which he believed could account for all topological objects. With late twentieth-century developments, this may not hold up. But it shows the importance Peirce gave to topology.

For us, the significant point is that the matrix within which logical complexes are constructed in this model is not a symmetry group, but a (topological) surface, whose overall structure is described by a scroll cut. Together, these two elements, the surface and its double-cut, represent or model the relation of *consequention*. The diagram below, published by Ahti-Veikko Pietarinen, summarizes the structure of the Alpha level of EG.[20]

Alpha part

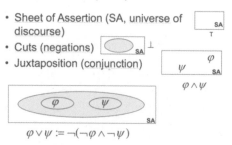

- Sheet of Assertion (SA, universe of discourse)
- Cuts (negations)
- Juxtaposition (conjunction)

$$\varphi \vee \psi := \neg(\neg\varphi \wedge \neg\psi)$$

- Conditional ("the scroll")

$$\varphi \supset \psi := \neg(\varphi \wedge \neg\psi) = \neg\varphi \vee \psi$$

Predicate Logic in EG: Beta

In EG, the predicate, or beta level is derived by simply adding a *copula*. According to Peirce (following a long line of theoretical ancestors, but in opposition to

20. Pietarinen, 'Independence-Friendly Existential Graphs'.

the emerging dominant view of the twentieth century), to add a copula is to add an axiom asserting the existence of an individual, *this* individual · *here*, in *this* universe of discourse. The copula *is itself that existential complex, not just its sign.* This is why Peirce called it the 'line of identity', or LoI. With the line of identity, we can make many different assertions:[21]

Beta part

- Rhemas (predicate terms)
- Lines of identities (LI, existence, identity, predication, subsumption)

A man eats a man

A phoenix doesn't exist

Something exists that is not phoenix

If it thunders, it lightens

However, a copula, or LoI, should not be conceived of as a mark merely drawn on SA; it is an independent line, like a thread, which tacks together different points on different areas separated by cuts in SA. Thus, a copula or LoI cannot be equated with the structuralist Mark of Difference. Operations in EG are more like surgical processes or acts of patchwork sewing, in which pieces of a surface are cut up and then stitched back together.

We should also note that an empty copula '————' is a legitimate graph asserting: 'Here is some existence', or '*Here* some (thing) is', where 'is' indicates '*existence*'. (For Peirce 'existence' is one aspect of being only, but it is that aspect designated by the logical copula.) Like the chemical diagrams by which Peirce was inspired, empty terminations on LoIs are places where signs for qualities can be added, and where copulas can be joined, if they lie on the same area and are not separated by cuts. Thus, the following two diagrams:

———— has red pulp
———— is an orange

21. Ibid.

assert the same existence and can be joined to form the more complex

With the copula and the scroll of consequention, we now have a fully formed predicate logic, for the universal quantifier naturally follows. The graph:

reads:

'*if* a man *is*, *then* he will die', or 'All men die'.

We can further complexify the structures of existential complexes, because every point on the line of copulation Ÿ is triadic —is⟨ when blown up. These are called 'ligatures' in Peirce's terminology. With ligatures we can develop more complex propositions:[22]

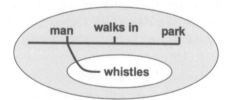

A man walks in the park. He whistles.

Ahti-Veikko Pietarinen describes Peirce's ligatures in contemporary terms as follows:[23]

22. Ibid.
23. Ibid.

- "Binding scope" is given by the system of LIs (ligatures)
- "Priority scope" is given by the system of cuts
- In FOL these go together, in Beta they do not
- Beta not isomorphic to FOL
- Rather like dynamic semantics

$$\exists x (S_1 x \wedge S_2 x) \ ?$$

$$\exists x \, S_1 x \wedge S_2 x \quad ?$$

Roberts adds:[24]

> There is practically no limit to the number of ways a line of identity can be made to branch. Consider, for example, this description of Aristotle:

> 'There is a Stagirite who teaches a Macedonian conqueror of the world and who is at once a disciple and an opponent of a philosopher admired by Fathers of the Church' (Ms 450, p. 18).

Note that the above diagram represents three different individuals or existential complexes—Aristotle, Alexander, and Paul. With the addition of copulas, or lines of identity, we can now develop a fully formed predicate calculus. Pietarinen's summary of the Beta portion of EG runs as follows:

- Rhemas, graphs, inferences are "continuous with one another" (1908).
- Connectivity between different parts of SAs by LIs and juxtapositions gives rise to *propositions*
- Meaning-preserving transformations as continuous deformations give rise to *inferential* arguments
- Topological system[25]

24. Roberts, *The Existential Graphs*, 49.
25. Pietarinen, 'Independence-Friendly Existential Graphs'.

However, we should note that in the EG conception of logic, there is no essential difference between subjects and predicates. To inscribe the graph

$$s\text{——}is\text{——}p$$

is not to privilege 's' as having an independent existence to which properties such as p can be attributed. *Existence subsists in the copula alone.* Both 's' and 'p' are merely signs referring to properties that can be coupled into existential complexes via the mediation of a copula. An accurate reading of the above graph is thus not 's is p', but rather, 's-ness and p-ness are coupled together in *this* existential complex, indexed by *this* copula'. This is why Peirce was opposed to set-theoretical formulations of logic: because they assume empty monad-like 'subjects' or potential members of sets to which existence is added as a property: whereas in EG, the existence, inscription, or utterance of a copula-relation *is* that existence. Or perhaps we could say that the copula is the (existential) 'subject'. This conception of the copula in EG unites a number of logical operations often seen as different in other notations. Pietarinen again:

- Different readings of 'is' not logically different
 - Existence *Socrates exists*
 - Identity *L. Carroll is C. Dodgson*
 - Predication *Socrates is mortal*
 - Subsumption *Man is an animal*
 - Coreference *A man walks in the park. He whistles.*[26]

In summary, in EG there are two, and only two *wholly distinct* principal *elements of structure*, and neither may be conceived of as the mere negation or 'opposite' of the other:

(1) the topological inscribing surface SA with its scroll cut representing the relation of con-sequention, and

(2) the line of identity representing both copulation and existence.

26. Ibid.

All (empty) logical complexes (of the classical kind) can be constructed from these two principles alone: and no more is required.

Conclusion: A Moving Picture of Thought

As Peirce said in 1906, existential graphs 'put before us moving-pictures of thought', thought conceived as a surface that can be cut up and glued back together, and to which threads can also be stitched to join different severed areas. There is a surface, and there is a line, and they *interpierce* one another.... If EG is not to be taken as a metaphor, which I believe it was not for Peirce, this is an extraordinary image of mind. One might well ask how a mind initially constituted through long-iterated rotations of a symmetry could develop into this. But given that mathematical objects can be translated into different forms, depending on one's perspective (or mathematical formalisation), once created by/as a symmetry group, the same mind can be seen from a topological perspective. The real question then becomes how and why the copula was added. Does *this* indicate a time in (pre)history when the existential identity of individuals became important, or was even constructed from scratch? And if so, what prompted this development, and how was it materially achieved? For us, the most important matter is the overall image of mind (or at least its logical portion) as the *interpeircing* of a line or thread (re)presenting the relation of copulation:

and a surface or membrane (Peirce occasionally used this term), described by a double cu$_n$t:

How can this image aid in the proposition of possible new worlds?

Two points may be highlighted here. Firstly, this image is substantial. Although the elements of thought *represented* by the membrane and quilting thread may

be purely virtual, they are not therefore wholly immaterial. (Perhaps we need to return to the idea of a *cogitans res* or thinking substance.) Secondly, without positing a correlationist conspiracy, it cannot be 'mere coincidence' that when deductive logic is modelled with two and only two principles of structure, these turn out to be called copulation and consequention. (In old English and French the words 'con' and 'conny' were euphemisms for 'vagina.' The term 'cunt' may stem from the same origin.) My hypothesis is that, despite thousands of years of denial, or perhaps precisely because of it, the cultural unconscious of the Occidental mind has finally, in what Freud would call a classic return of the repressed, succeeded in revealing its *own conception* of a link between sexed bodies and logic. The exact nature of this link—that is, which comes first, a sense of sexual difference, or the incorporation of a form that can be used to construct arguments—is as yet unclear. However, in an age where 'gender' is a hotly contested question, and the social imaginary keeps returning to apocalyptic futures ruled by artificial minds constructed from logical machineries, I would argue (sic) that this is a link worth pursuing.[27]

27. Oddly enough, Lacan seemed to think the same, if his sexuation formulas are anything to go by.

Notes on Contributors

ELIE AYACHE was born in Lebanon in 1966, trained as an engineer at the École Polytechnique in Paris, and was an options market-maker on the floor of MATIF (Paris, 1987–1990) and LIFFE (London, 1990–1995). He then co-founded ITO 33, a financial software company that specialises in derivative pricing and the calibration of volatility surfaces, in 1999. Elie has published many articles on the philosophy of financial derivatives and their market (*Wilmott* magazine) as well as two books on the subject: *The Blank Swan: The End of Probability* and *The Medium of Contingency: An Inverse View of the Market*.

ANIL BAWA-CAVIA is a computer scientist working with computational media. In 2009 he founded a speculative software studio, STD-IO. His practice engages with machine learning, algorithms, protocols, encodings, and other software artefacts.

AMANDA BEECH is an artist and writer living in Los Angeles. Drawing from popular culture, critical philosophy, and real events, her work manifests in different media including critical writing, video installation, drawing, print, and sculpture. Using a range of rhetorical and often dogmatic narratives and texts, Beech's work poses questions and proposes models for a new realist art in today's culture: that is, a work that can articulate a comprehension of reality without the terminal mirror of a human identity. Beech is Dean of Critical Studies at CalArts

ADAM BERG is a philosopher and artist, and teaches philosophy and critical theory at Otis College of Art and Design and at Cal Arts. Recent publications are *Phenomenalism, Phenomenology, and the Question of Time* (2016) and *Hephaestus Reloaded: Composed for 10 Hands*.

MAT DRYHURST is a 'medium-agnostic' artist and thinker whose work intersects with the worlds of music, tech, art, philosophy, and activism. He frequently collaborates with his partner, Holly Herndon, and has worked with record labels such as PAN and Southern Records.

JEREMY LECOMTE is is Maître de Conférences (Associate Professor) at the École Nationale Supérieure d'Architecture de Versailles. He holds a PhD in Architecture from the University of Manchester (Manchester Architecture Research Centre, 2017), an Mphil in Cultural studies (Goldsmiths, University of London, 2013) and an MA in Political Philosophy (École des Hautes Études en Sciences Sociales, 2009). He is a founding member and co-editor of *Glass Bead*, a bilingual English-French journal that explores the relations between art, architecture, science and philosophy.

ANNA LONGO holds a PhD in aesthetics from Paris 1–Panthéon-Sorbonne, where she has been teaching for five years; She has been visiting professor at CalArts for two years, and is currently a member of the Collège International de Philosophie where she runs the seminar 'Technologies of Time: Risk, Uncertainty, Knowledge'. She has published papers and edited books on German Idealism, Speculative Realism, and the work of Gilles Deleuze.

ROBIN MACKAY is director of Urbanomic, has written widely on philosophy and contemporary art, and has instigated collaborative projects with numerous artists. He has also translated a number of important works of French philosophy, including Alain Badiou's *Number and Numbers*, Quentin Meillassoux's *The Number and the Siren*, François Laruelle's *The Concept of Non-Photography* and Éric Alliez's *The Brain-Eye* and *Undoing the Image*.

MATTHEW POOLE is Chair of the Department of Art & Design at California State University, San Bernardino. His writing involves theory and criticism of modern and contemporary art and design, curatorial history and theory, and the political and socioeconomic ramifications and influences of the production and reception of art and design.

PATRICIA REED is an artist, writer, and designer based in Berlin. Recent writings have been published in *Glass Bead Journal*, *The New Normal* (MIT Press/Strelka, forthcoming), *e-flux Journal*, *Making and Breaking*, *Angelaki*, *Para-Platforms* (Sternberg); and *Post Memes: Seizing the Memes of Production* (Punctum Books).

DANIEL SACILOTTO is a PhD in Comparative Literature from the University of California Los Angeles (UCLA). His research focuses on the reconciliation of rationalism and materialism, and the methodological relation between epistemology and ontology in contemporary philosophy. He is currently editing a full-length monograph tentatively titled, *Saving the Noumenon: An Essay on the Foundations of Ontology*, in which he proposes a critical reading of the 'ontological turn' in contemporary philosophy, and lays the foundations for a new transcendental epistemology, chiefly inspired by the works of Wilfrid Sellars, Robert Brandom, Alain Badiou, Lorenz Puntel, Ray Brassier, and Jay Rosenberg. He is adjunct faculty at CalArts.

CHRISTINE WERTHEIM is author of eight books including three poetic suites, *The Book of Me*, *mUtter-bAbel*, and *+|'me'S-pace*, experiments in auto-bio-graphy fusing graphics and text to explore the potentialities of the English tongue, and the relationship between suppressed infantile rage and global violence. With her sister Margaret, she is co-creator of the project Crochet Coral Reef (crochetcoralreef.org), and co-director of the Institute For Figuring, a non-profit focusing on the aesthetic dimensions of science and mathematics. She teaches at CalArts.

INIGO WILKINS is a writer and lecturer (CalArts, New School for Research and Practice) working across many disciplines (sonic culture, cognitive science, philosophy, and finance). He is co-director of the online journal *Glass Bead*. He has published articles in such journals as *Litteraria Pragensia*, *Mute Magazine*, and *HFT Review*. His book *Irreversible Noise* is forthcoming from Urbanomic.